To my wife, Gigi, without whom this book would not have become a reality.

R.F.K.

A PHOTOGRAPHER'S JOURNAL
HARRY BENSON

pH **powerHouse Books** BROOKLYN, NY

If you are too young to remember, Robert Francis "Bobby" Kennedy (November 20, 1925–June 6, 1968) was many things to many people: the seventh child of Ambassador Joseph P. Kennedy and his wife Rose; younger brother of slain President John F. Kennedy; older brother of senator Edward "Ted" Kennedy; husband of Ethel Skakel; father of 11 children and a myriad of grandchildren; and for some, the hope for a new beginning.

RFK had served his brother well as Attorney General during JFK's brief tenure as president from 1961–63 and had stayed on for nine months under President Lyndon B. Johnson before being elected U.S. senator from New York. No one will ever know what direction America would have taken or what could have been had RFK lived to become president. But his dedication to civil rights and economic justice were hallmarks of his beliefs.

" Each time a man stands up for an ideal, or acts to improve the lot of others, or strikes out against injustice, he sends forth a tiny ripple of hope...."

RFK, June 6, 1966
University of Cape Town
South Africa

Although my memories of Bobby are as vivid as if it were yesterday, I went back to my old diaries for details, as 40 years is a long time ago.

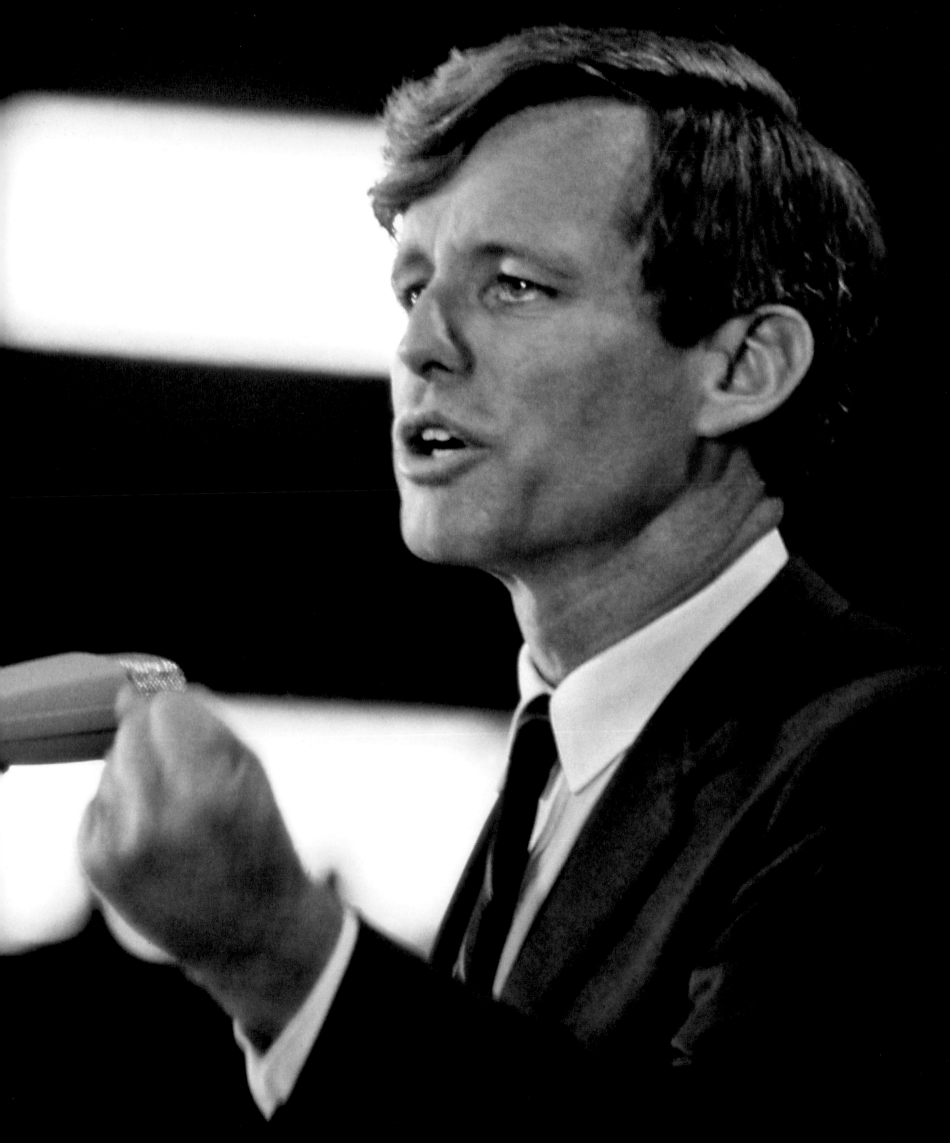

1966

SATURDAY–MONDAY / JULY 2–4 / SNAKE RIVER / IDAHO

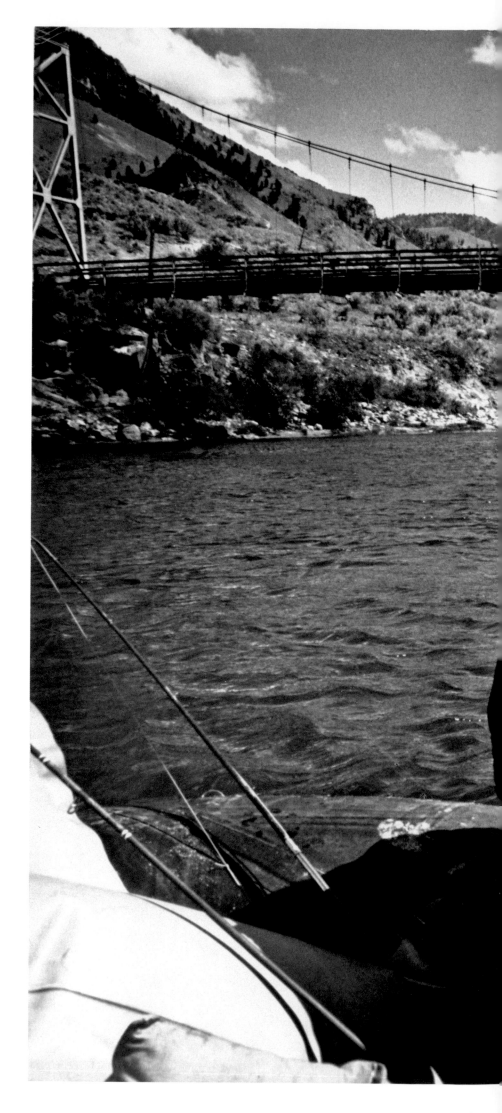

SATURDAY / JULY 2

I first met Bobby Kennedy when I flew to Boise, Idaho, to photograph his family vacation on the Snake River, also called the River of No Return. Earlier, when I had spoken to his press office, they were noncommittal about the senator's whereabouts and would only say that he would be away for a few days. However, they had told *Life* Magazine and the Associated Press exactly where to find Bobby. Luckily for me, there was a *Life* photographer, Enrico Sarsini, on the plane to Boise, whom I recognized from some of the civil rights marches we had been on with Martin Luther King, Jr. He was a jovial sort and told me to come along with him. I have to admit that after working on London's Fleet Street, where the competition between journalists is fiercer than in America, if it had been the other way round, I probably would not have told him where I was going, but would have kept the exclusive to myself.

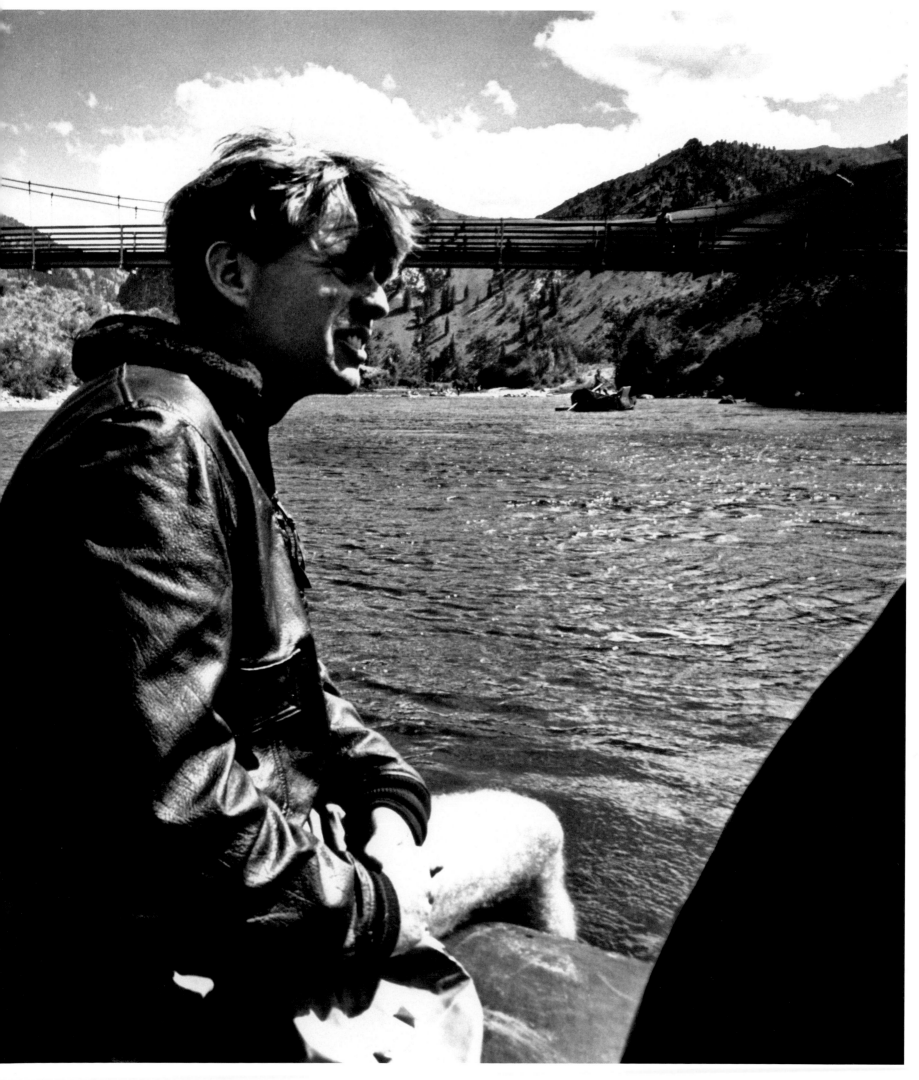

When I got to the Kennedy campsite, Bobby seemed not to care that there was one more photographer along. He and his family went about their holiday, not paying much attention to the photographers on hand. It was all very relaxed and non-structured, and there were no restrictions placed upon what I could photograph.

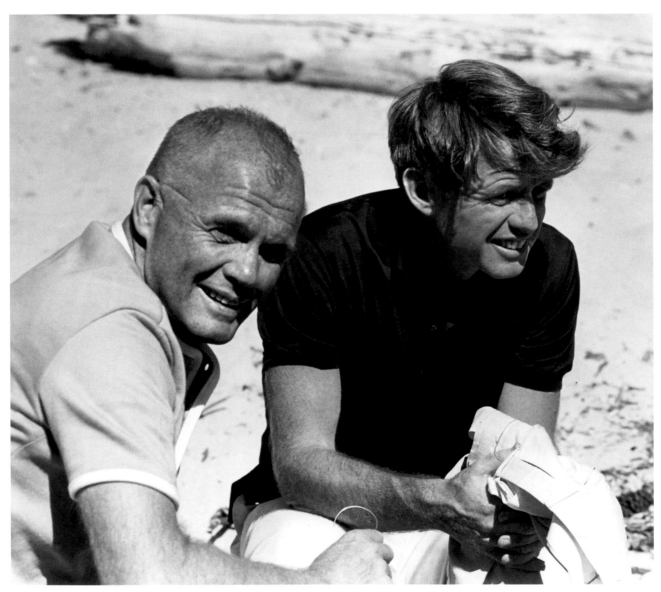

RFK and astronaut John Glenn.

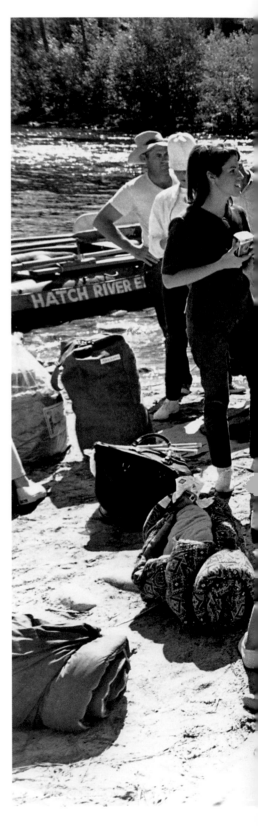

Kennedy, with his family and several friends, including astronaut John Glenn, singer Andy Williams' wife Claudine Longet, and several guides, rode the rapids down the Snake River in sturdy, blow-up rubber rafts. *Life* Magazine had arranged for a raft, too, so with life jackets in place and cameras dangling around our necks, Sarsini and I were off.

Ethel with her children.

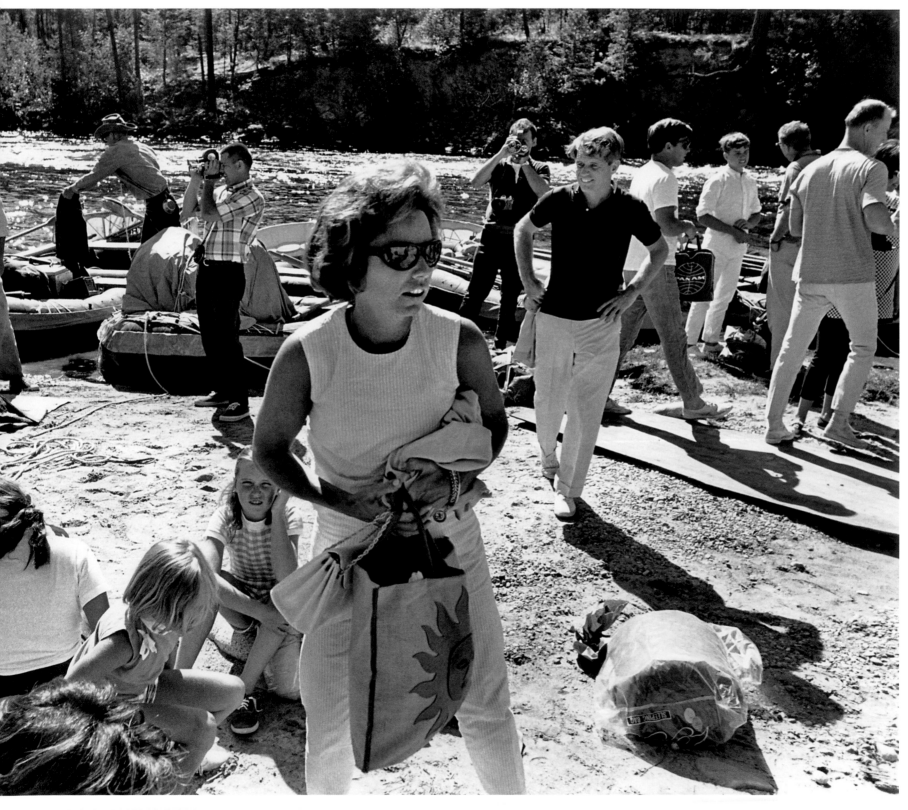

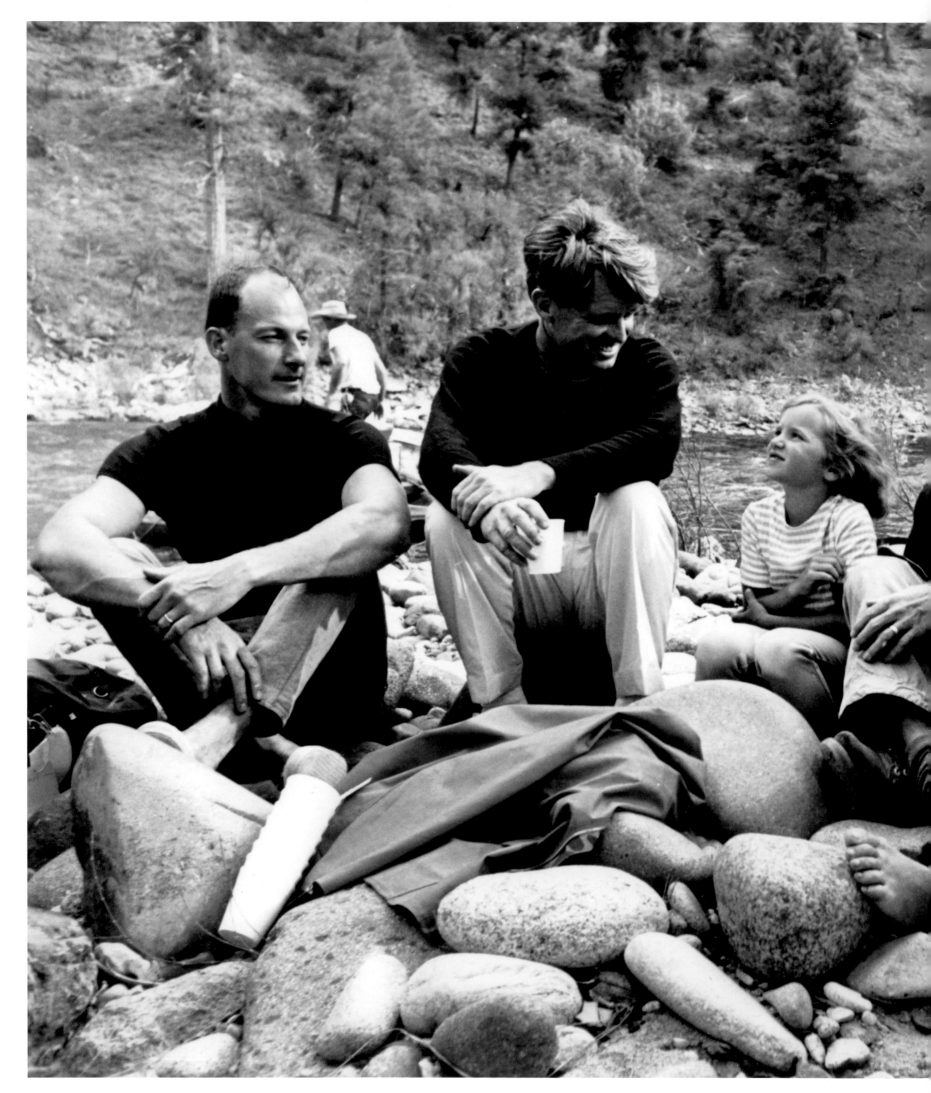

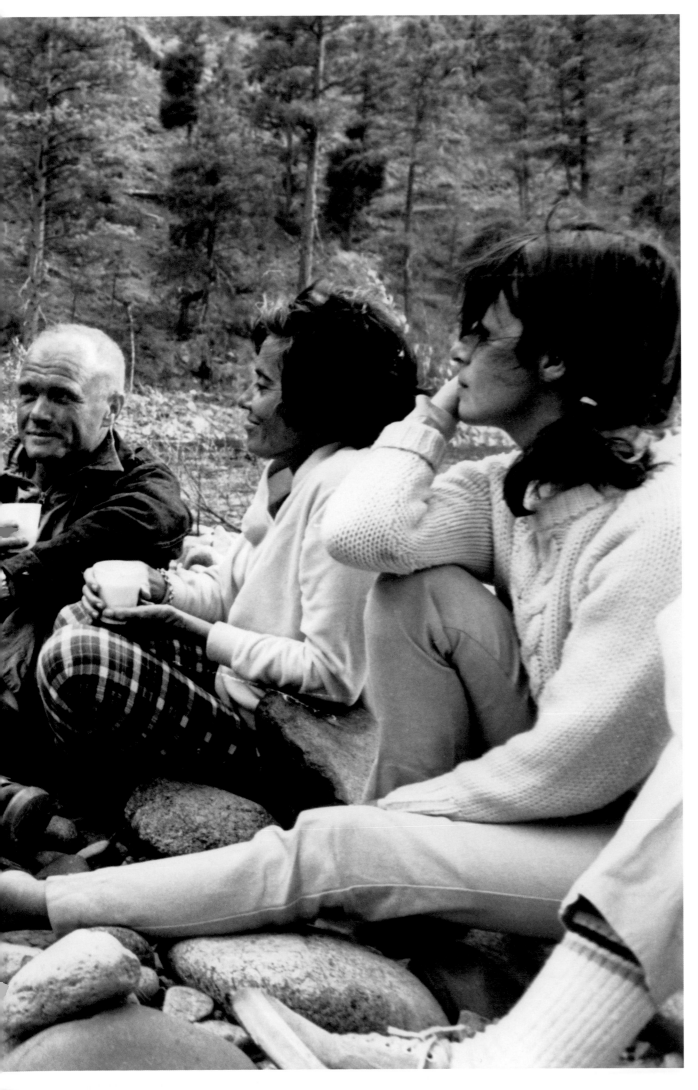

Jim Whittaker, RFK, Carrie,
John Glenn.

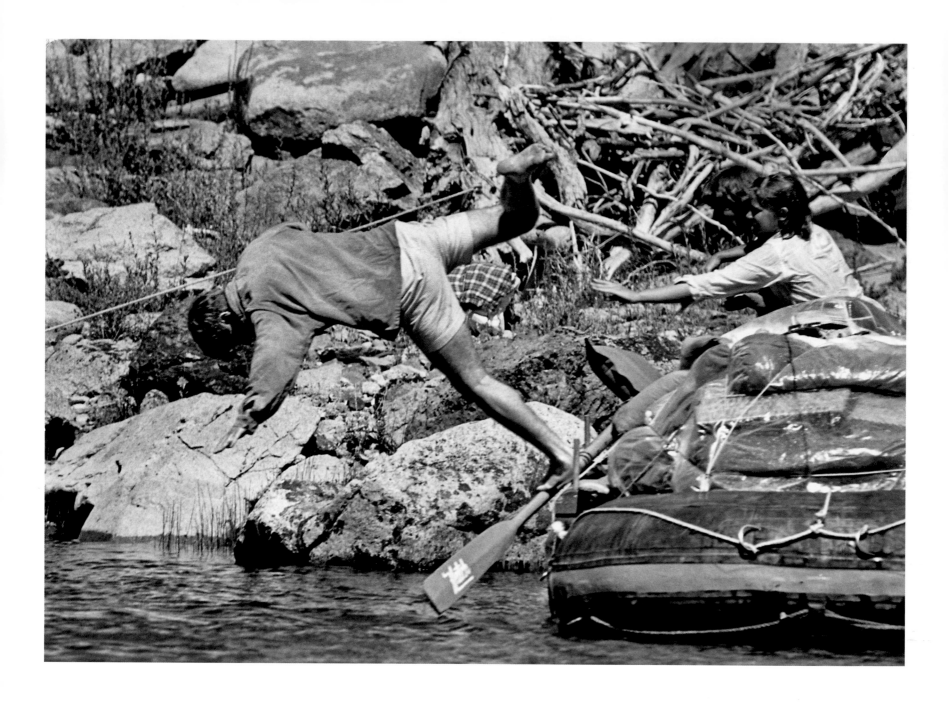

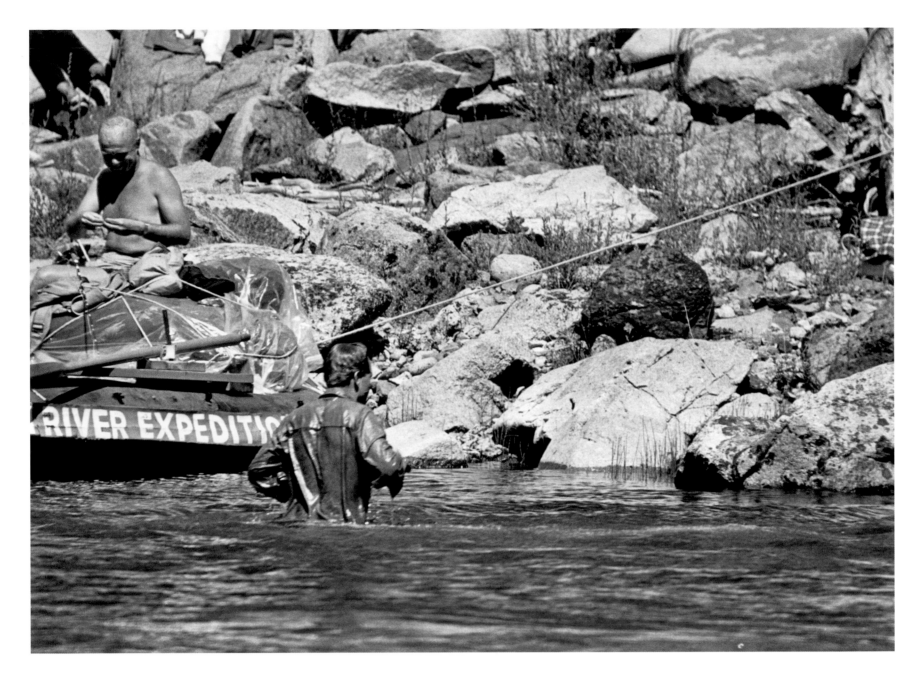

At one stop along the way where the water was calm, Bobby was pushed into the water by his daughter Kathleen after he had playfully pushed her in. I was the only one with a 500 mm fixed lens, a Russian lens—I've still got it somewhere—and from about a hundred yards away I was able to get the photo. The zoom lenses at the time were of no use, so I was the only one to get the shot.

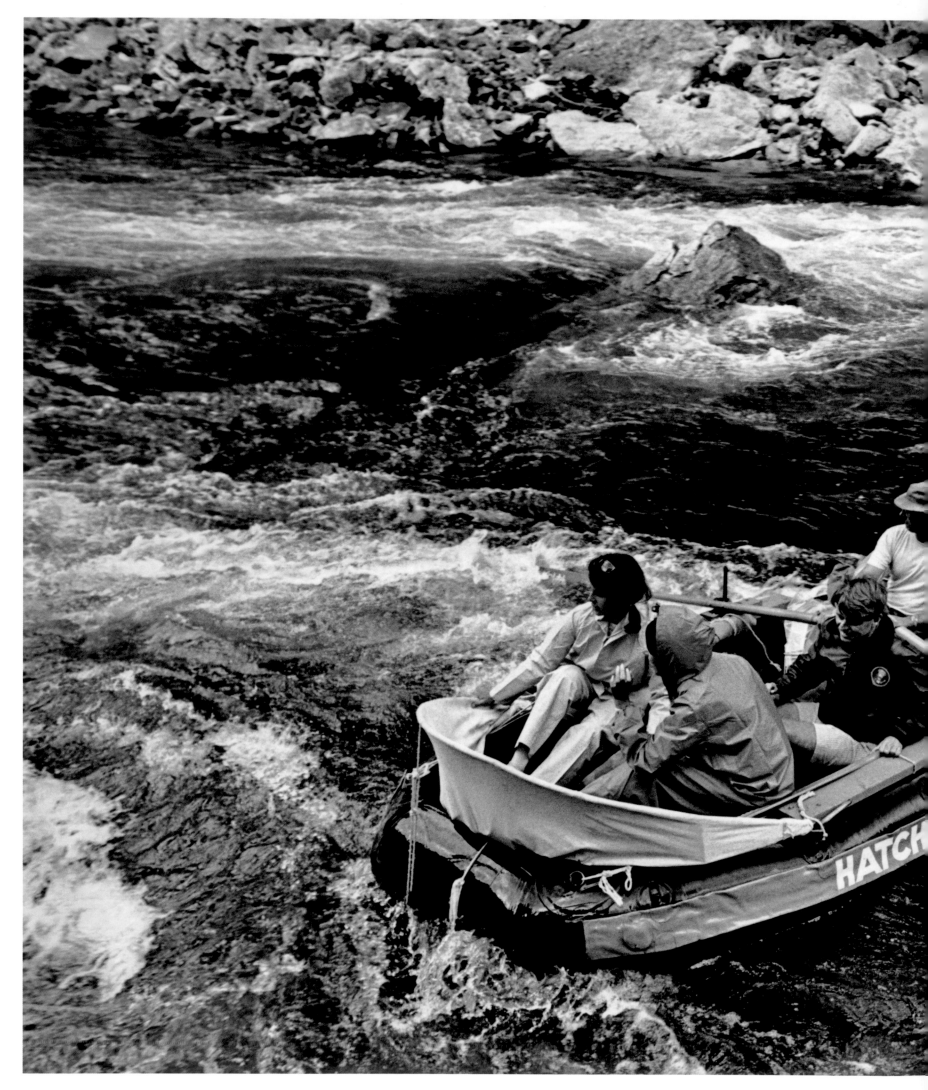

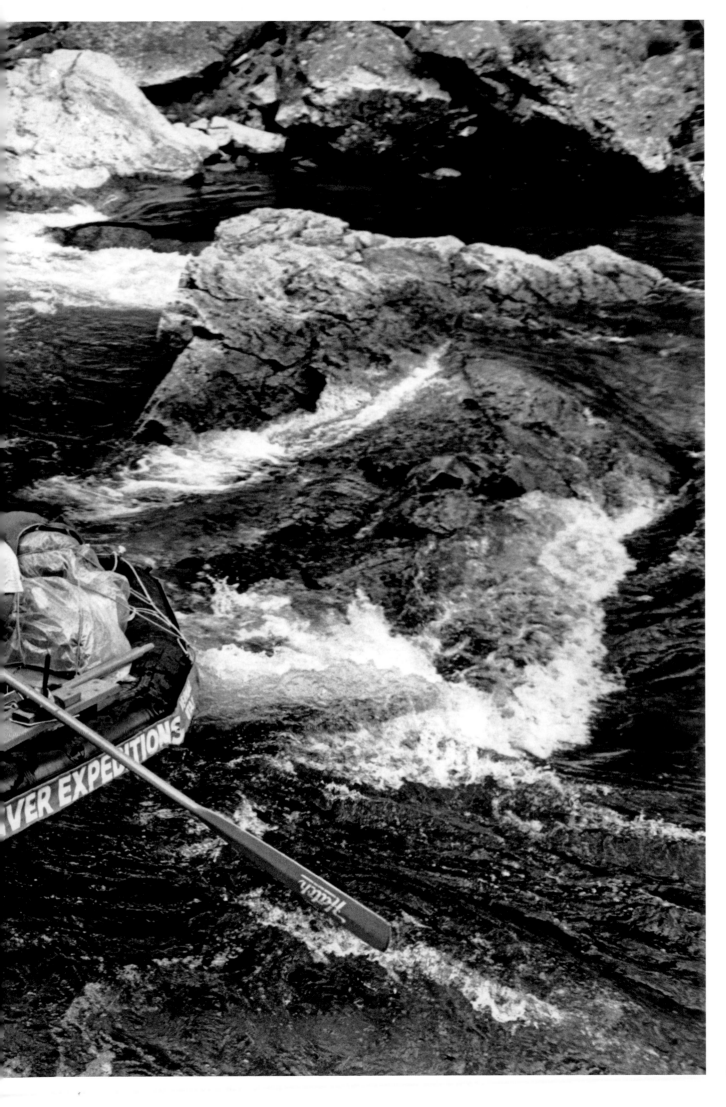

RFK and friends on a Hatch River raft.

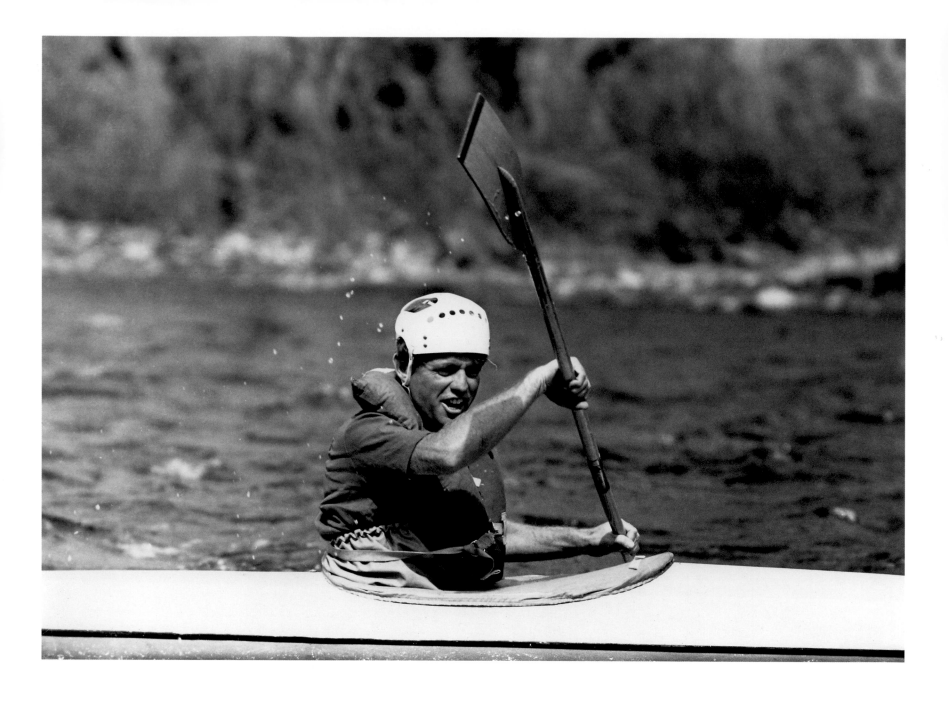

RFK kayaking.

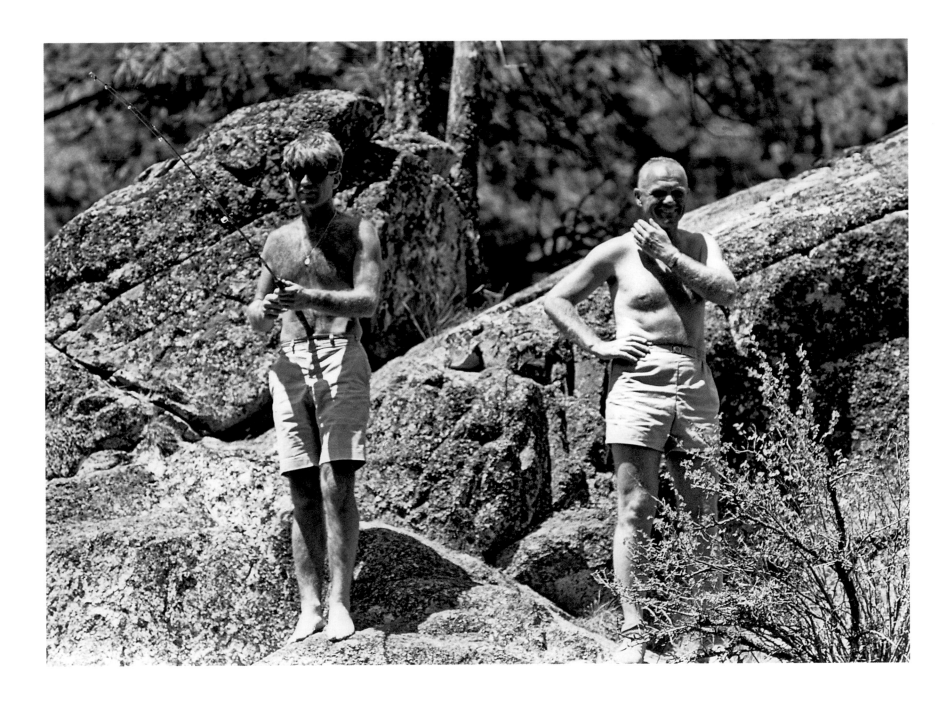

RFK and John Glenn.

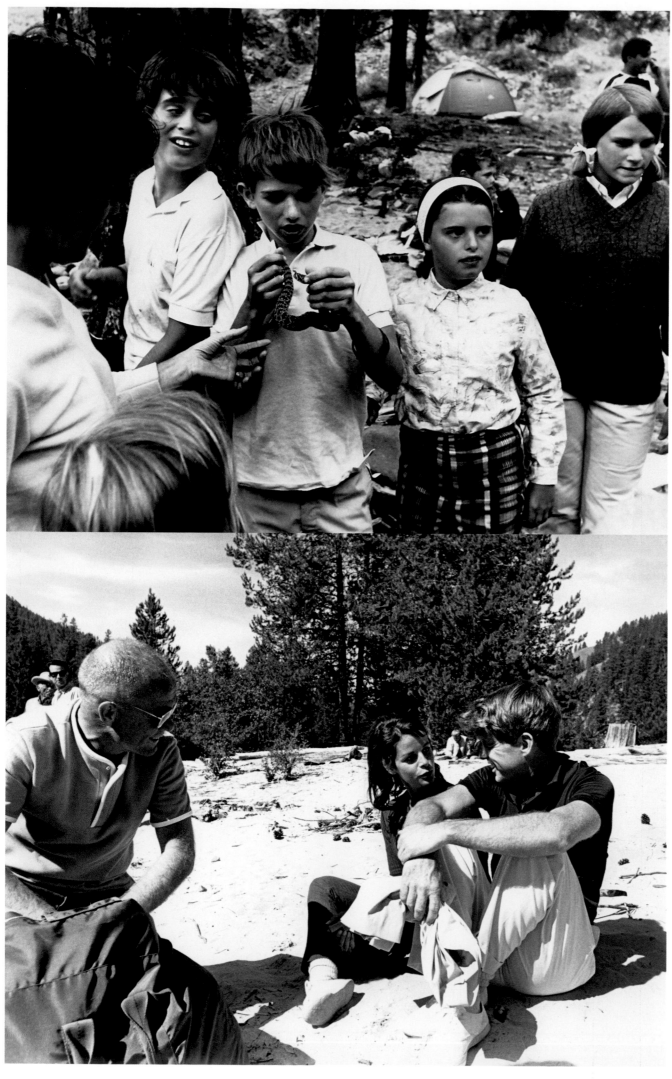

Bobby, Jr., holds a snake while Maria and Bobby Shriver look on.

John Glenn, Claudine Longet, RFK.

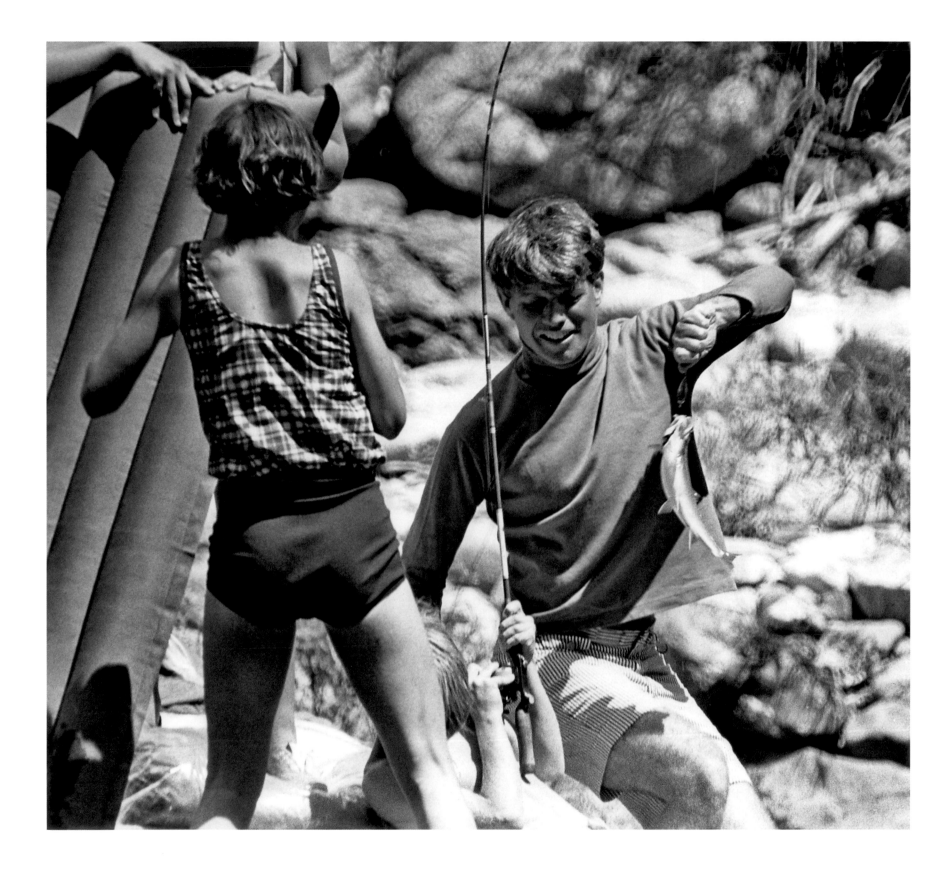

Bobby, Jr., caught a snake. It was a baby rattlesnake; I heard it rattle. Bobby, Jr., wasn't scared at all. The other children, including Maria and Bobby Shriver, gathered around. RFK asked daughter Kerry, who seemed a bit frightened by the snake, if she wanted to hold it. She answered, "Noooooooh."

At the day's end, the family went ashore, setting up a campsite—putting up tents and starting a campfire. Everyone else slept outside. I had not brought much camping gear, and someone loaned me a blanket—the rest all had sleeping bags. I saw a water snake nearby and that kept me awake for quite a while that night.

Sitting around the campfire, Bobby said he was going on to Los Angeles after the trip. When I said that would be fun he told me no, he wished those people would stay away from politics. I took it to mean he was speaking about movie stars. Bobby said some people just showed up to be photographed for the

RFK and Kerry.

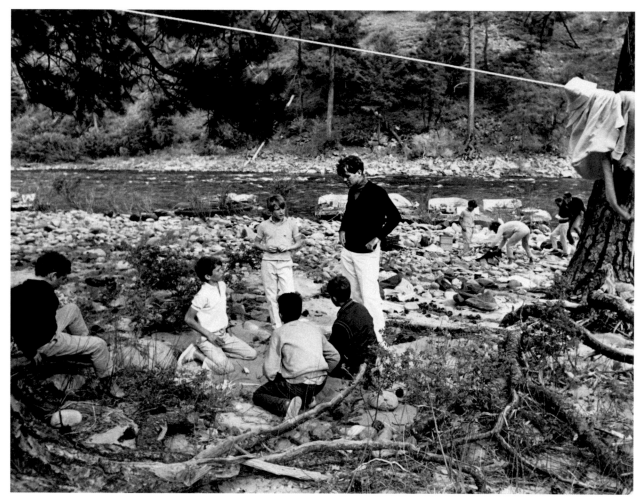

RFK with children.

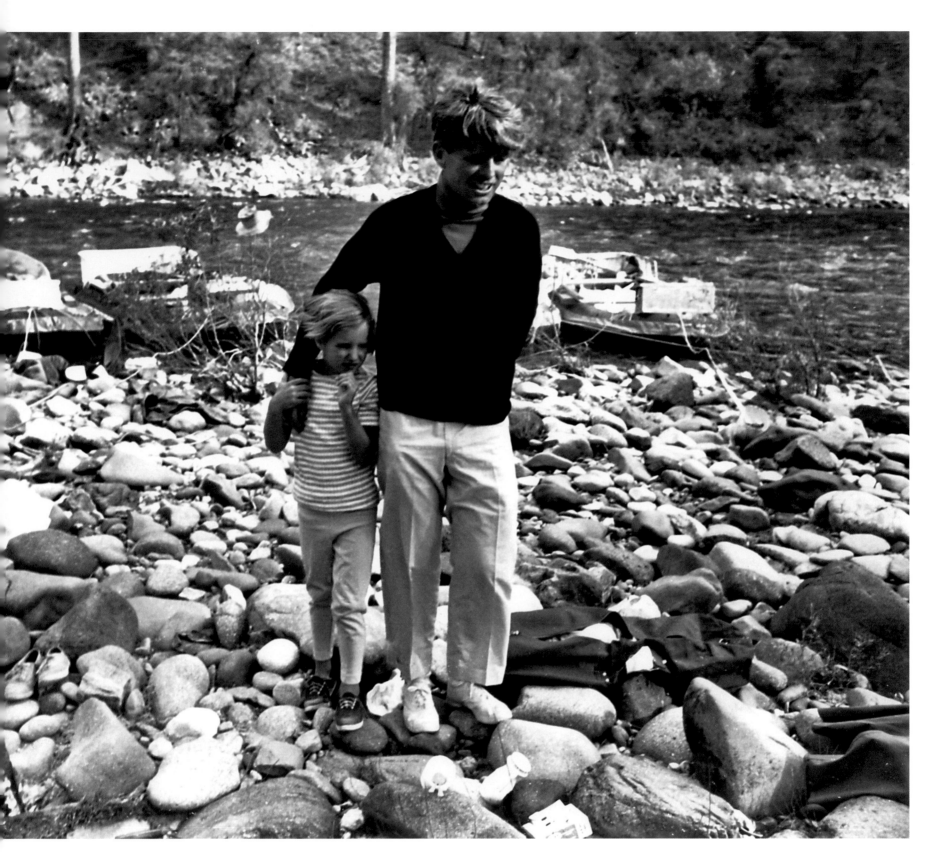

Civil Rights movement, without any real involvement, which was a great aggravation to him. It was the complete opposite of what I thought he would say about Hollywood. That night Bobby and I also spoke at length about Martin Luther King, Jr. I was pleased to have marched during the Civil Rights movement with Dr. King and so we exchanged stories of our different experiences from that time.

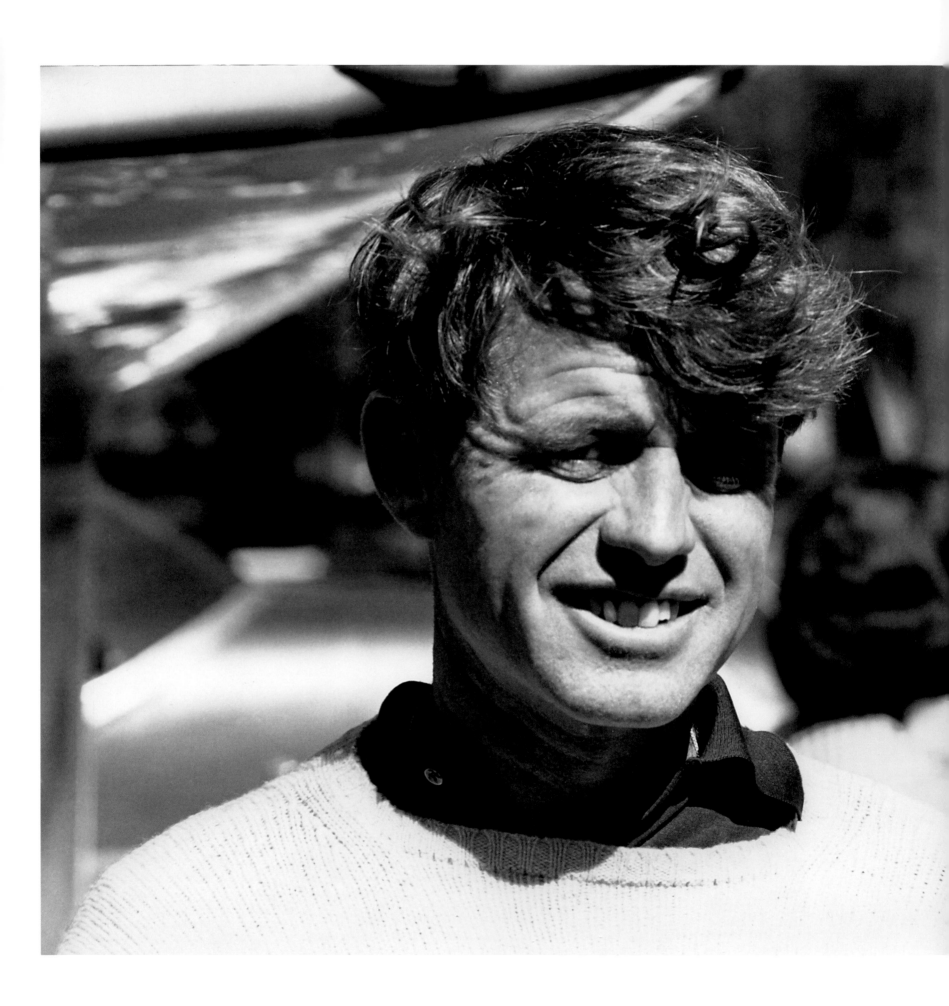

" 'Give me a place to stand,' said Archimedes, 'and I will move the world.' These men moved the world, and so can we all. Few will have the greatness to bend history; but each of us can work to change a small portion of the events, and in the total of all these acts will be written the history of this generation."

RFK, June 6, 1966
University of Cape Town
South Africa

I was glad to have photographed the Kennedys on holiday. Since there were only three photographers there—*Life*, which did not run a big story, AP, which usually transmitted only one or two pictures, and me— I basically had an exclusive. After two days I had enough photos to send back to my paper and was tired of sleeping on the ground, so I returned to New York. I didn't photograph Bobby again until 1968.

1968

MARCH–MAY / PRESIDENTIAL CAMPAIGN TRAIL

I have always thought that 1968 was the year America had a nervous breakdown. If you went along without thinking much, with blinders on, as if on holiday (and without access to the drug of the twenty-first century, the internet), everything seemed fine. But if you really stopped to look at and think about what was happening, the country was having a meltdown, ideologically dividing in two as it went.

On the surface, it seemed like an average year, especially when you look back at some of the events that made the headlines: the Montreal Canadiens won the Stanley Cup; the Green Bay Packers won the Super Bowl; Lee Trevino won the U.S. Open; O.J. Simpson won the Heisman Trophy; and the Detroit Tigers won the World Series. "Up, Up, and Away" by the 5th Dimension won the Grammy for Record of the Year (the following year it would go to Simon and Garfunkel for "Mrs. Robinson"). The Album of the Year was *Sgt. Pepper's Lonely Hearts Club Band* by the Beatles.

The smell of marijuana permeated the air. The radical anti-war musical *Hair* moved to Broadway in 1968 and was a smash hit. The first rock musical, it reflected the sentiments and values of the younger generation, depicting drugs, sex, and rock and roll.

The top-grossing film in 1968 was *The Graduate* and the Oscar for Best Picture went to *In the Heat of the Night*, which had premiered the year before. Barbra Streisand and Katherine Hepburn were both Oscar nominees for their movies *Funny Girl* and *The Lion in Winter*. They tied for the Best Actress Oscar and Barbra Streisand accepted her award in 1969 in a see-through get-up by Arnold Scaasi that turned heads even in Hollywood. At that same Oscar ceremony, one small nod to reality was producer Charles Guggenheim's "Robert Kennedy Remembered," which won the Award for Best Live Action Short Subject.

The most popular TV show in 1968, the cutting-edge, irreverent, politically savvy *Rowan & Martin's Laugh-In*, was neck-and-neck in the ratings with mainstream shows *Gomer Pyle* and *Bonanza*. The Nobel Peace Prize went to René Cassin of France, president of the European Court for Human Rights, and the Pulitzer Prize for Fiction went to William Styron for his 1967 novel *The Confessions of Nat Turner*.

The dichotomy between these statistics and what was actually happening in the world—the seizure of the U.S. Navy ship *Pueblo* by the North Koreans, the massacre at My Lai, and the polarization of the country over the Vietnam war—was startling. Conflict, chasm, contrast, division. The gulf between the generations, between liberal and conservative, was huge and growing.

I found my 1968 diary with scribbled, fragmented entries of where I was that year and when I was with Bobby Kennedy. As a photojournalist, I documented his campaign from the day he announced his candidacy for the presidency. I was in New York when Kennedy flew in from Washington, had lunch in an Irish pub in Rockefeller Center called Charlie O's, and marched up Fifth Avenue in the St. Patrick's Day Parade. I was with him on the campaign trail in Kansas and Los Angeles, and documented his assassination from beginning to end. I was there at the funeral at St. Patrick's Cathedral in New York, and rode the train with the casket in the smoldering heat to Washington, D.C., for the burial at Arlington Cemetery next to his slain brother, President John F. Kennedy.

SUNDAY / JANUARY 21

The Vietnam War was raging and the defeat of American forces at their stronghold in Khe Sanh was a portent of things to come. Two days later came the unprecedented taking of the *Pueblo*, the U.S. intelligence-gathering ship, brazenly captured by the North Koreans for allegedly entering their waters.

WEDNESDAY / JANUARY 24

A breaking news story: I flew to Thule, Greenland, because a B-52 had crashed there on January 21st. The bomber carried four nuclear weapons, which were destroyed by fire when it crashed. None of the bombs had detonated, but some radioactive contamination had occurred in the area of the crash.

TUESDAY / JANUARY 31

The Tet Offensive quickly followed the Battle of Khe Sanh, showing more and more Americans the overwhelming evidence that the Viet Cong were never going to give up. They attacked the U.S. Embassy in Saigon. Night after night Walter Cronkite read the disastrous events of the war on the *CBS Evening News*, to a country increasingly asking *why*. Why were we there? Why were we losing so many of our soldiers? *Why?* Students on college campuses across the country began burning their draft cards, staging flower-power sit-ins, or simply fleeing to Canada or Mexico to avoid being drafted into a war they didn't believe in.

MONDAY / FEBRUARY 19

Off to Canada to photograph Jackie Kennedy and her children on a ski holiday in the Laurentian Mountains.

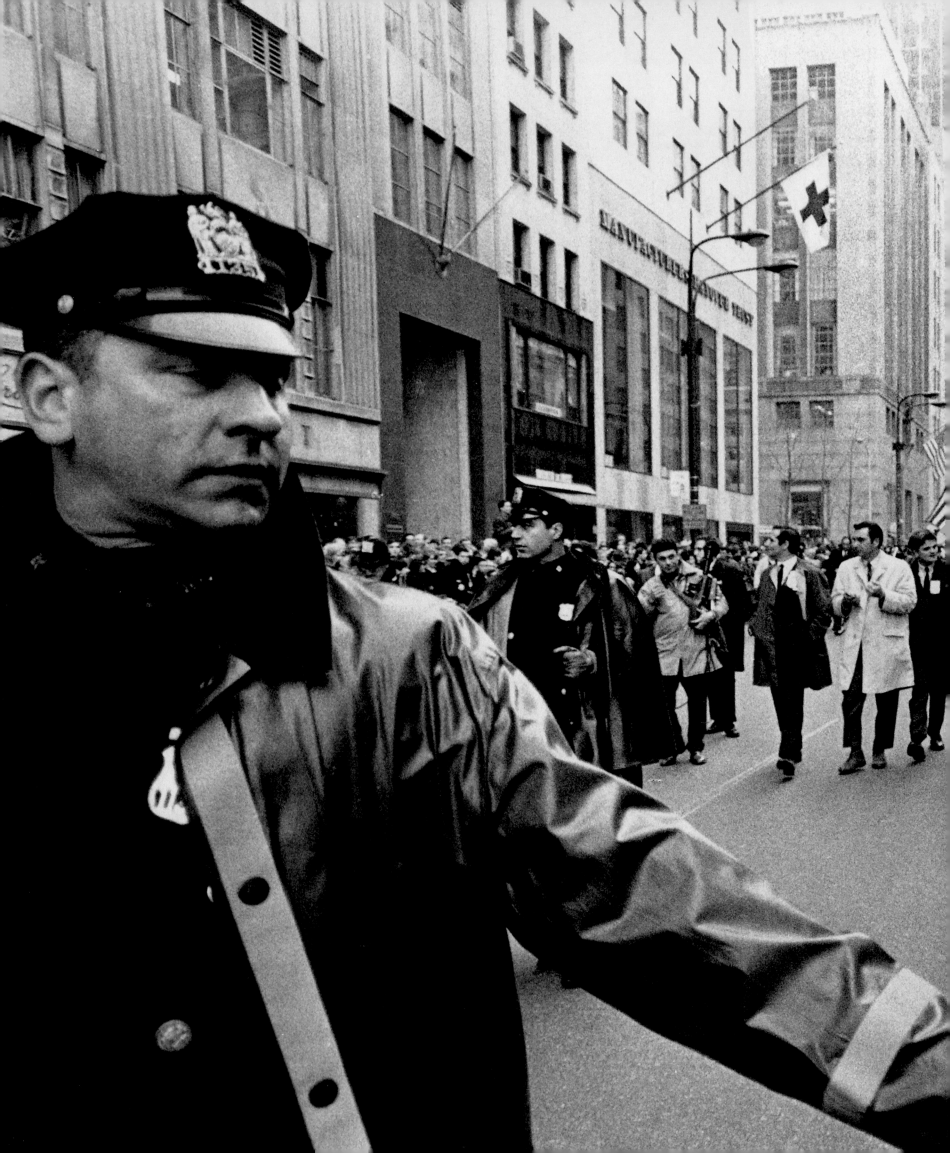

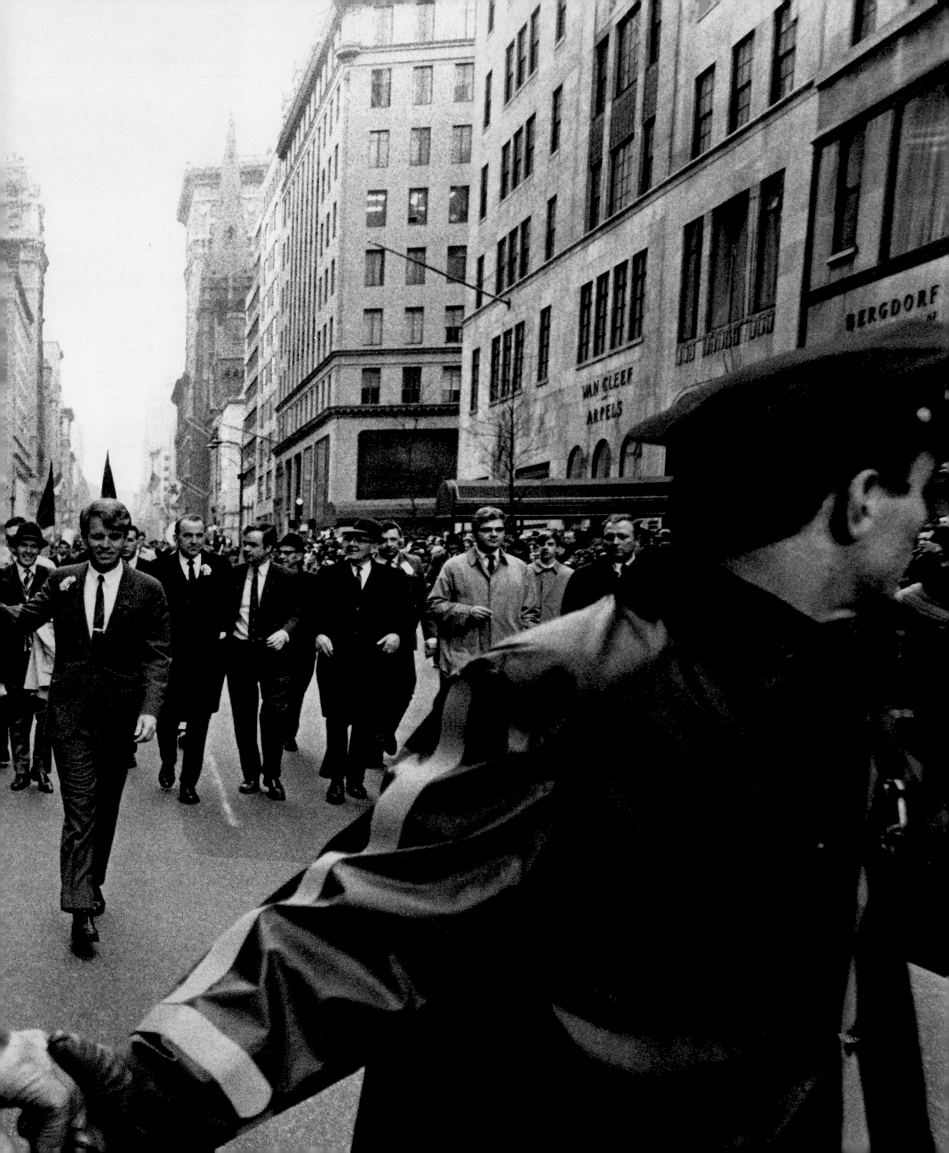

SATURDAY / MARCH 16

American troops slaughtered scores of civilians in the My Lai massacre in Vietnam. Four days earlier Senator Eugene McCarthy, who vehemently opposed the war, had garnered 42 percent of the vote in the New Hampshire primary against the incumbent President Lyndon B. Johnson. But that wasn't going to deter Bobby Kennedy from entering the race.

Kennedy, deluged by supporters, led the annual St. Patrick's Day Parade and announced he would seek the Democratic nomination for president in the upcoming November election.

" I am announcing today my candidacy for the presidency of the United States.

I do not run for the presidency merely to oppose any man but to propose new policies. I run because I am convinced that this country is on a perilous course and because I have such strong feelings about what must be done that I feel I am obliged to do all I can."

RFK, March 16, 1968
Senate Caucus Room
Washington, D.C.

P.30–31: RFK leads the St. Patrick's Day
Parade up Fifth Avenue.

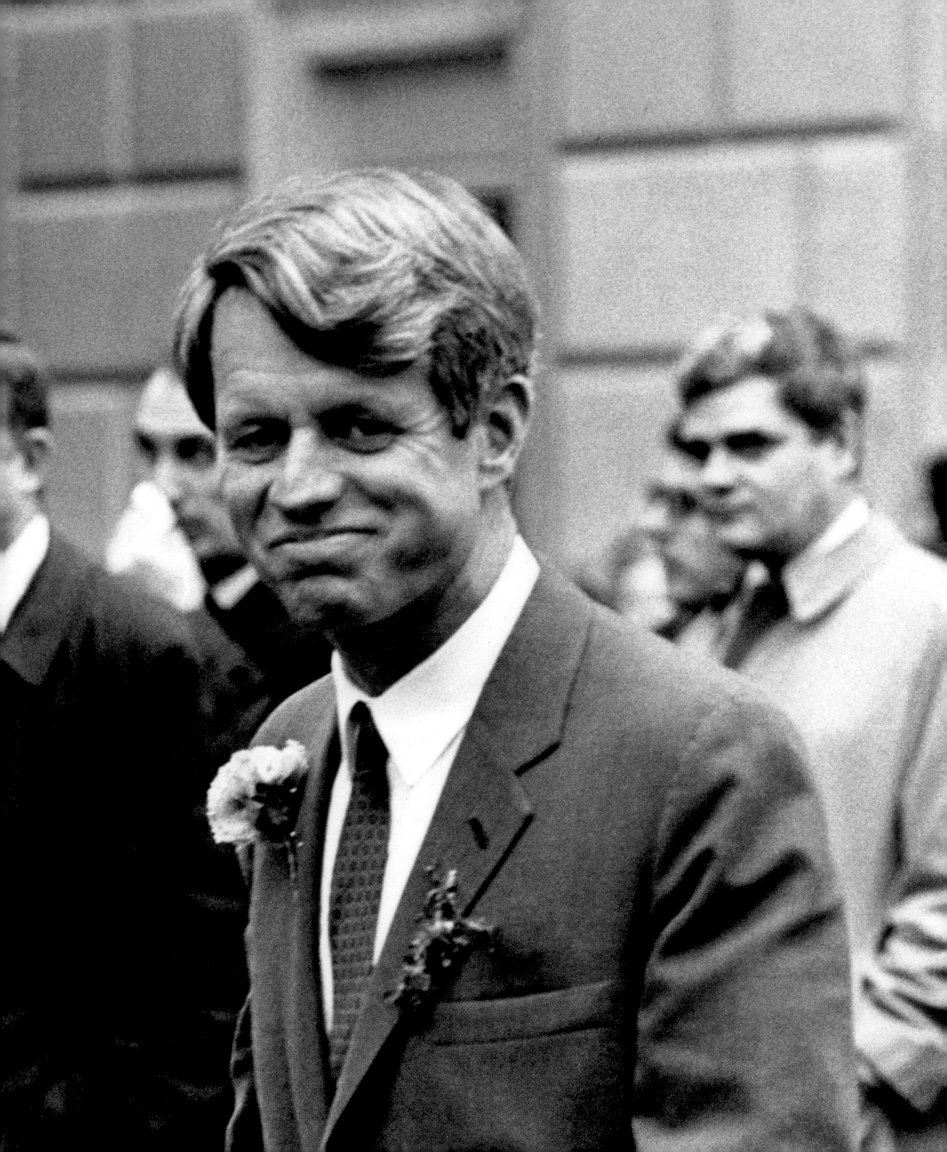

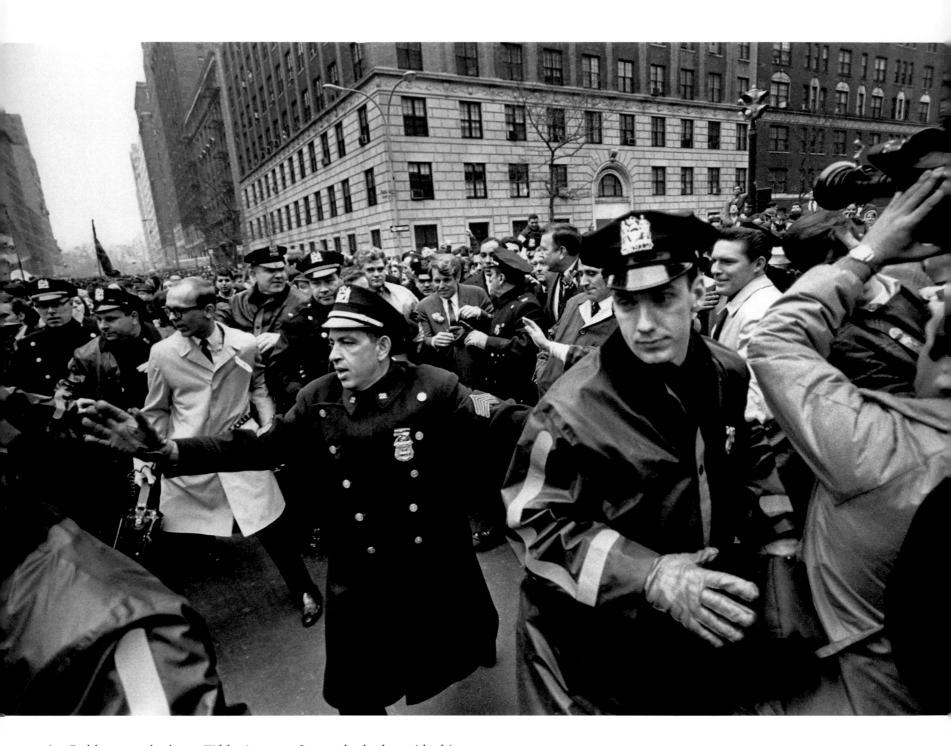

As Bobby marched up Fifth Avenue, I marched alongside him and watched as he was mobbed by adoring supporters who broke through the police lines just to touch his hand. To them he symbolized the hope for a new beginning. He instilled a belief that he could change the world. He galvanized young and old alike who were opposed to the Vietnam War.

As we marched, Bobby would dive into the crowd, smiling, and shake hands with people. They all wanted to touch him.

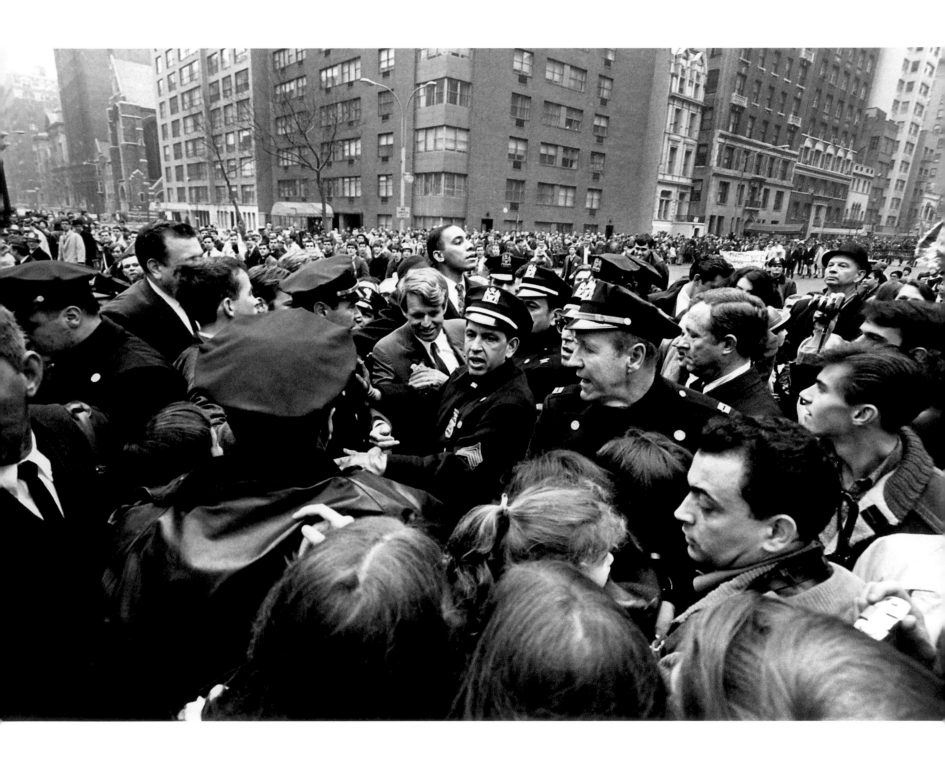

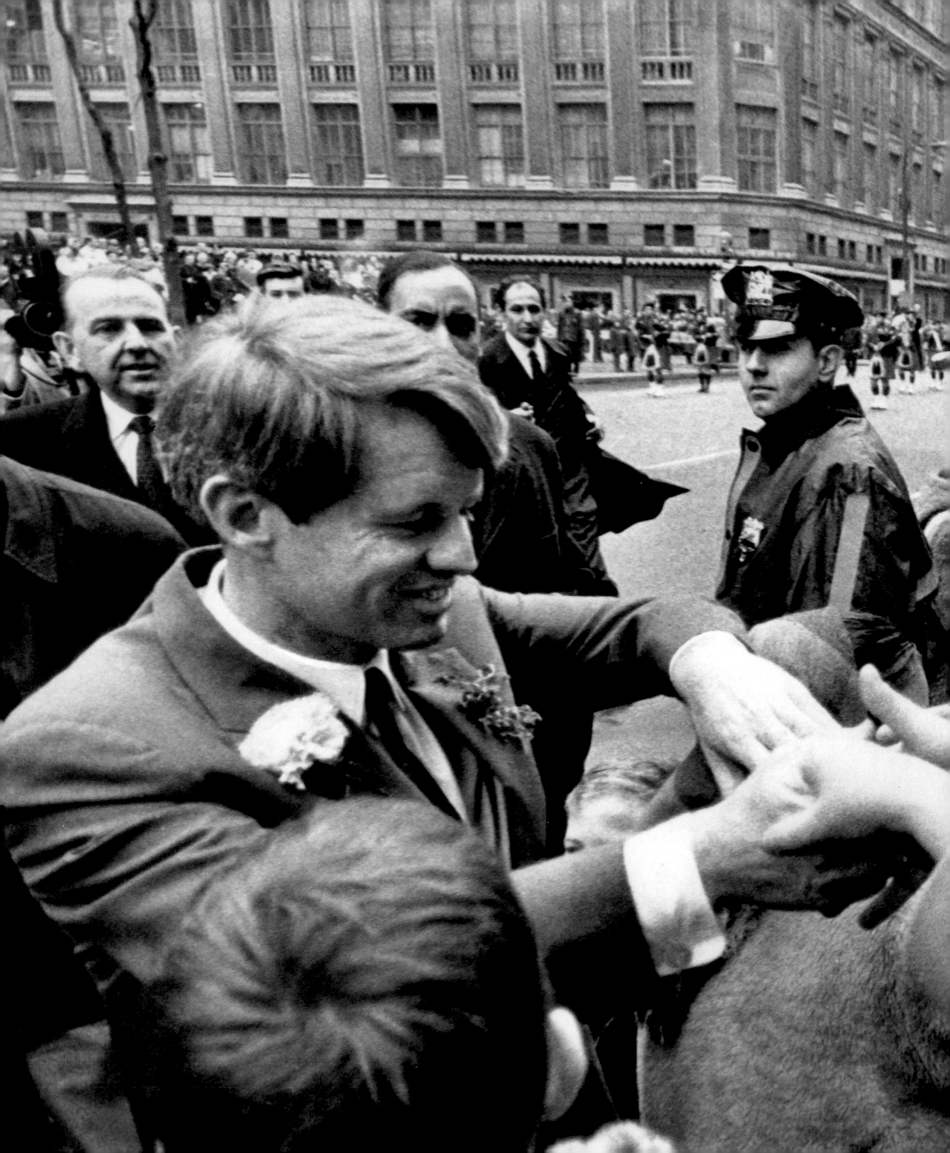

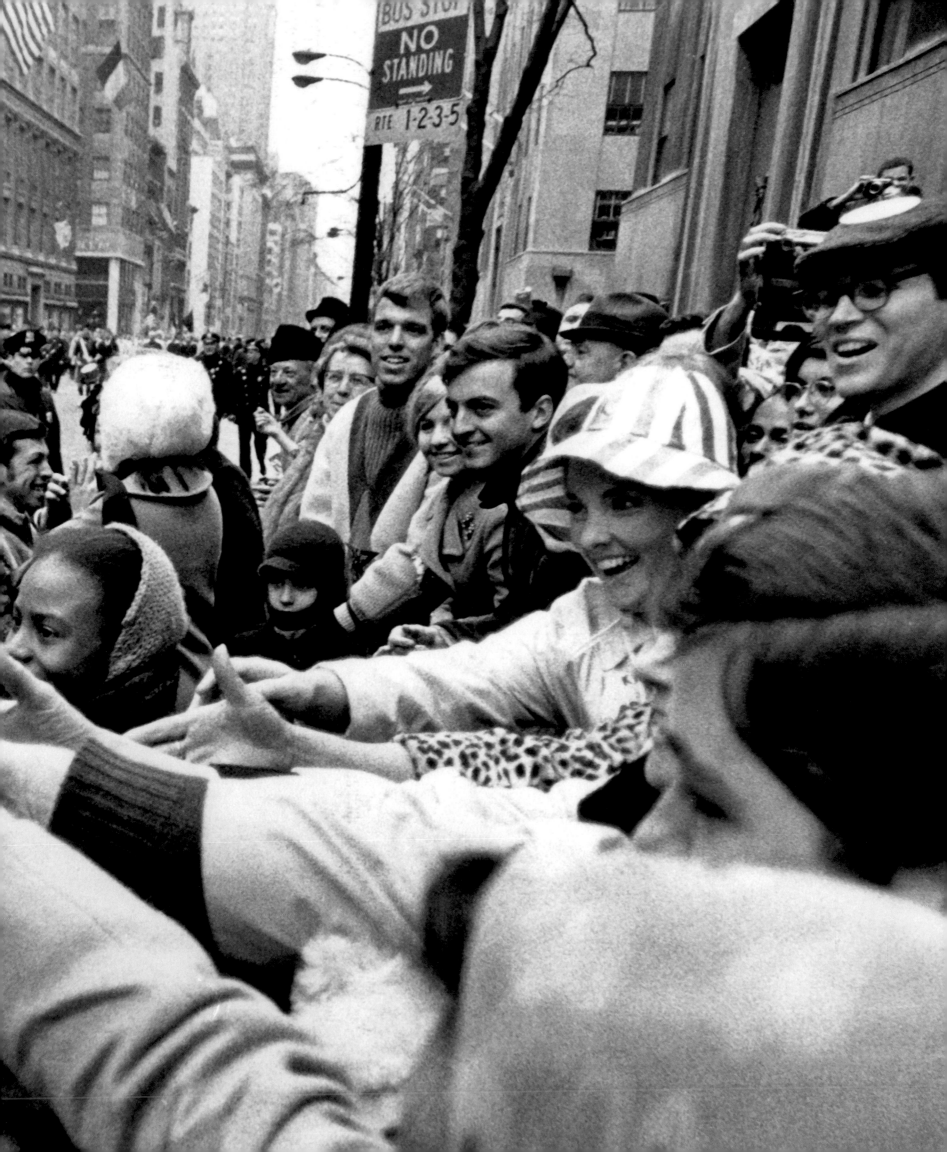

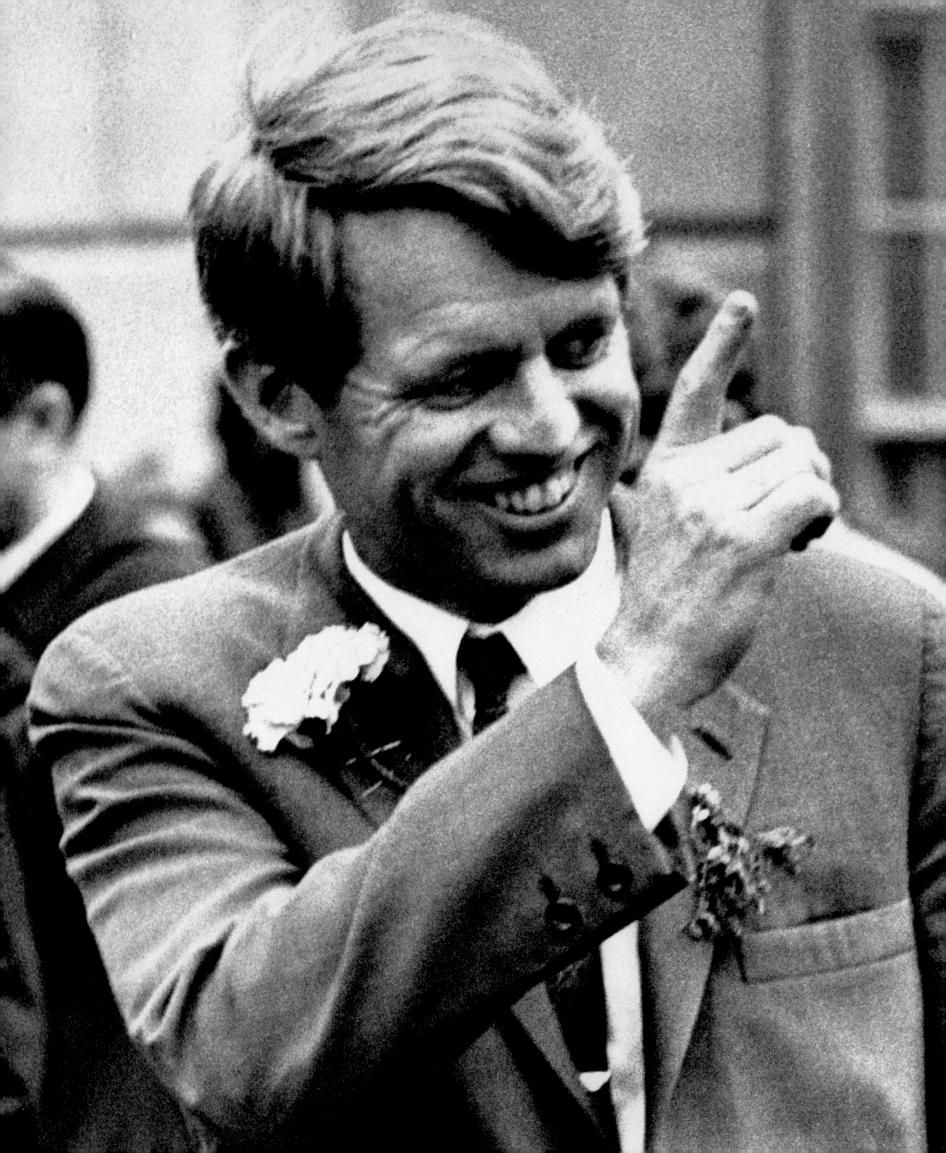

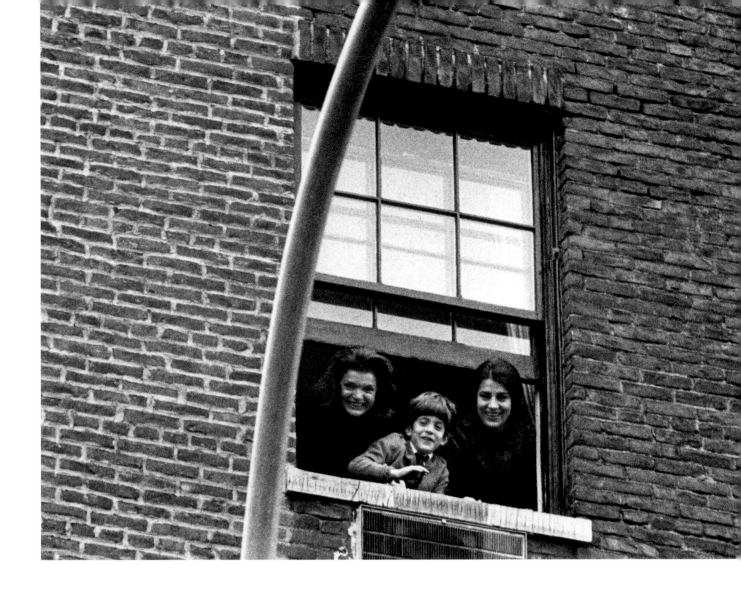

At one point, as we were marching, Bobby turned his head and looked up. He pointed a finger toward a nearby building, and his face lit up in a broad smile. I followed his movement with my camera and saw Jackie Kennedy and John, Jr., leaning their heads out of a window, smiling and waving back at him. He had known they would be there.

"I run to seek new policies—policies to close the gaps between black and white, rich and poor, young and old, in this country and around the world. I run for the presidency because I want the Democratic Party and the United States of America to stand for hope instead of despair, for reconciliation of men instead of the growing risk of world war.

I run because it is now unmistakably clear that we can change these disastrous, divisive policies only by changing the men who make them...."

RFK, March 16, 1968
Senate Caucus Room
Washington, D.C.

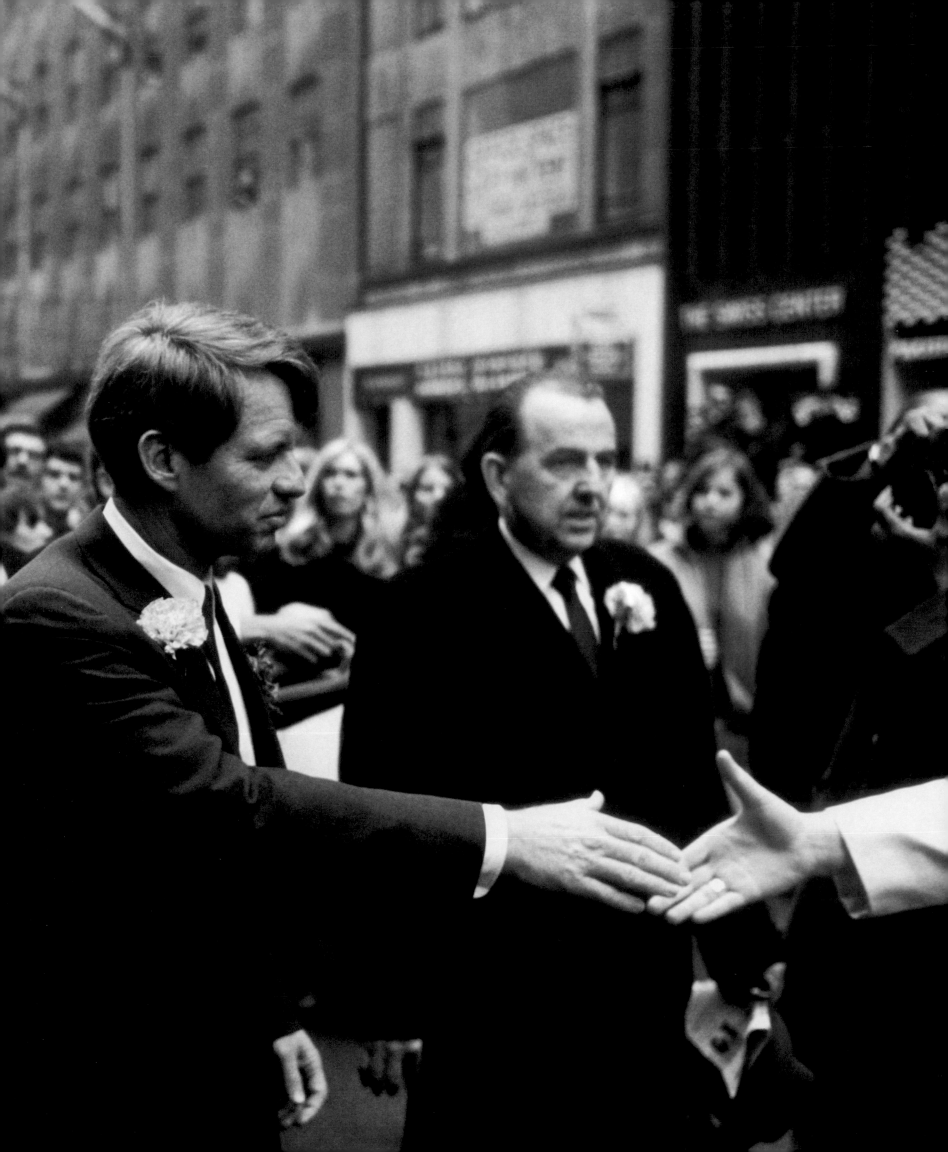

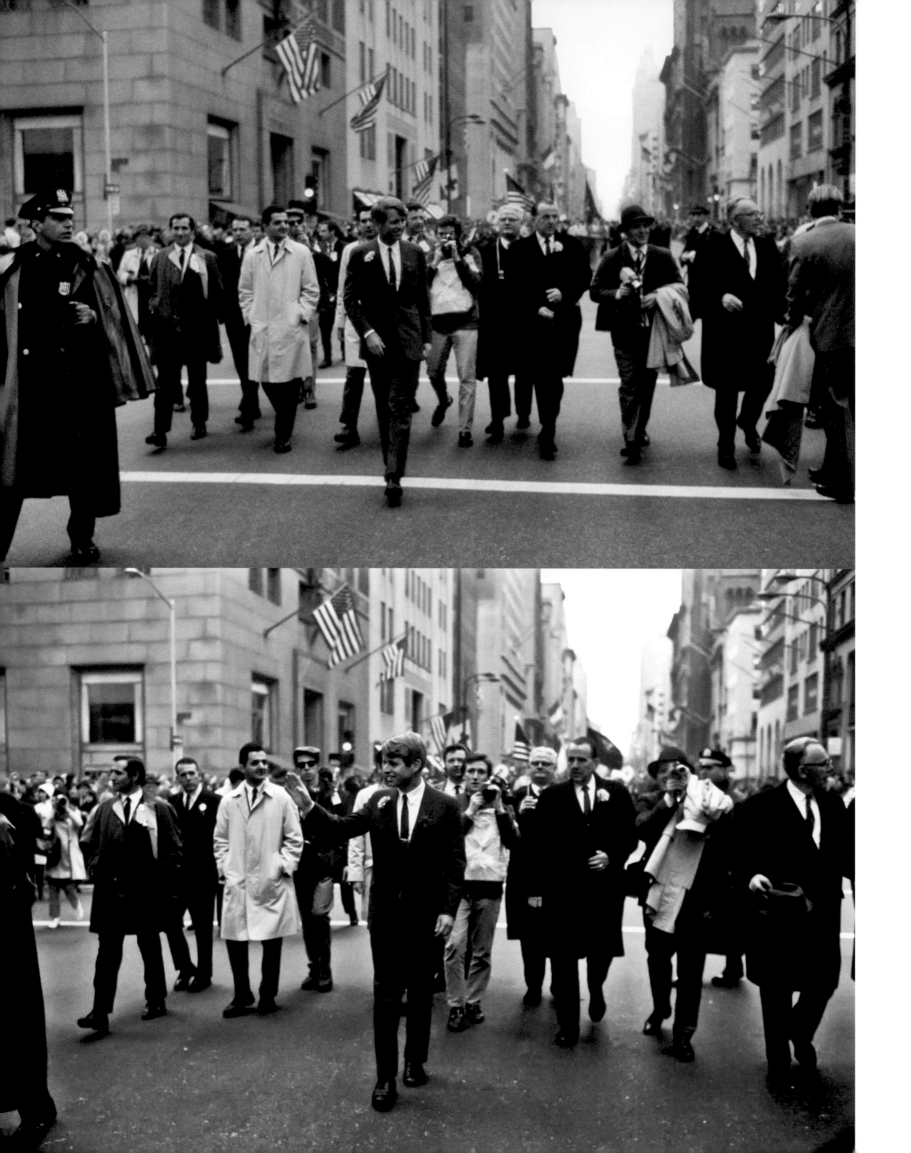

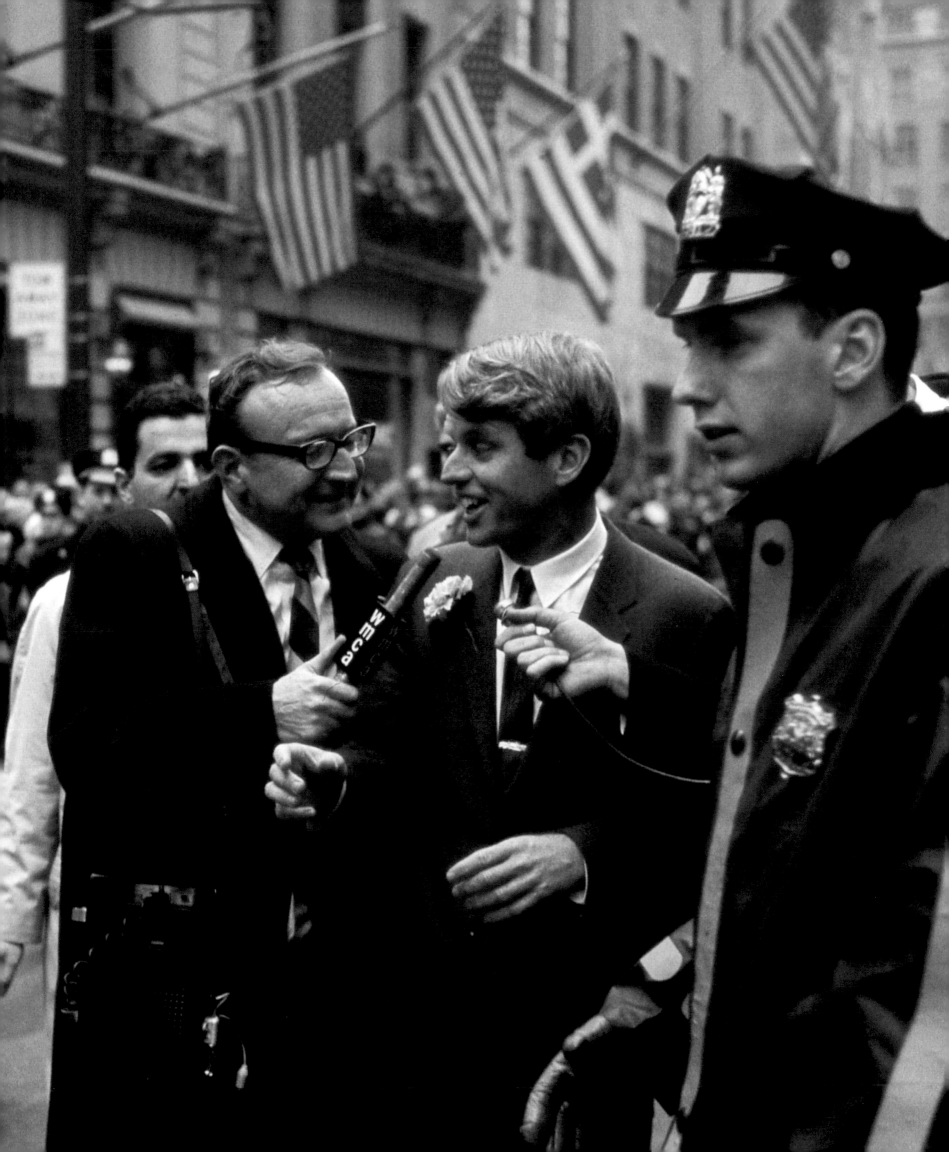

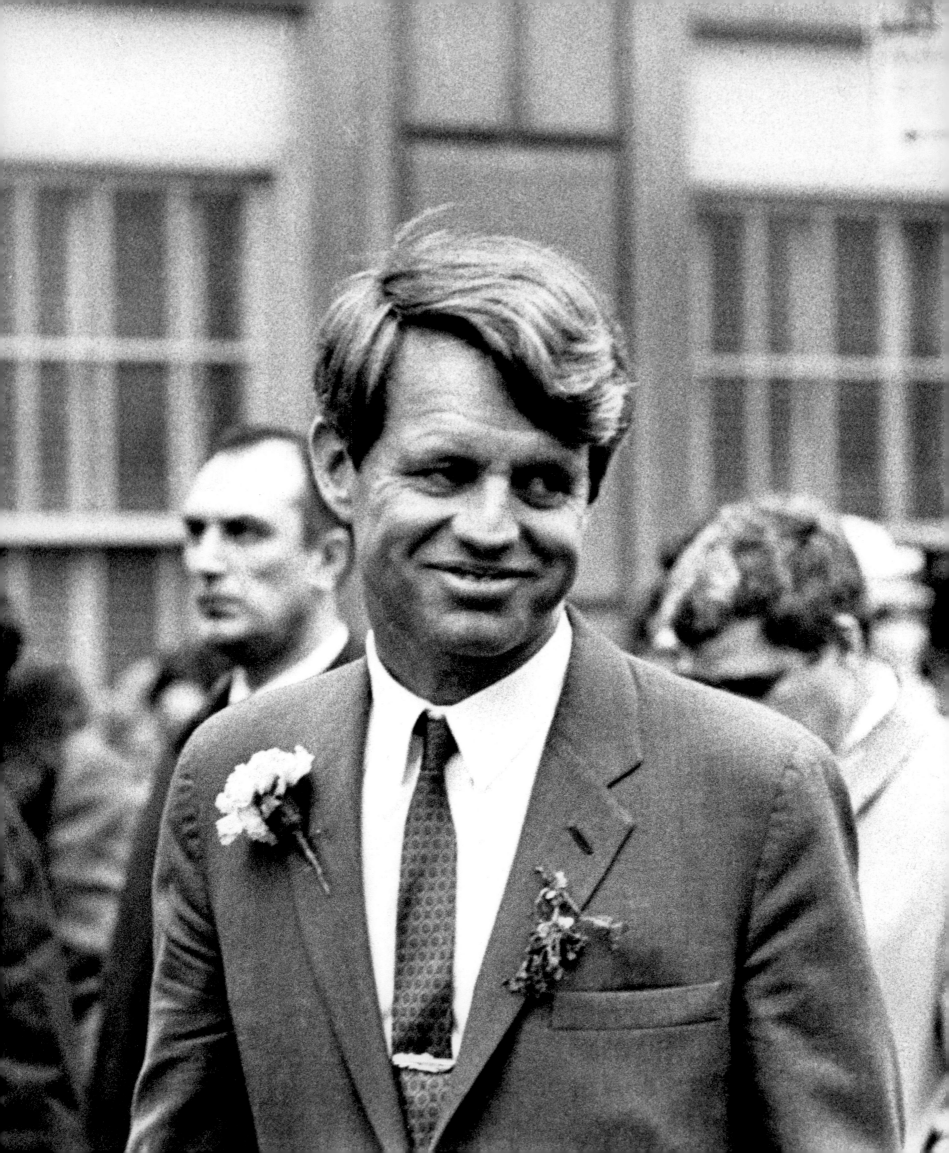

SUNDAY / MARCH 17

The next day we left for Kansas and the start of the campaign. I was on the campaign trail for the duration, off and on. I liked Bobby. He always left you feeling you were important to his campaign.

There was a camaraderie among the press corps traveling with him. You always got a photograph before the end of the day. Like any good politician, he made you feel like one of his inner circle. I knew it was manipulative, but it worked. The press loved Bobby.

Soft-spoken, to-the-point, he seemed to care about changing the plight of the poor, and they believed him. Bobby spoke to the people. It was like Jack all over again. He made everyone feel perfectly comfortable. There was that superstar quality about him, which was partially imposed upon him by the fans and admirers. He knew how to communicate with the people—Catholics, Jews, Protestants, white, black, brown, red, yellow. He could relate to all of them, and they could feel it instinctively.

P.42–43, opposite: RFK during the St. Patrick's Day Parade.

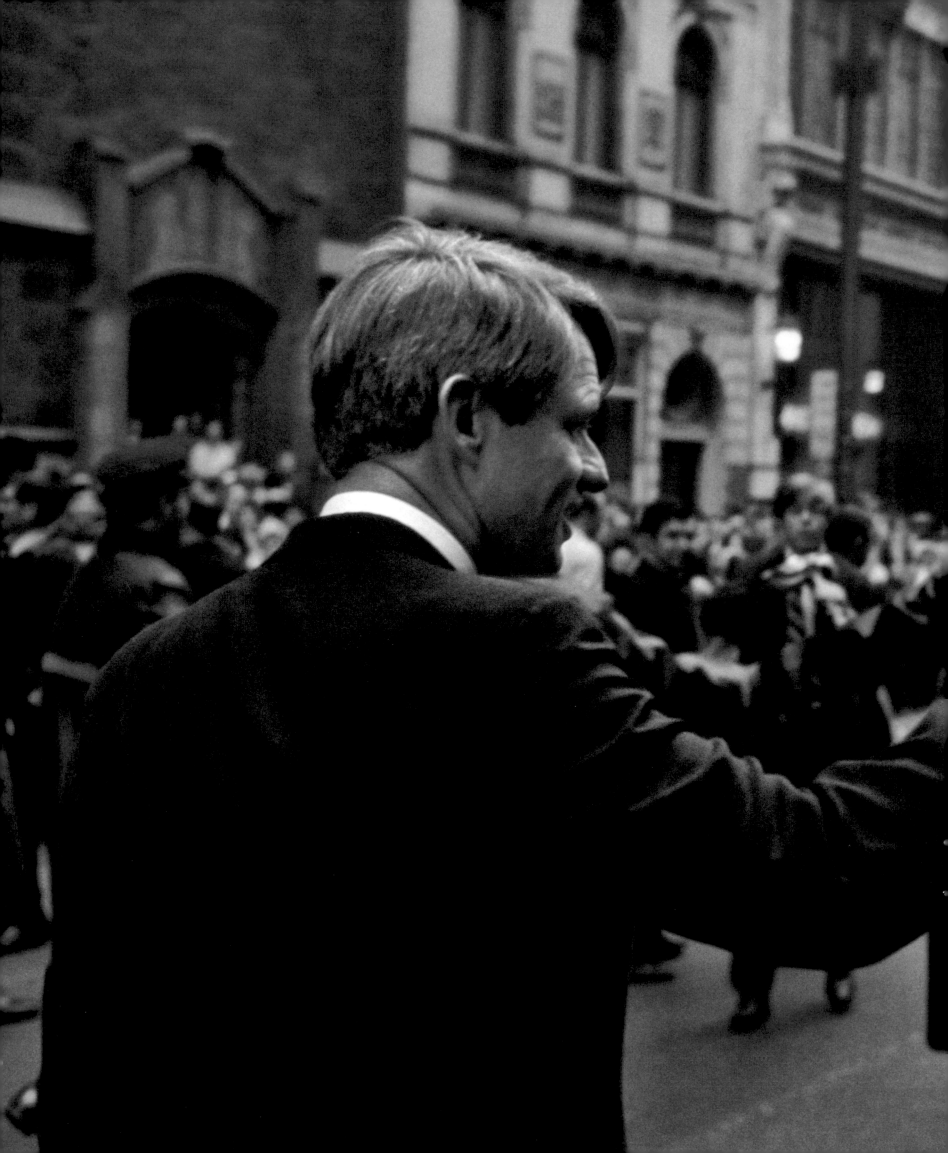

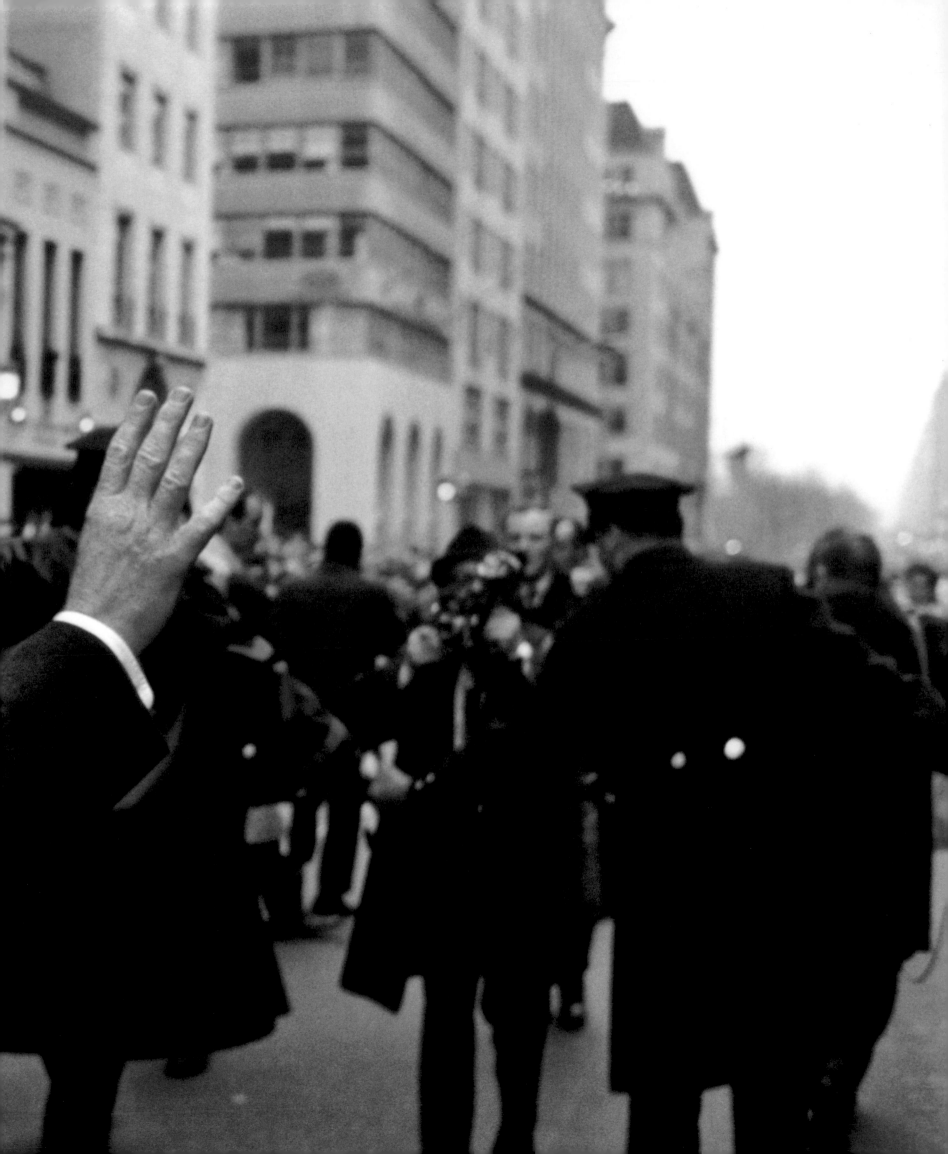

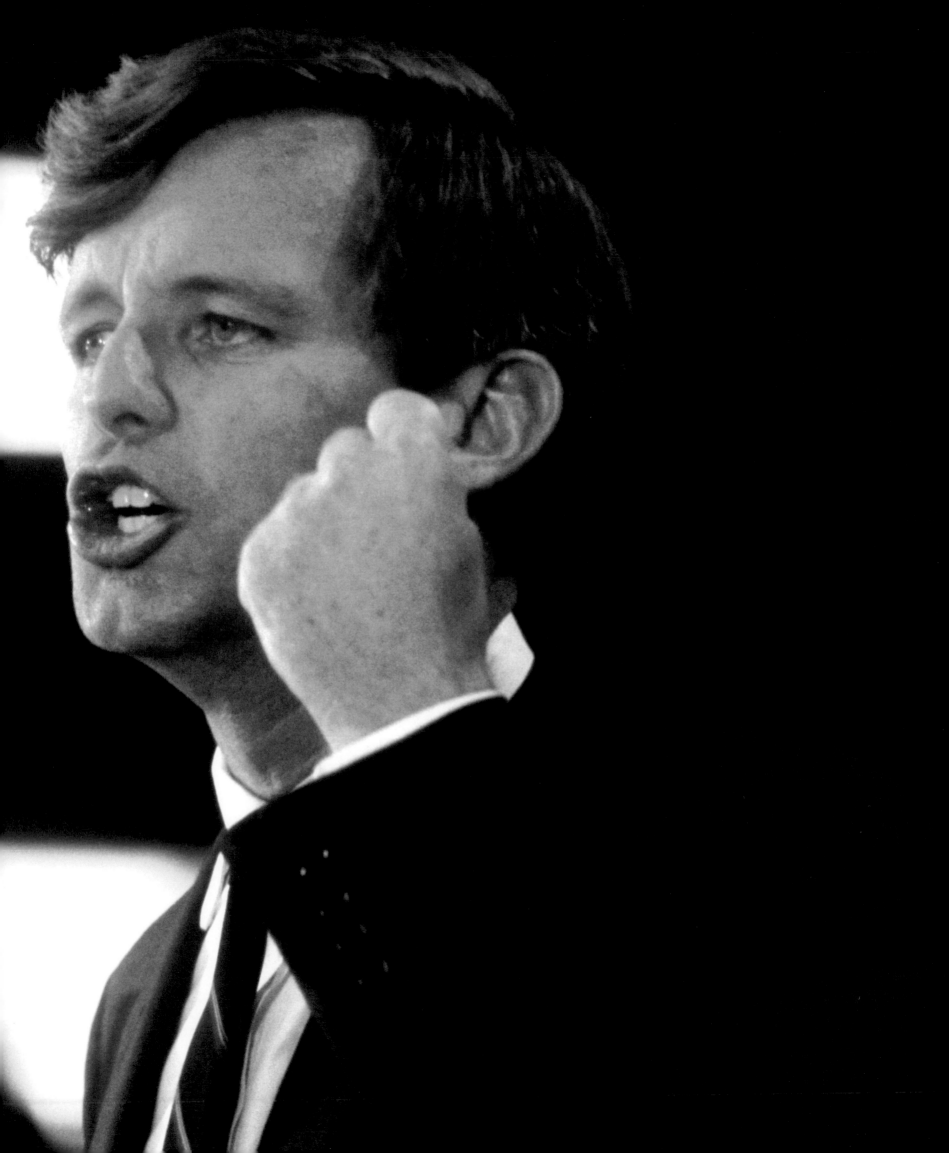

"There is a contest on, not for the rule of America, but for the heart of America. In these next eight months, we are going to decide what this country will stand for—and what kind of men we are. So I ask for your help, in the cities and homes of this state, in the towns and farms: contributing your concern and action, warning of the danger of what we are doing—and the promise of what we can do. I ask you, as tens of thousands of young men and women are doing all over this land, to organize yourselves, and then to go forth and work for new policies—work to change our direction—and thus restore our place at the point of moral leadership, in our country, in our own hearts, and all around the world."

"I am concerned that, at the end of it all, there will only be more Americans killed; more of our treasure spilled out; and because of the bitterness and hatred on every side of this war, more hundreds of thousands of Vietnamese slaughtered; so that they may say, as Tacitus said of Rome: 'They made a desert, and called it peace.'"

RFK, March 18, 1968
Kansas State University
Manhattan, Kansas

P.48–49, 50: RFK at Kansas State University.

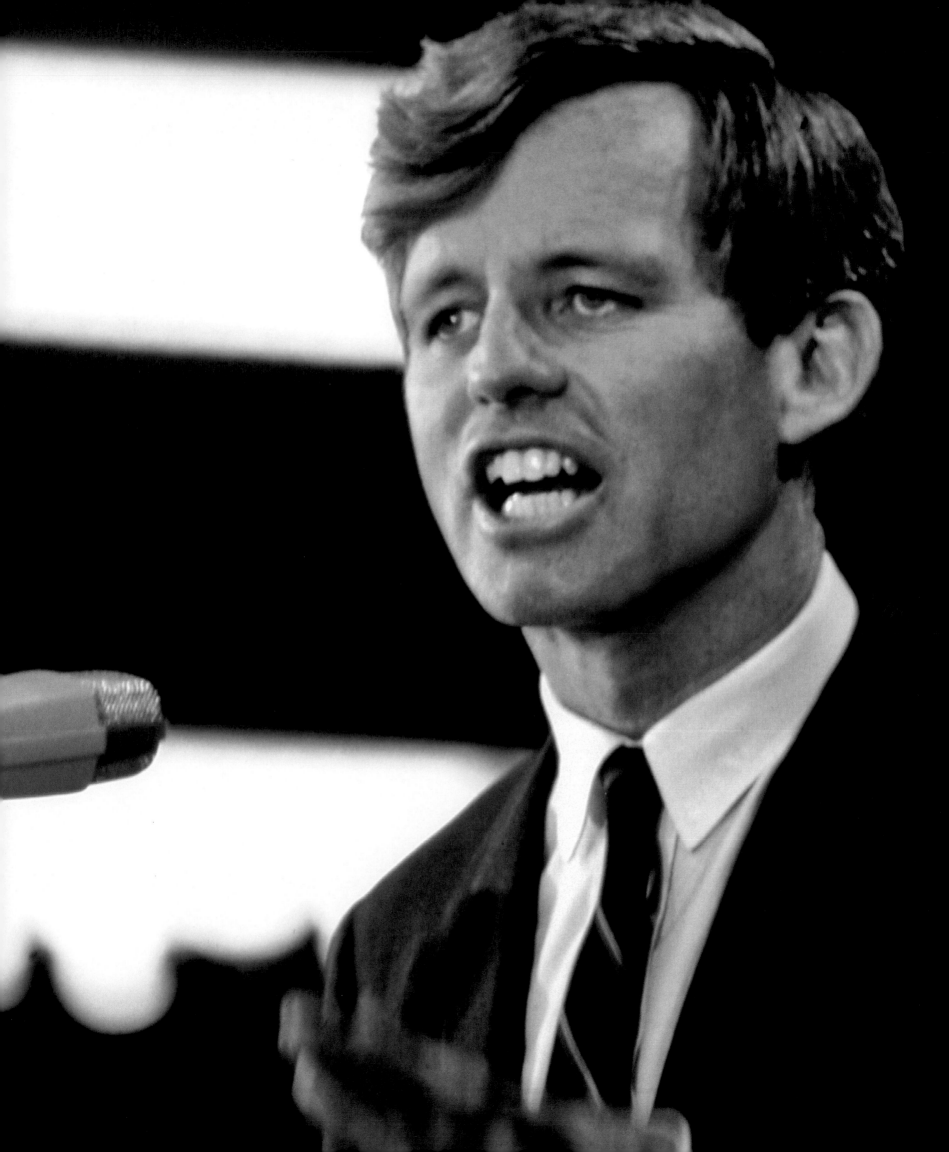

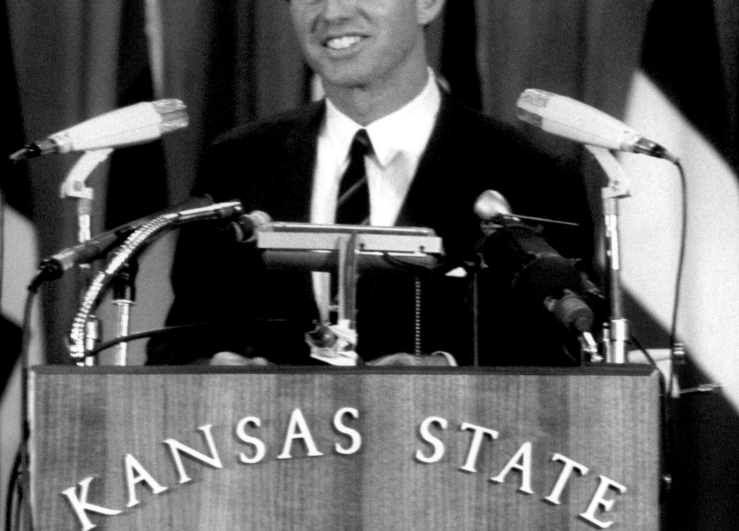

KANSAS STATE

UNIVERSITY

LANDON

LECTURES

"So I come here today, to this great university, to ask your help: not for me, but for your country and for the people of Vietnam. You are the people, as President Kennedy said, who have 'the least ties to the present and the greatest ties to the future.' I urge you to learn the harsh facts that lurk behind the mask of official illusion with which we have concealed our true circumstances, even from ourselves. Our country is in danger: not just from foreign enemies; but above all, from our own misguided policies—and what they can do to the nation that Thomas Jefferson once told us was the last, best, hope of man."

RFK, March 18, 1968
Kansas State University
Manhattan, Kansas

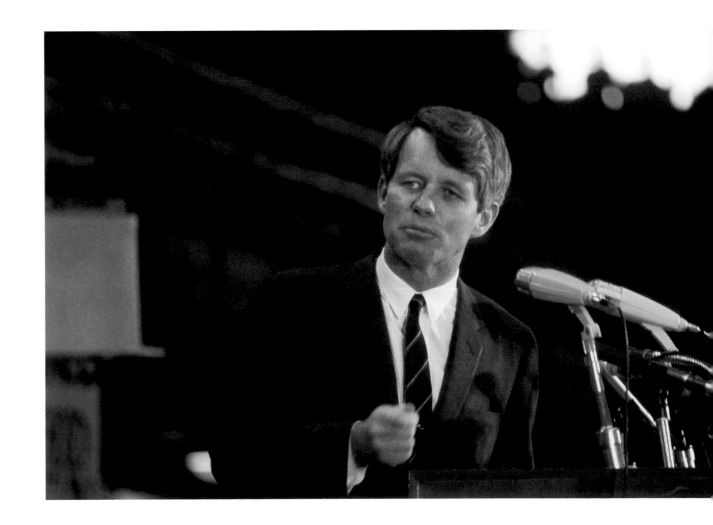

RFK at Kansas State University.

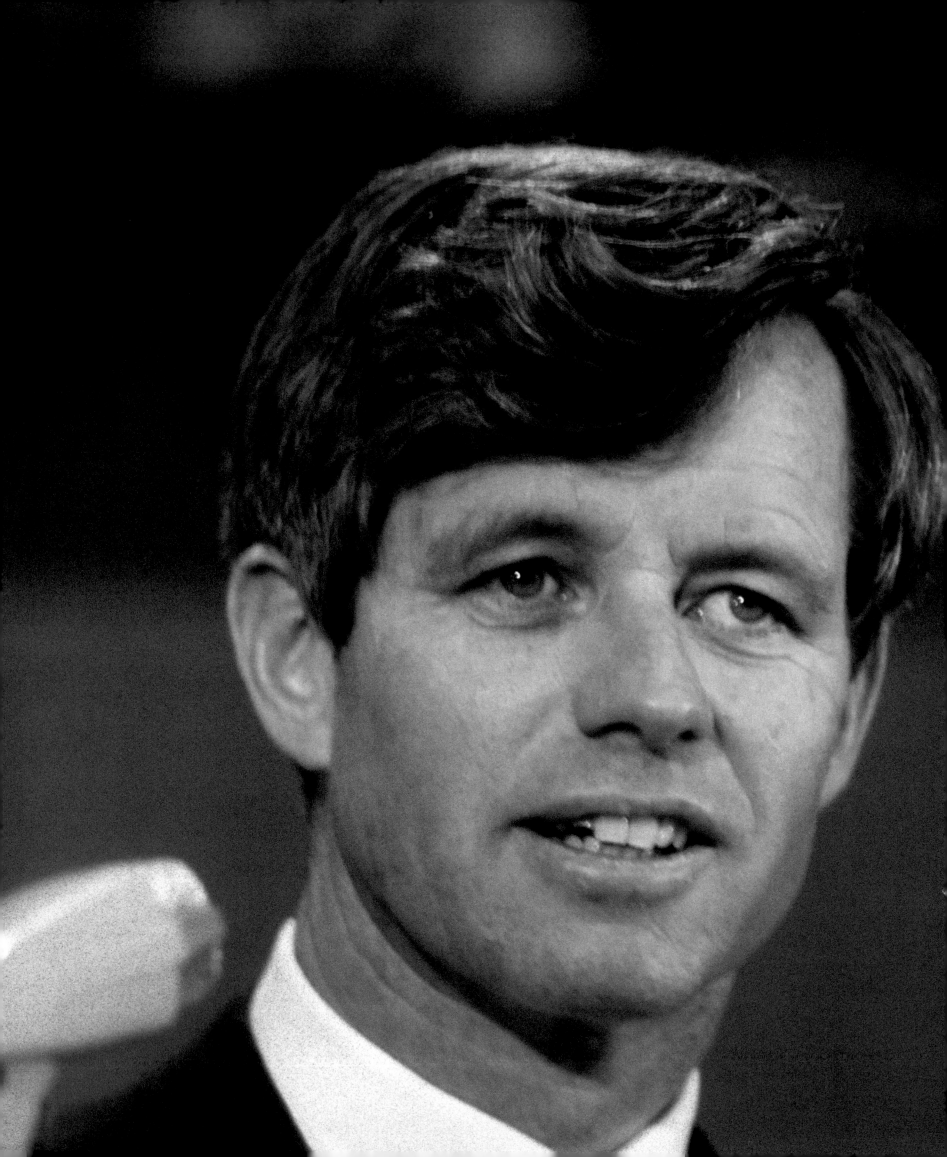

The youthfulness I speak of is not a time of life, but a state of mind, a temper of the will, a quality of the imagination, a predominance of courage over timidity, of the appetite for adventure over the love of ease. It is the spirit which knows the difference between force and reason. It does not accept the failures of today as a reason for the cruelties of tomorrow. It believes that one man can make a difference—and that men of good will, working together, can grasp the future and mold it to our will.

RFK, March 27, 1968
Weber State College
Ogden, Utah

RFK at Kansas State University.

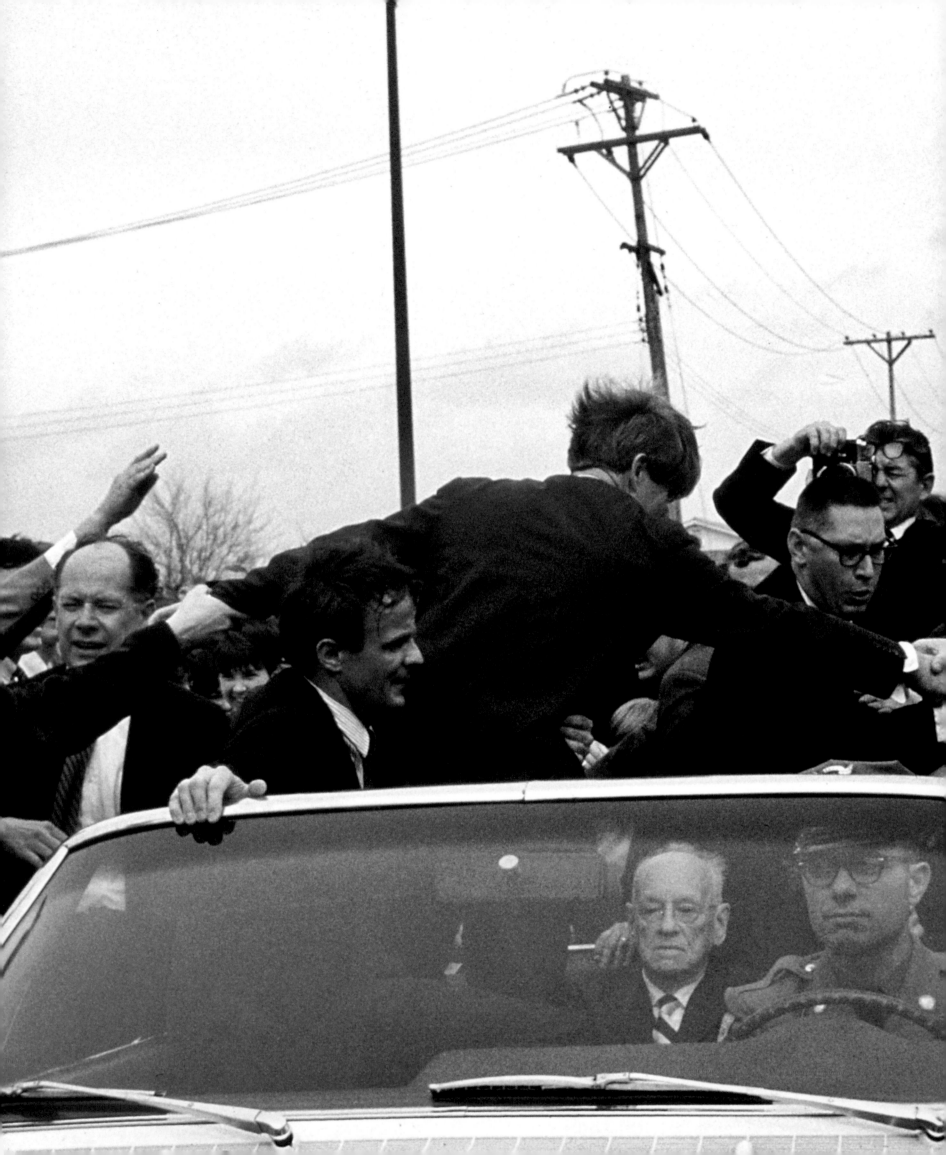

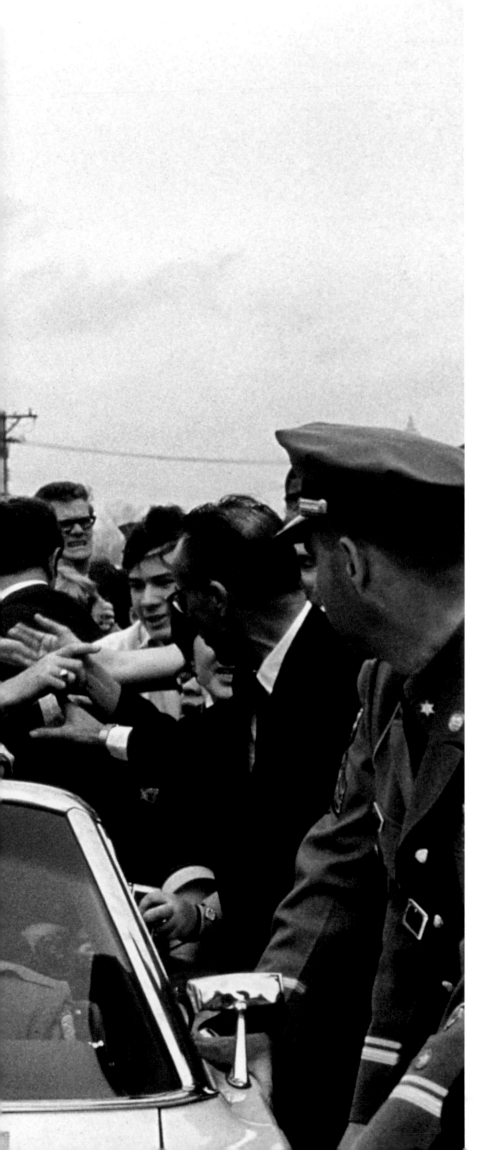

RFK campaigning in Kansas.

SUNDAY / MARCH 31

In a televised news conference, I can still hear LBJ addressing the nation in his unmistakable drawl: "I shall not seek, and I will not accept the nomination of my party for another term as your president."

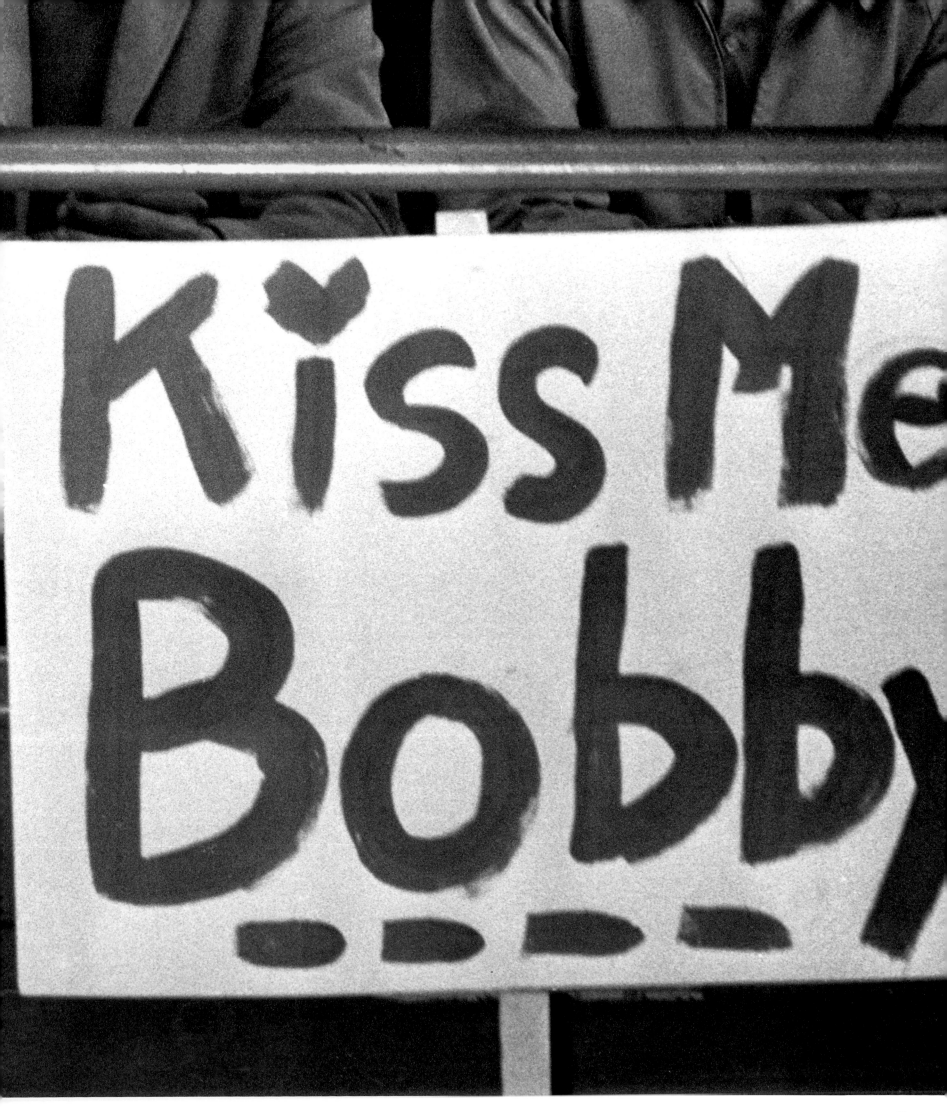

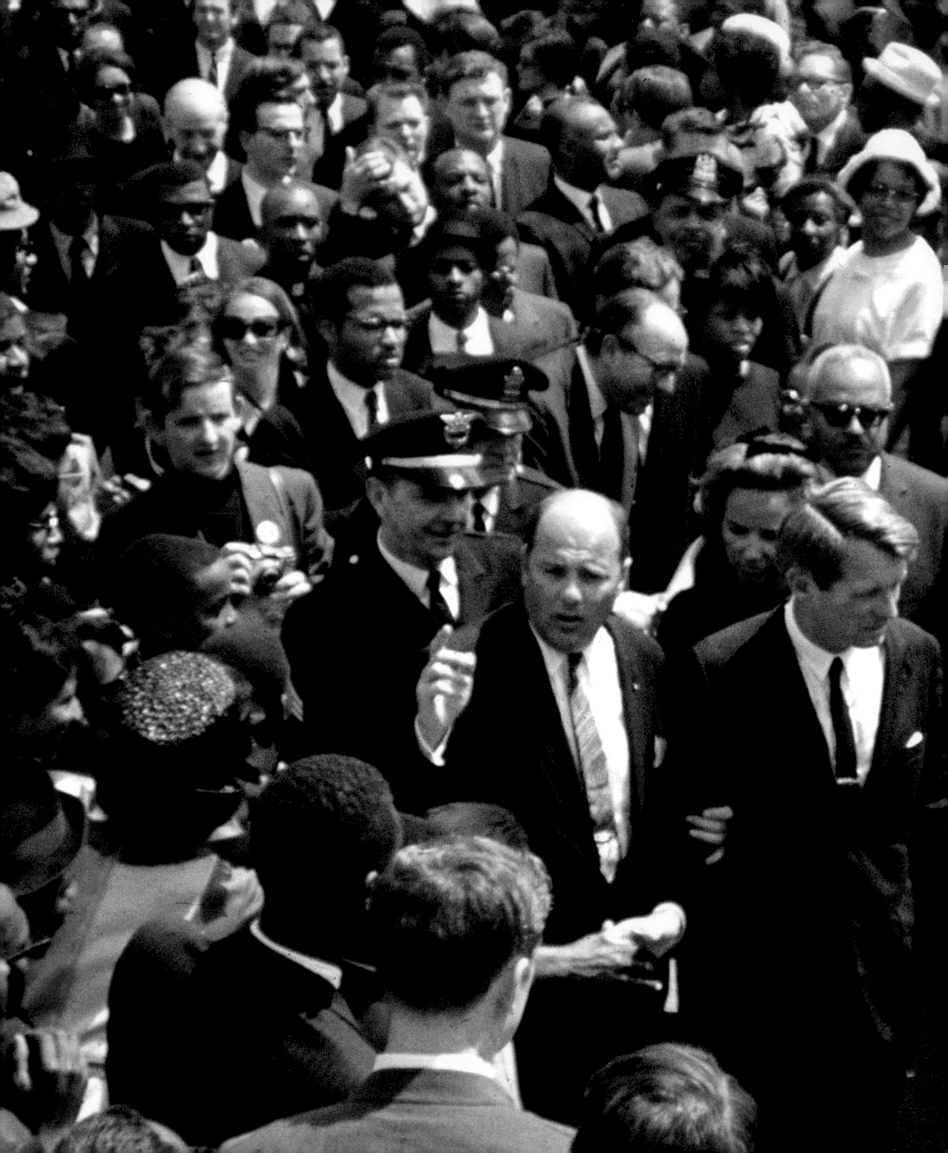

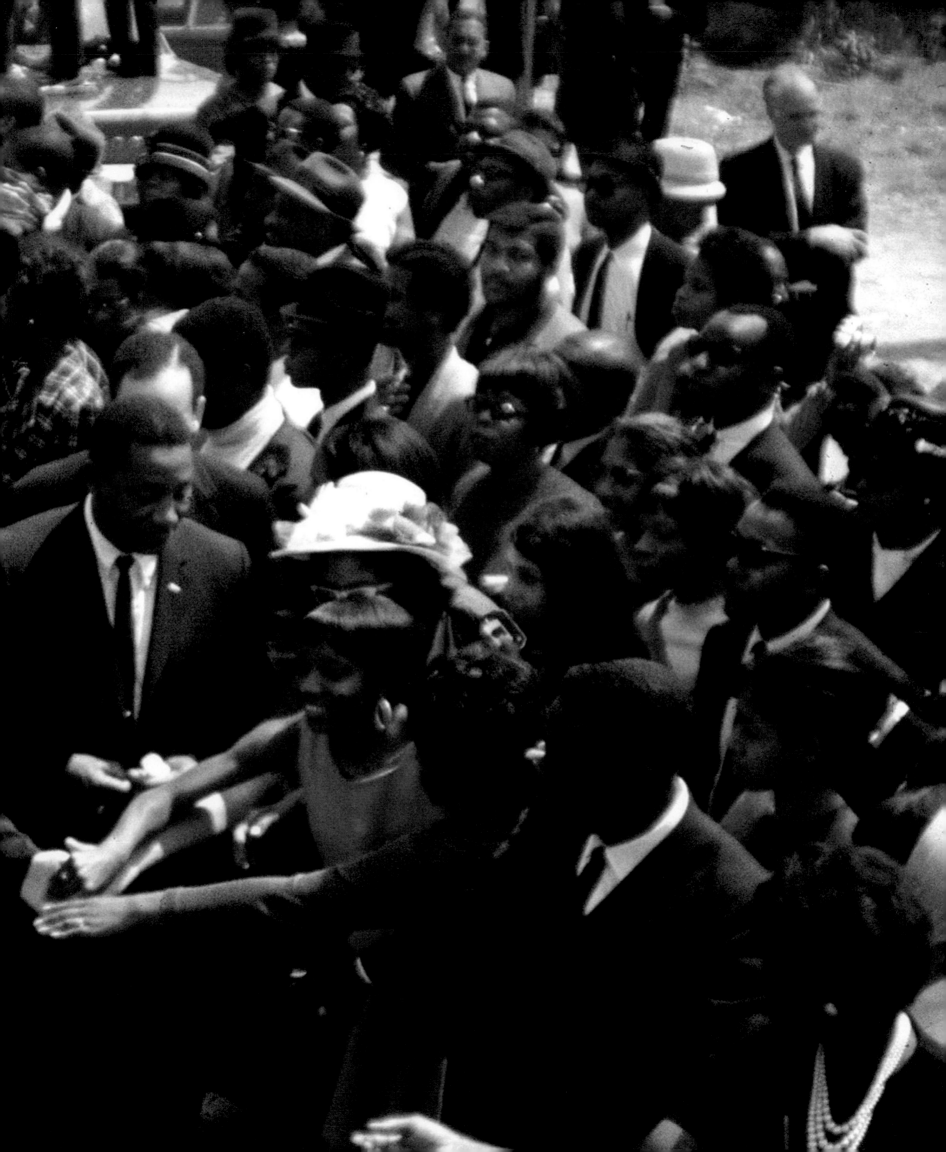

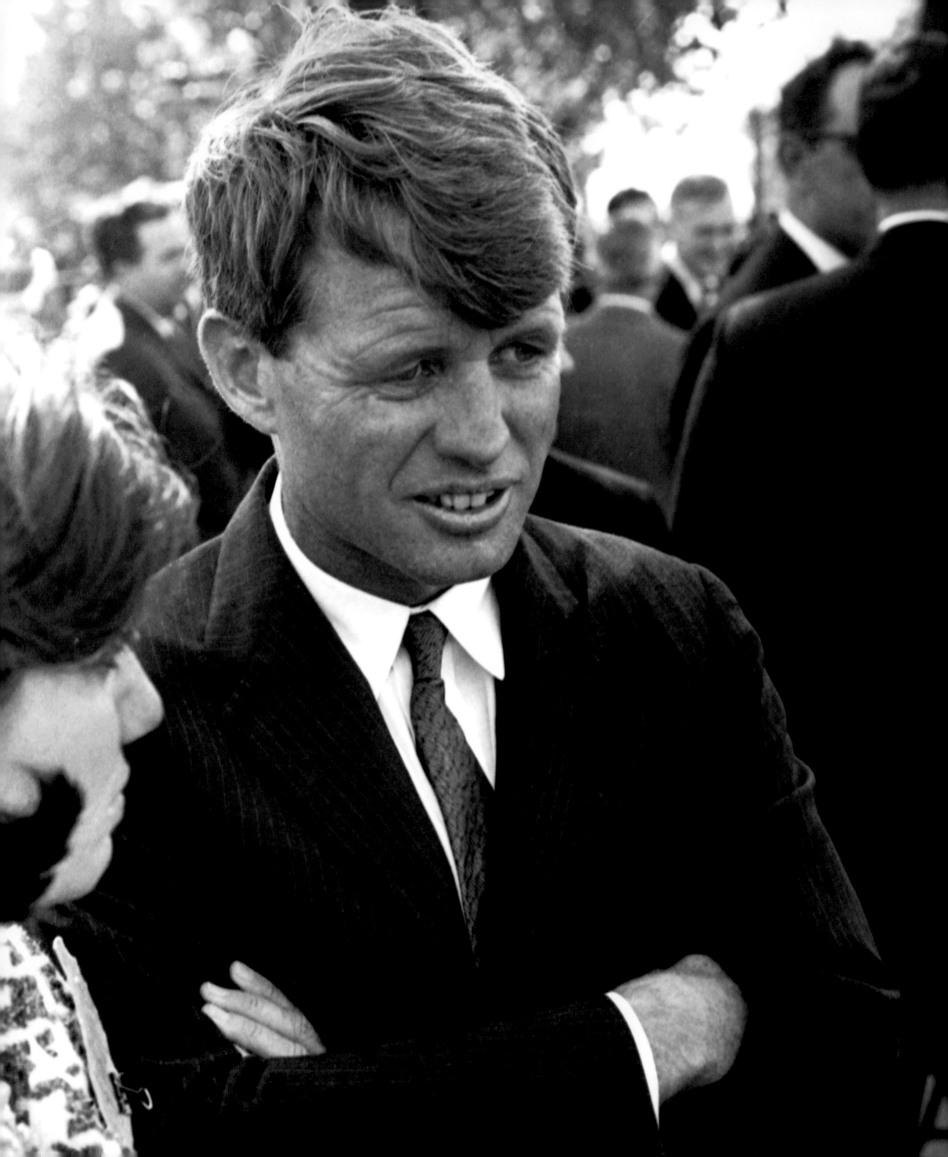

THURSDAY / APRIL 4

I flew to Memphis, Tennessee, when news of the assassination of the Reverend Dr. Martin Luther King, Jr., at the Lorraine Motel came over the wire. Dr. King's death further disillusioned those who favored peaceful integration and reinforced the memory of the November 1963 assassination of President John F. Kennedy while he was riding in an open car through Dealey Plaza in Dallas, Texas, his wife by his side. After Memphis I flew to Atlanta in time to photograph Mrs. King and their children as Dr. King's body was taken from the plane.

Bobby Kennedy, in Indianapolis at the time of King's death, fearlessly walked the inner-city streets and spoke out for non-violence and order. Riots broke out in 60 cities that night in response to the assassination, but not in Indianapolis.

" In this difficult day, in this difficult time for the United States, it is perhaps well to ask what kind of a nation we are and what direction we want to move in. For those of you who are black—considering the evidence there evidently is that there were white people who were responsible—you can be filled with bitterness, with hatred, and a desire for revenge. We can move in that direction as a country, in great polarization—black people amongst black, white people amongst white, filled with hatred toward one another.

Or we can make an effort, as Martin Luther King did, to understand and to comprehend, and to replace that violence, that stain of bloodshed that has spread across our land, with an effort to understand with compassion and love. "

RFK, April 4, 1968
Indianapolis, Indiana

Bobby marched with Dr. King's funeral procession in Atlanta and, as usual, spectators jostled one another to shake his hand and touch his sleeve.

P.60–61, 64–65: RFK at Dr. Martin Luther King Jr.'s funeral.

Left: RFK at the Statue of Liberty.

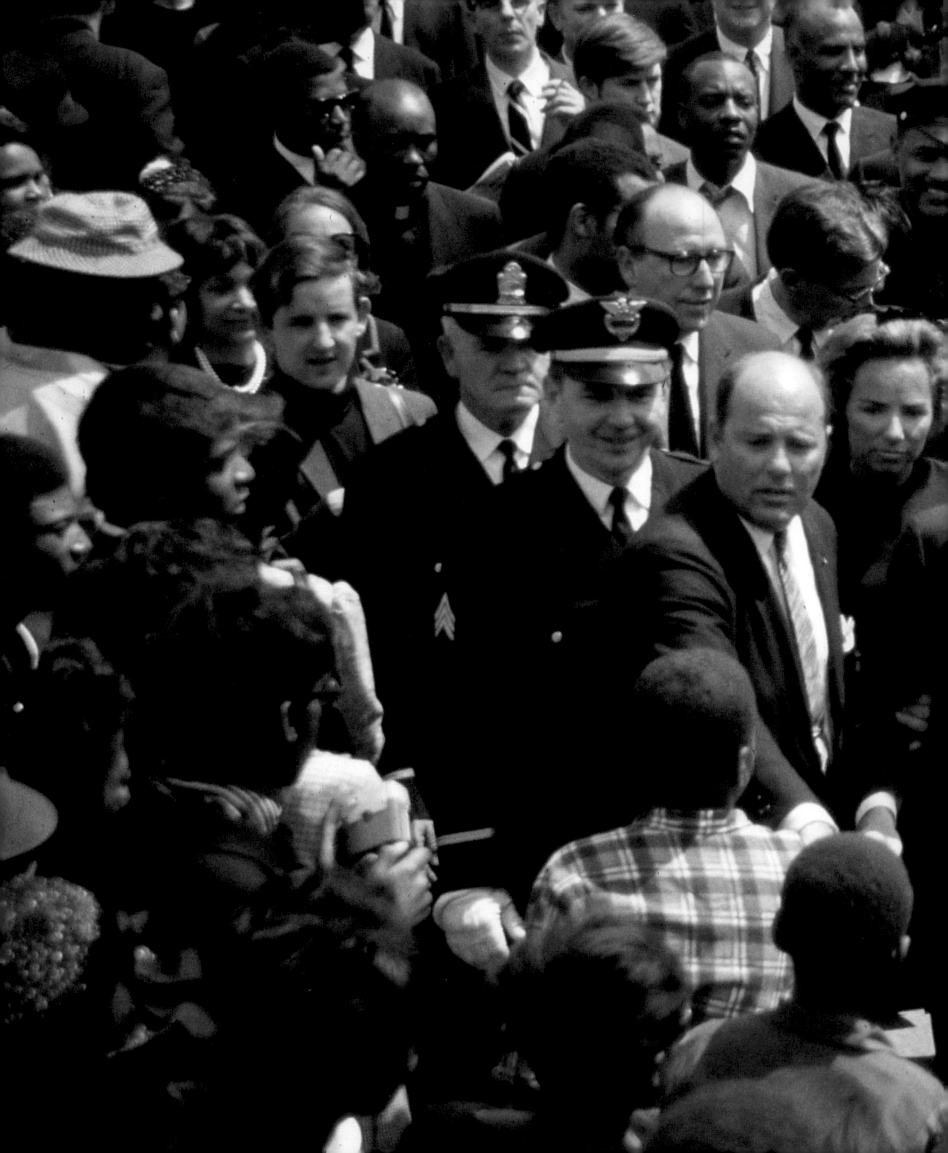

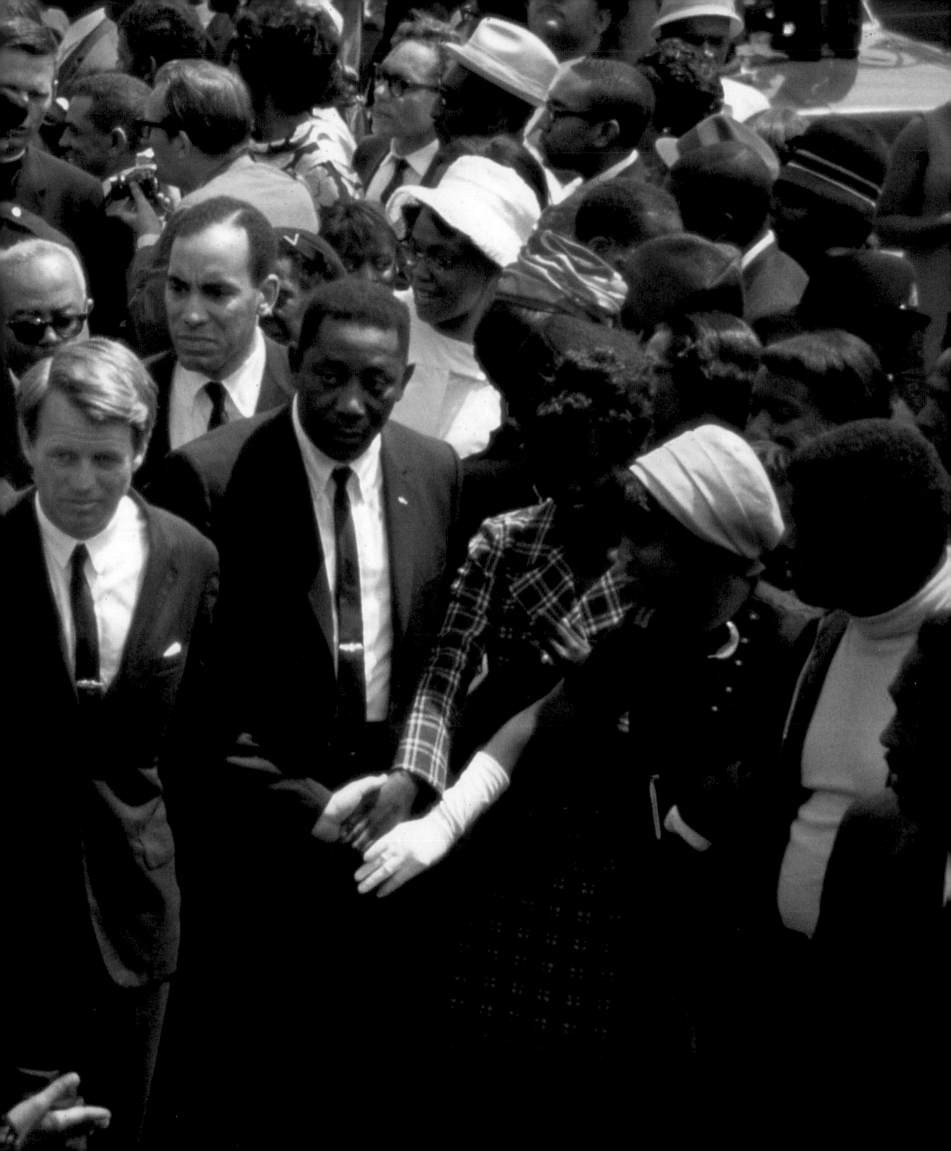

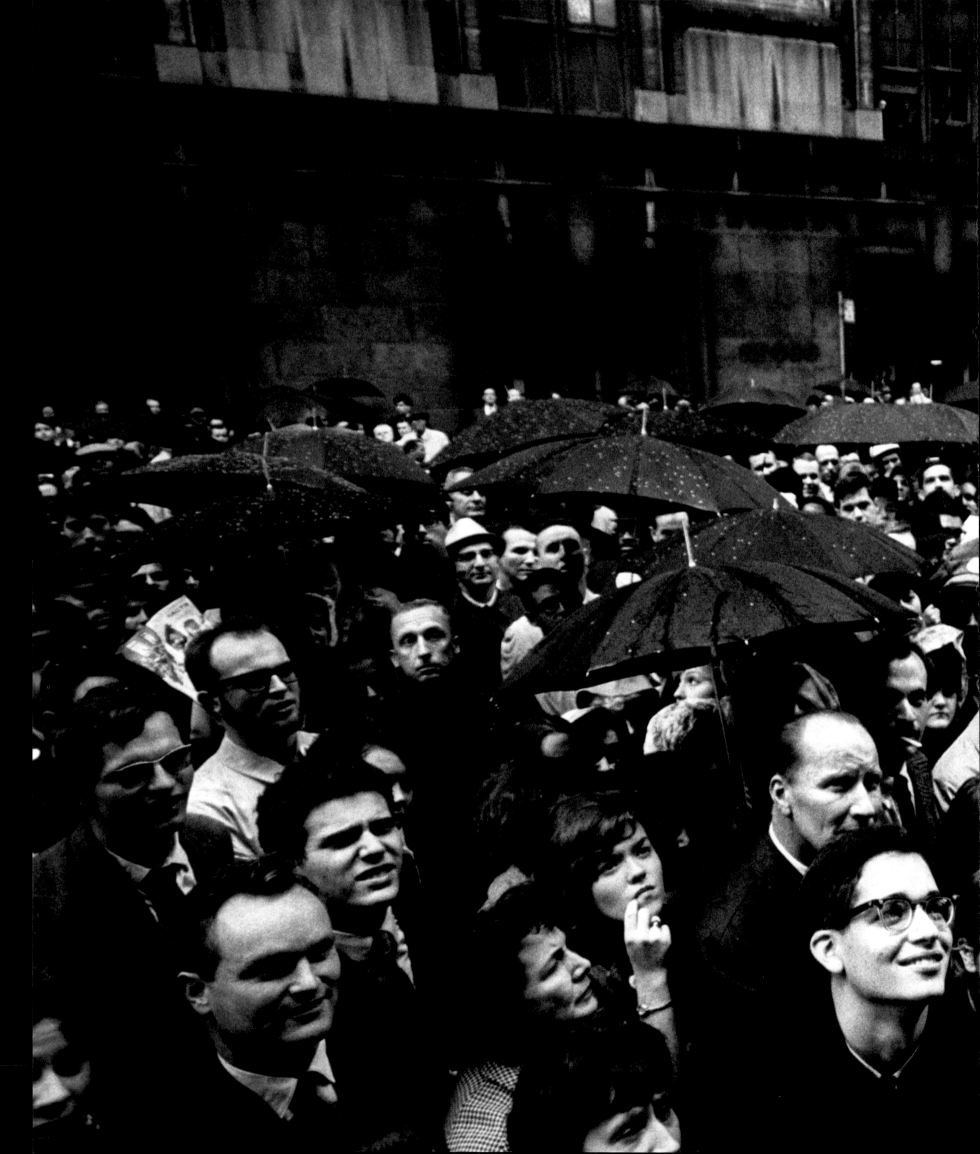

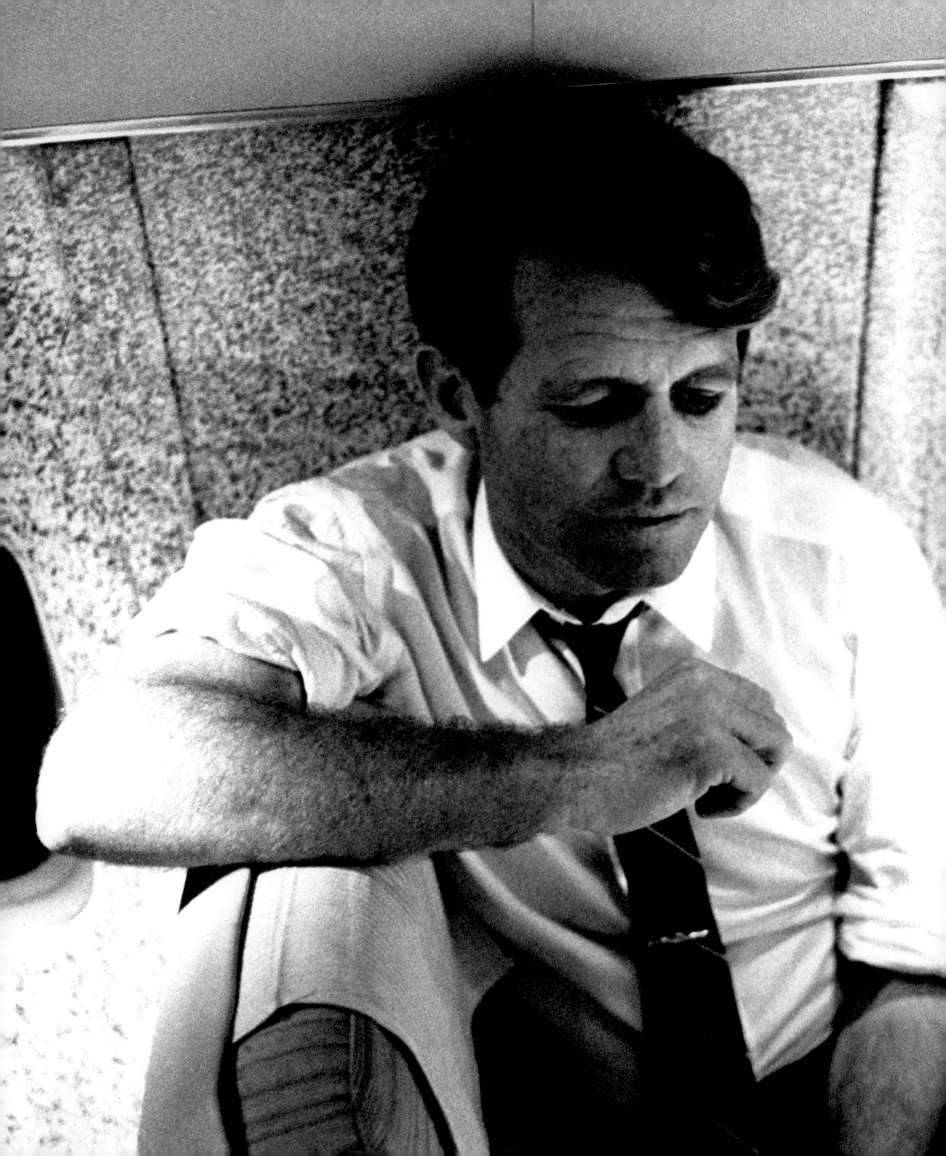

THE FIRST WEEK OF MAY 1968

Student protests burst out on campuses all over the world—Prague, Paris, Boston, Rome, and Turin. Police turned powerful hoses on the young rioters in West Berlin. British students filled London's Trafalgar Square to protest the United States' involvement in Vietnam.

I was assigned a cover story by *Newsweek* to photograph the student protest at Columbia University where almost 300 student activists took over five buildings, held the college dean Henry S. Coleman prisoner in his office overnight, and vandalized the office of the university president, Grayson Kirk. At first they walked with protest signs much like they would have held up at a football game to cheer on their team, except the words were not the same. When the scene turned more serious and the police were brought in, it got nasty.

"As we stand here today, brave young men are fighting across an ocean. Here, while the moon shines, men are dying on the other side of the earth. Which of them might have written a great poem? Which of them would have cured cancer? Which of them might have played in a World Series or given us the gift of laughter from a stage or helped build a bridge or a university? Which of them might have taught a child to read? It is our responsibility to let those men live...."

RFK, March 24, 1968
Salinas/Monterey, California

TUESDAY / MAY 7

The Indiana Democratic Presidential Primary. Kennedy went head to head with Eugene McCarthy and won as he had in Nebraska, but he lost to McCarthy in Oregon. A win in California, the next primary, would be very important.

P.66–67: RFK campaigning in the rain in New York City.

Left: RFK on a plane to Kansas.

TUESDAY & WEDNESDAY / JUNE 4–5 / AMBASSADOR HOTEL / LOS ANGELES

I don't know why I covered Bobby's speech that evening. I hadn't planned to go to the celebration because everyone knew he would win the California primary. I was planning to have dinner with friends, and I had hurt my wrist in a fall that afternoon on the hotel tennis court, but something told me not to miss it. A band made up of young kids was playing, providing the upbeat background music. Everyone was jubilant, shouting in unison, "Bobby, Bobby." It was very crowded. Bobby didn't join the celebration until very late, around midnight or after. I stood on a chair to get some photographs of Bobby's sister, Jean Smith, and to capture Bobby's victory speech from the podium. Bobby ended his speech with a victory sign and the words "On to Chicago," which brought a roar from the crowd.

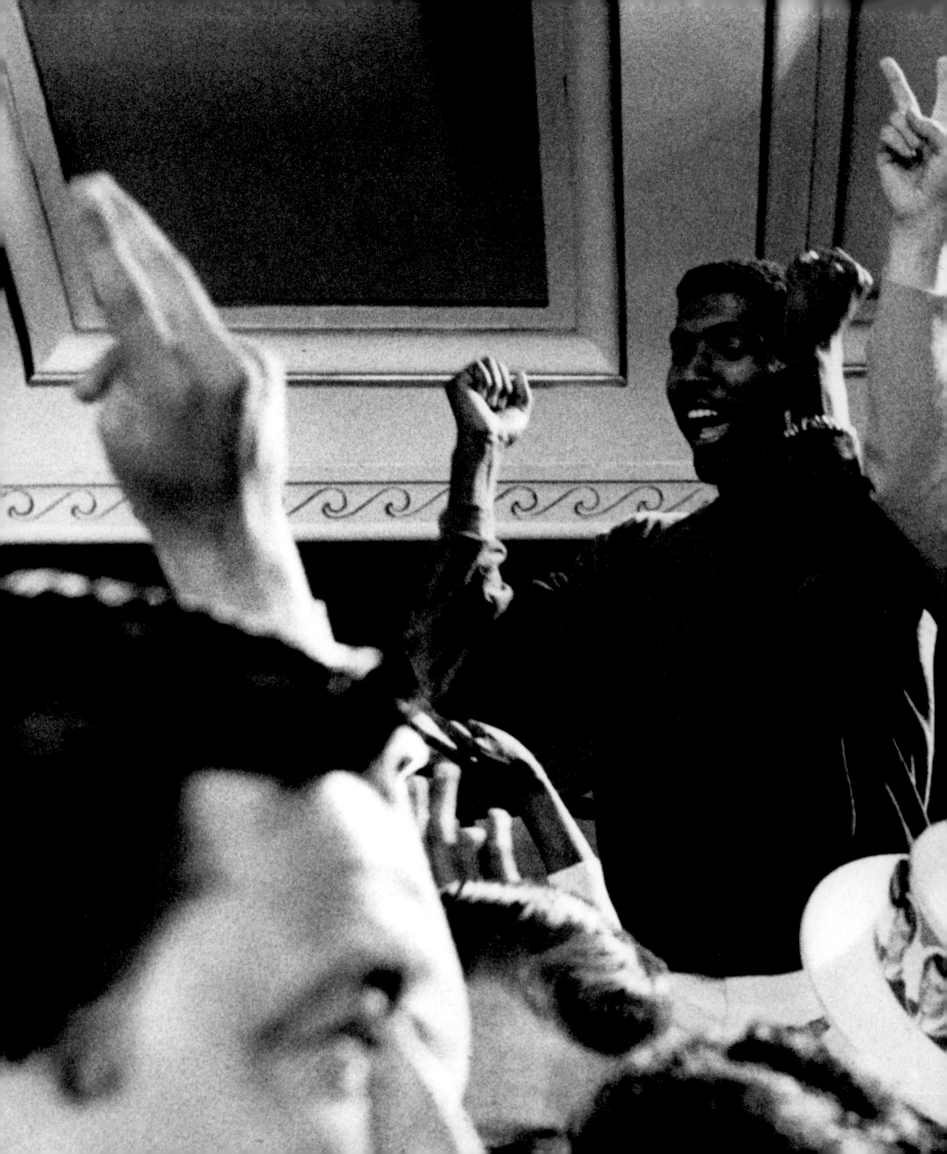

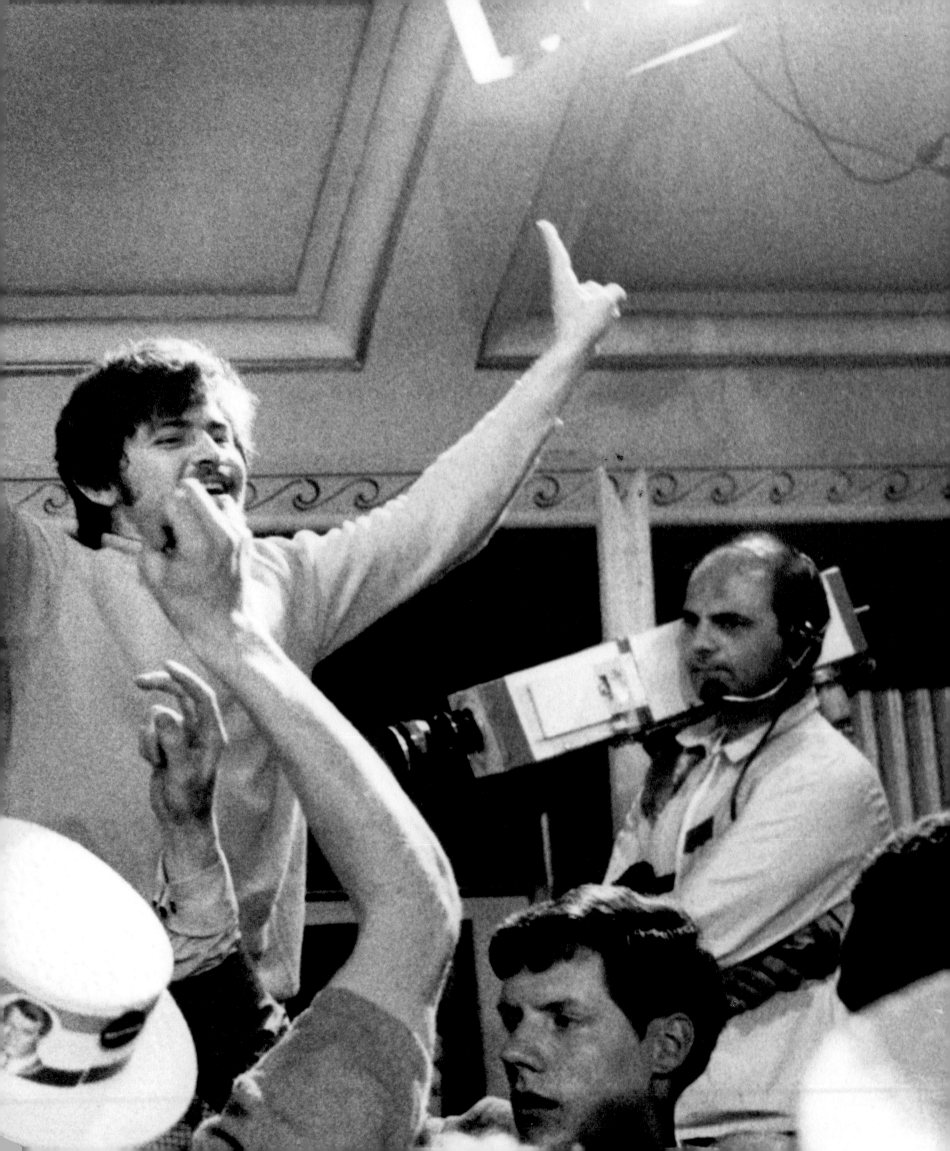

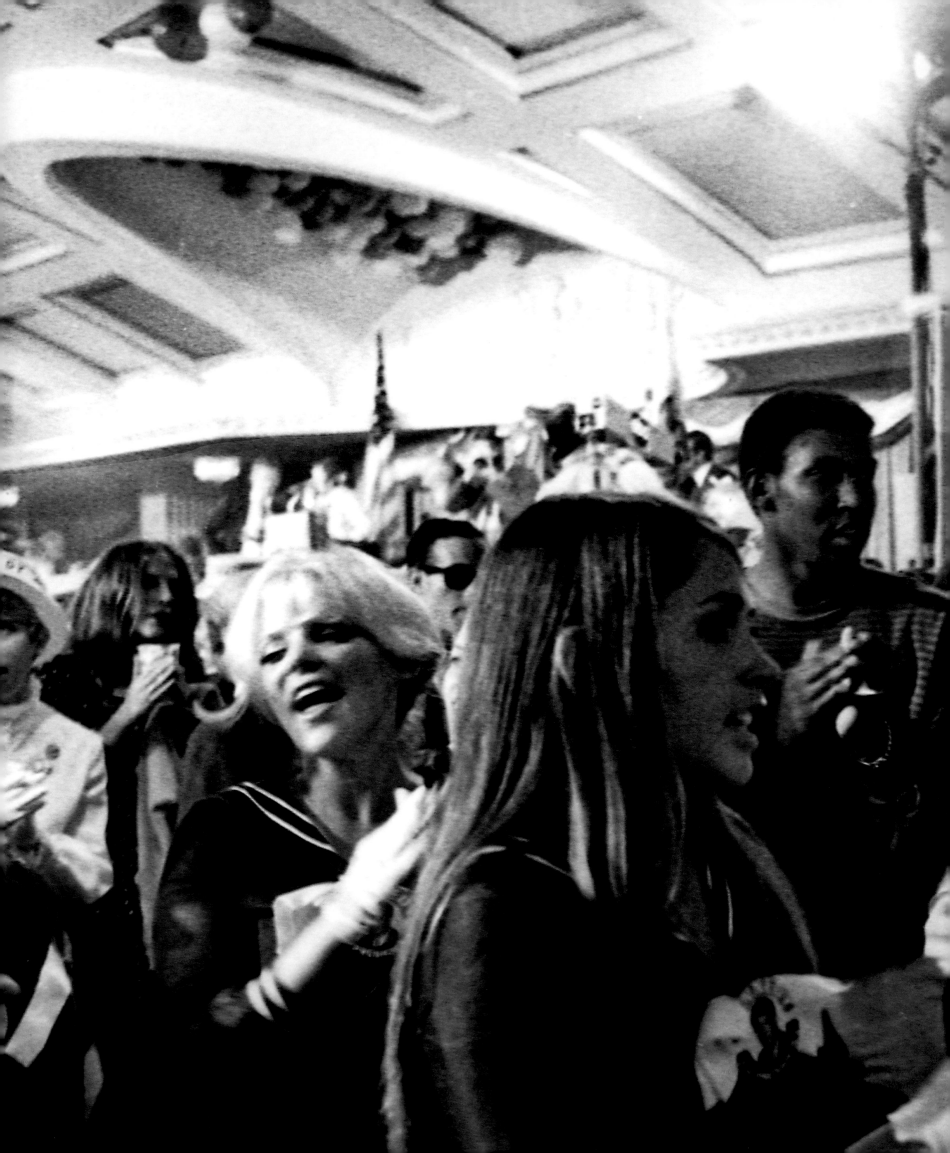

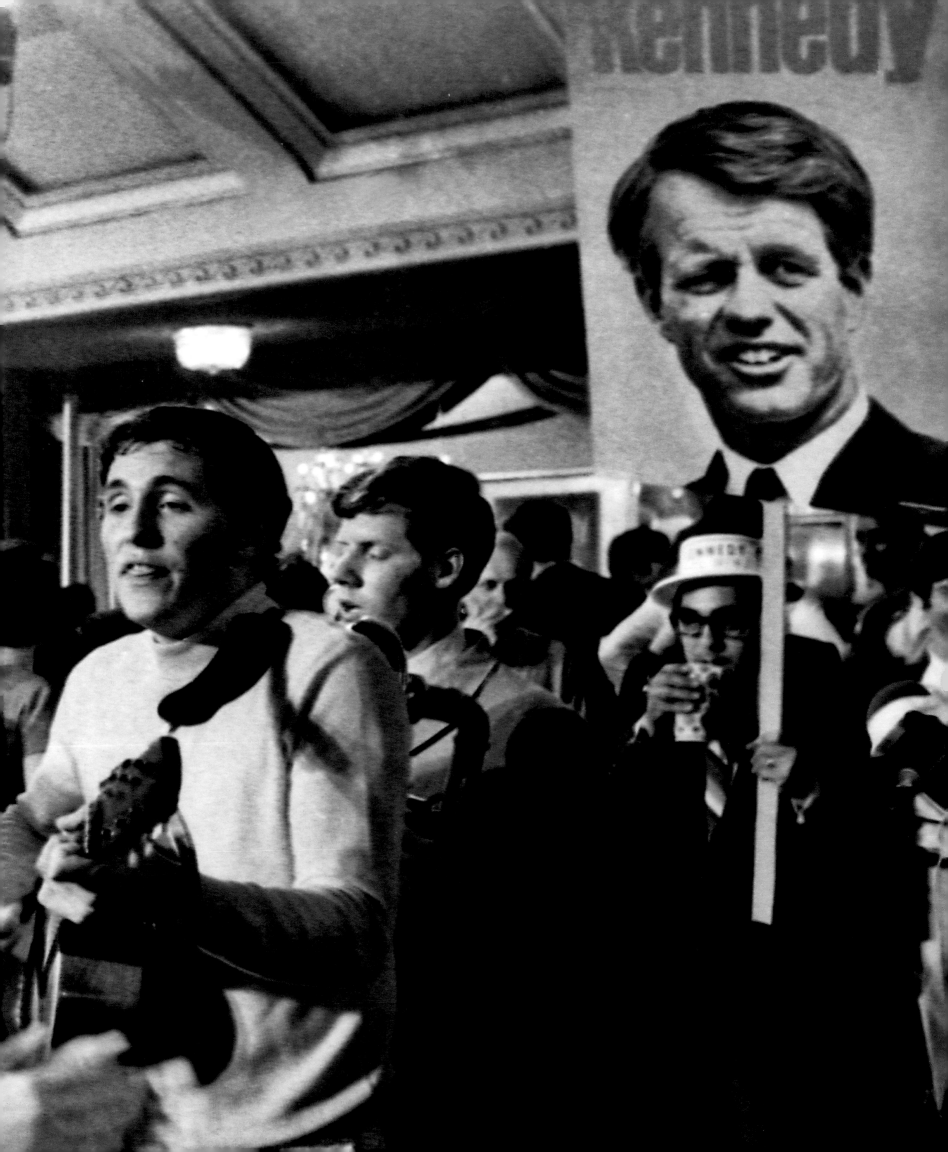

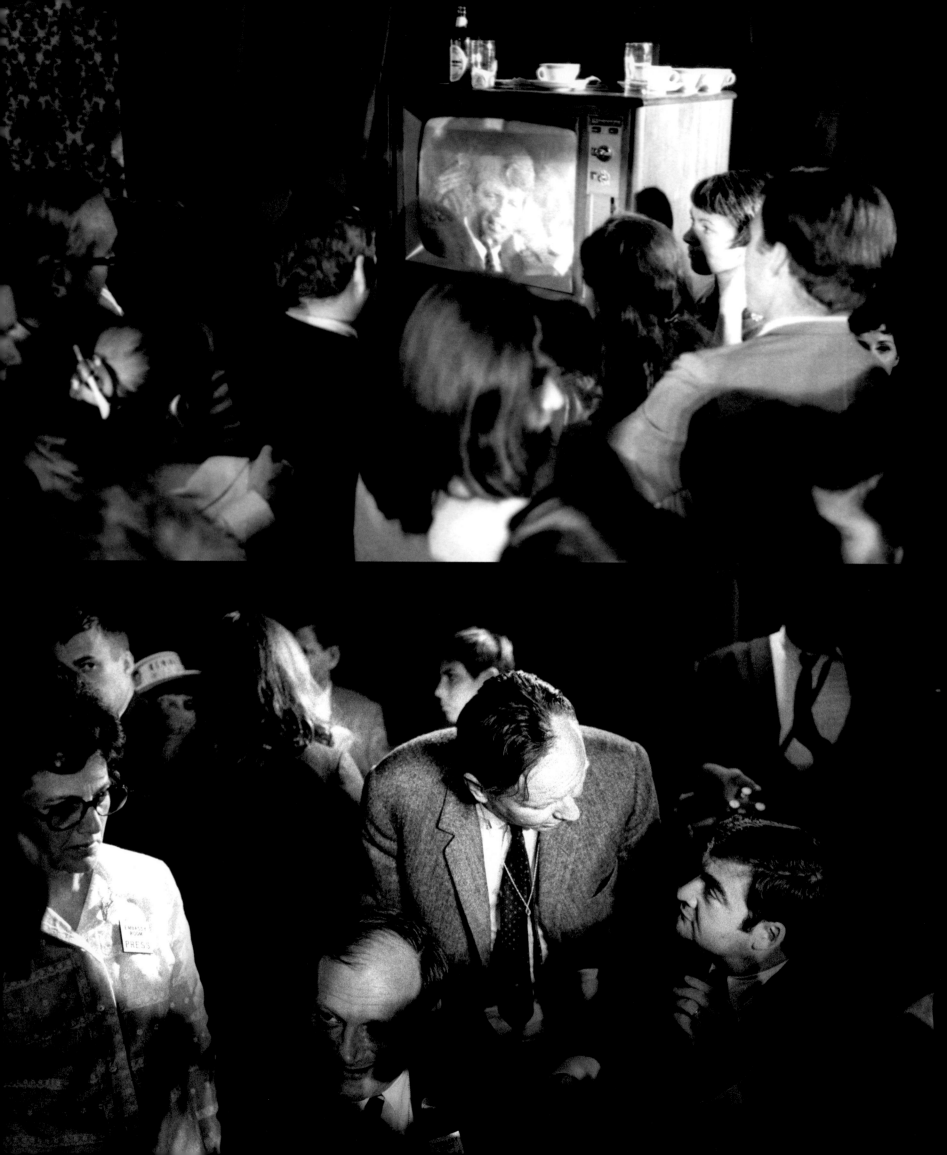

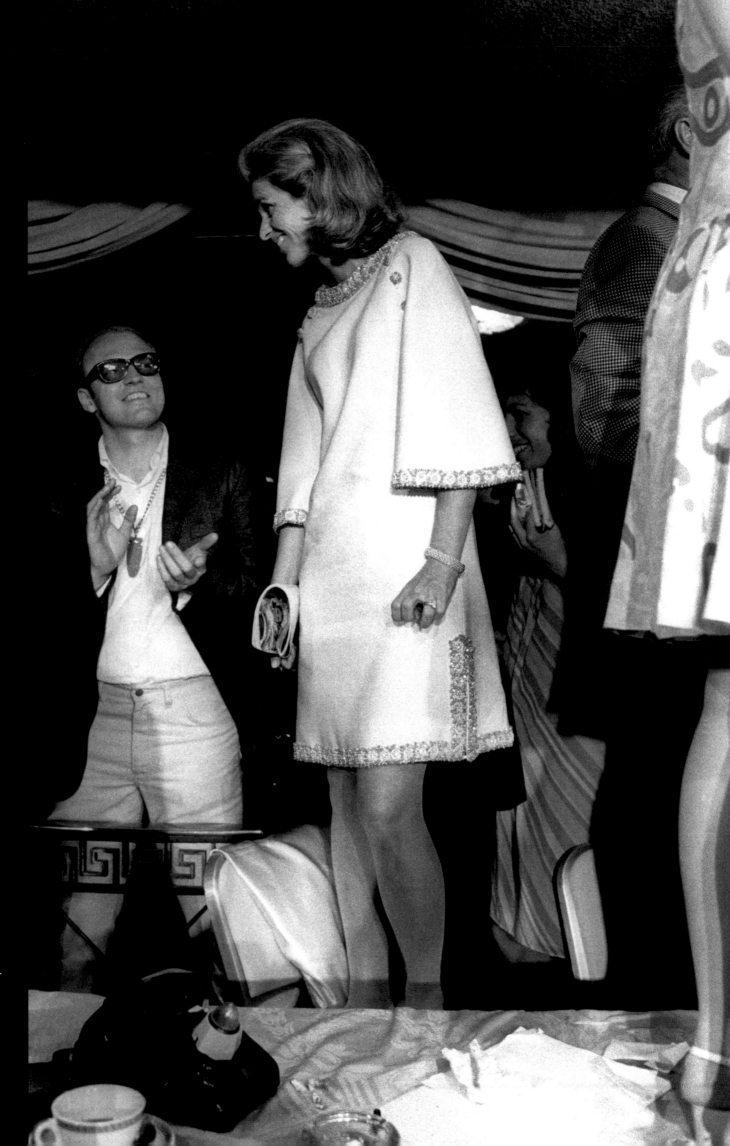

P.74–75: Revelers at the celebration.
P.76–77: L.A. band plays at the celebration.

Opposite, top: Pierre Salinger watches the victory speech on TV. Opposite, bottom: Salinger and Frank Mankowitz.

Right: Jean Smith.

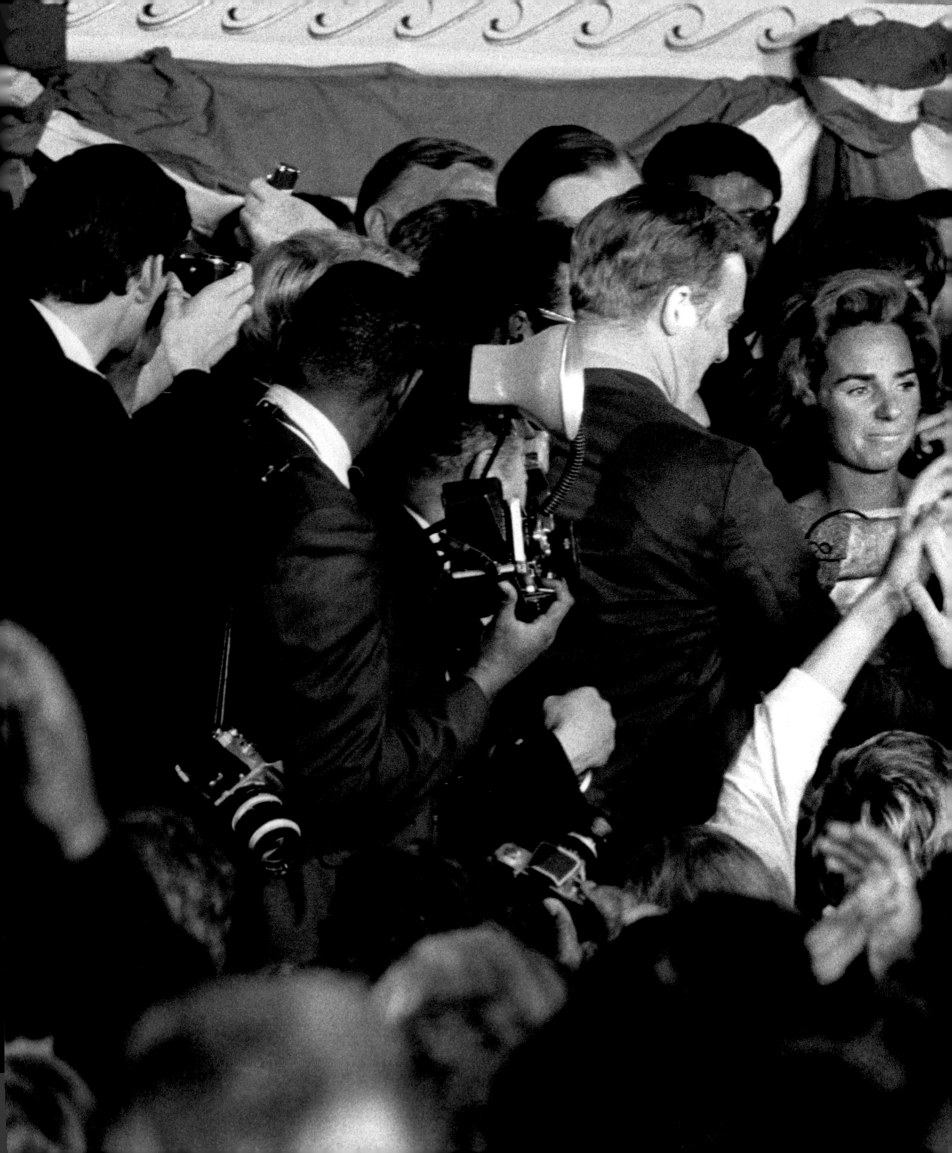

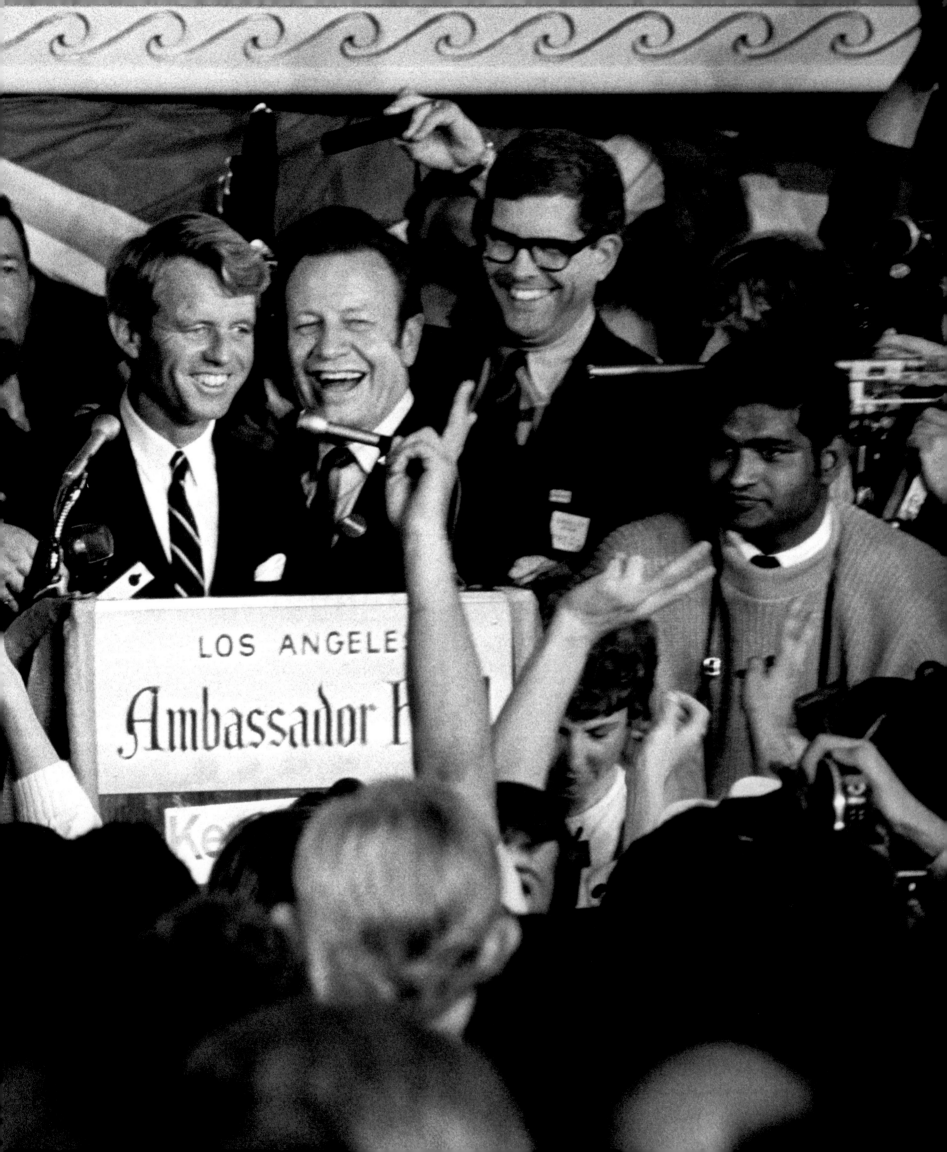

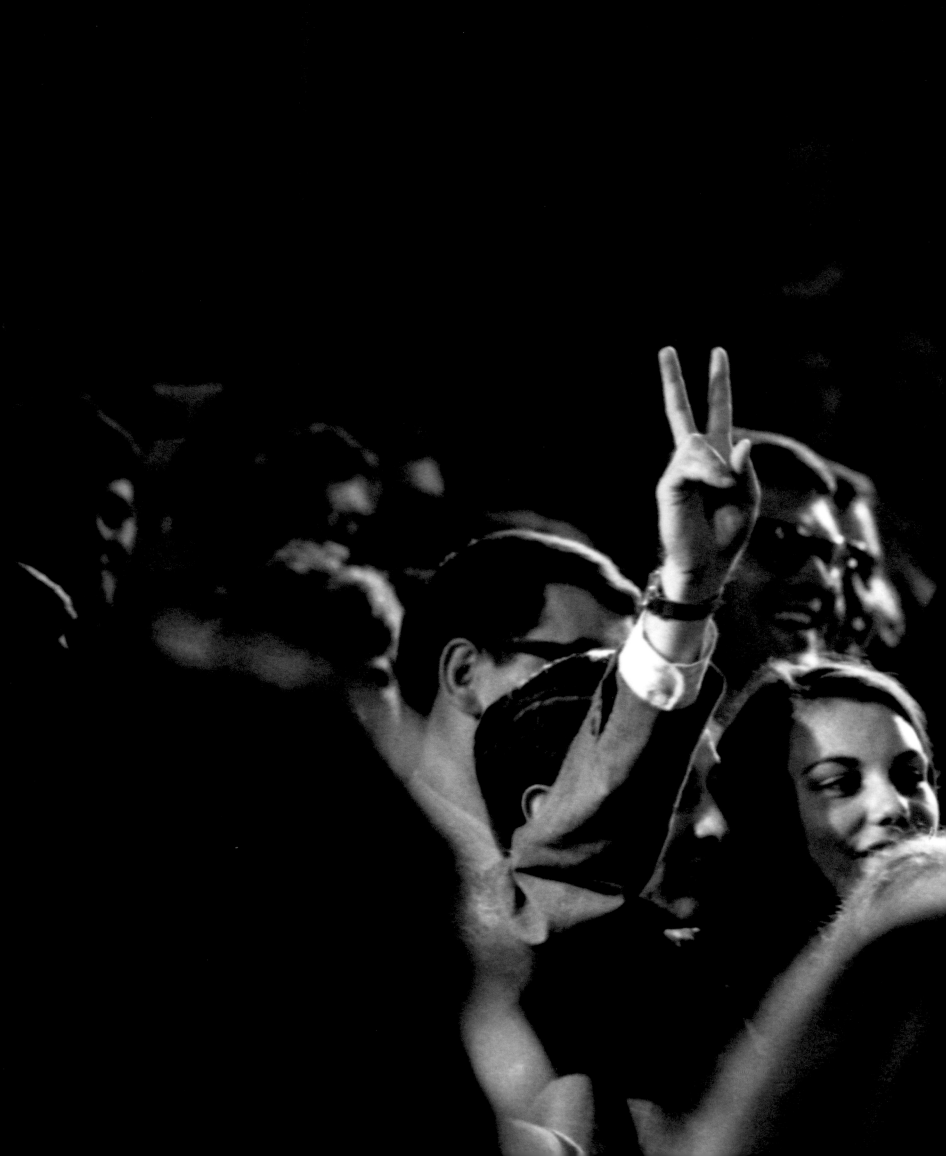

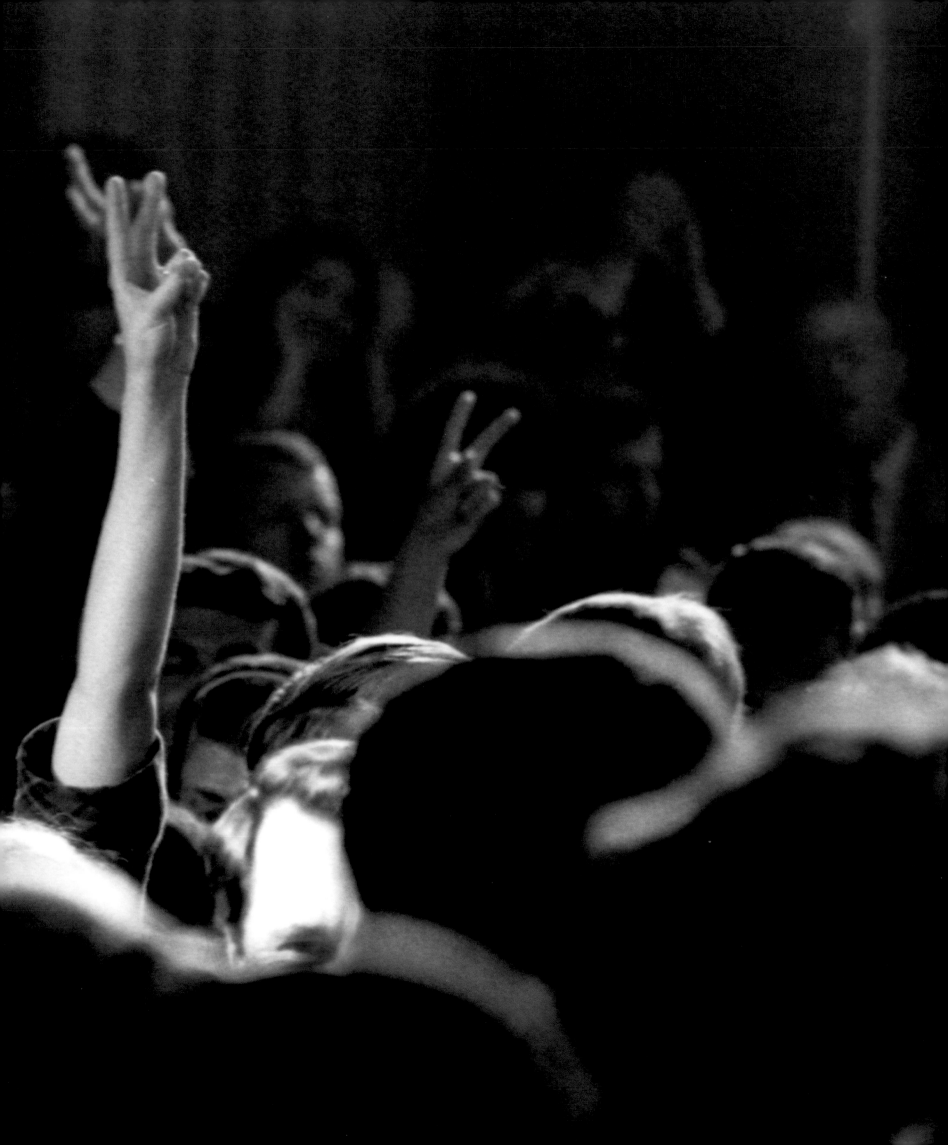

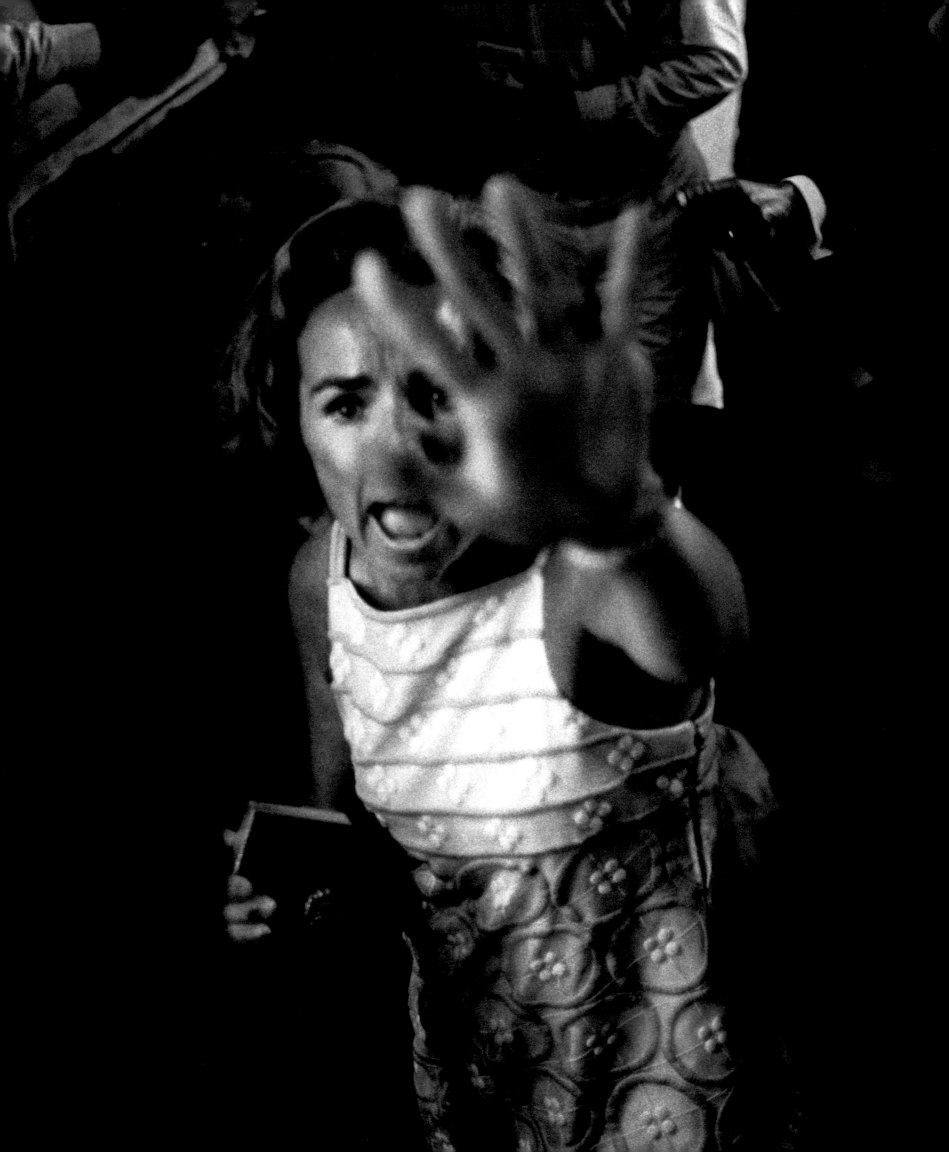

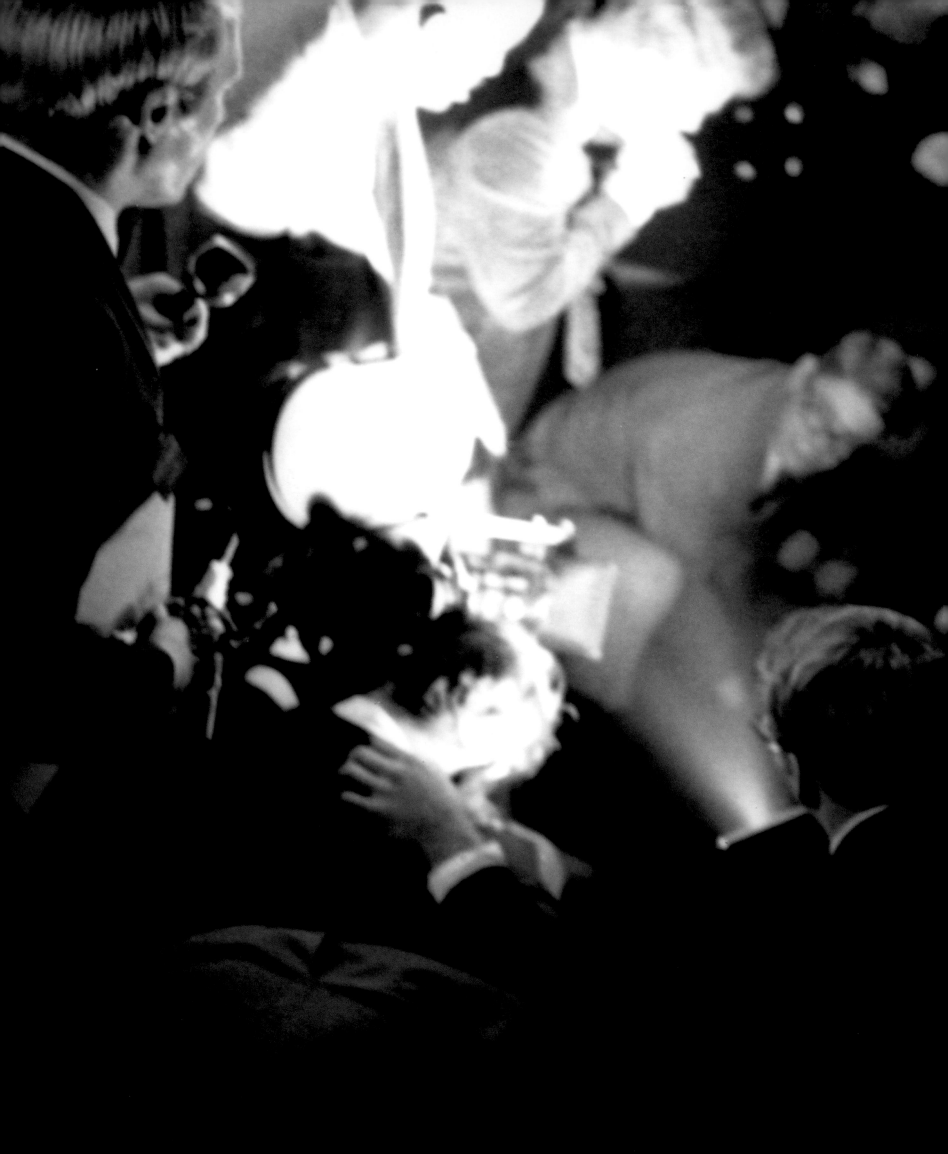

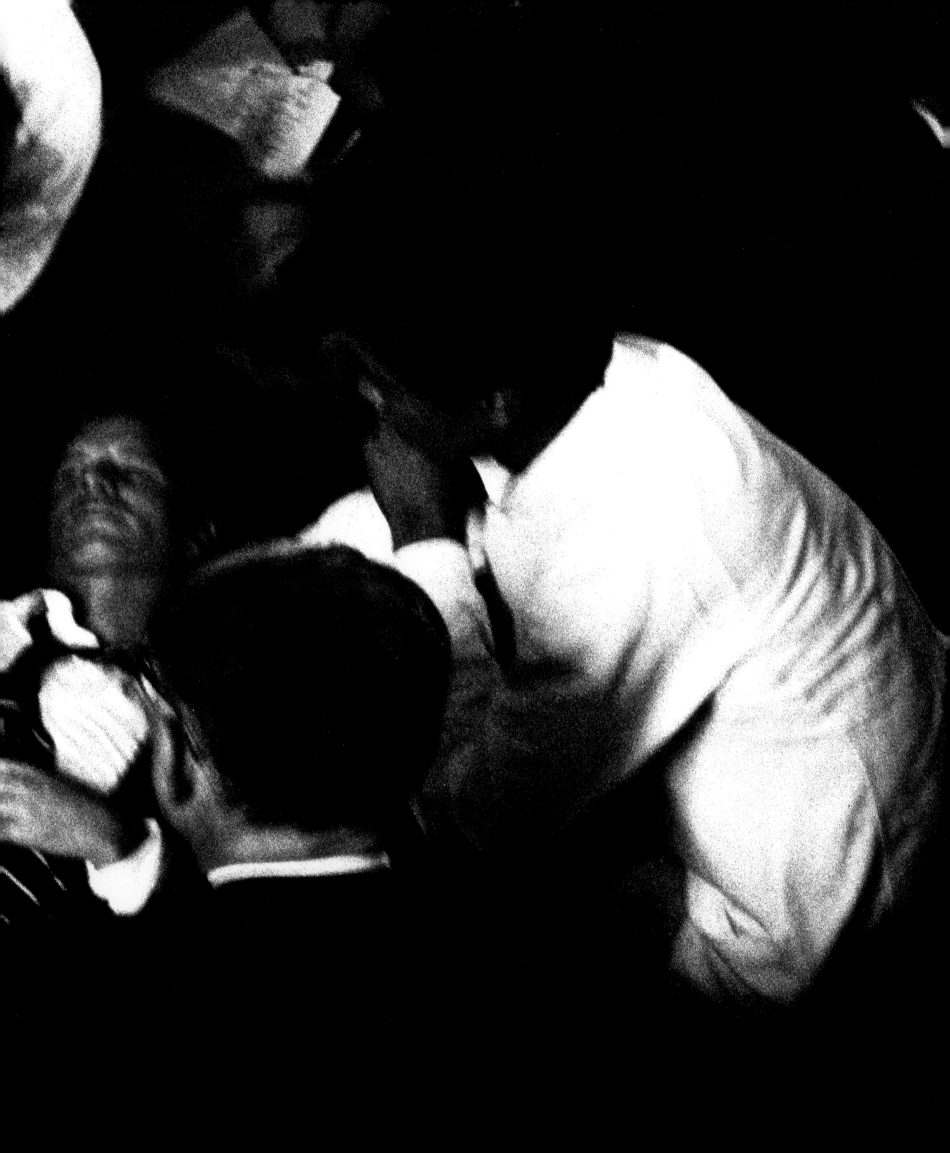

"With you I know we can keep faith with the American need and the American desire for peace and for justice and for a government dedicated to giving the people mastery over their affairs and future."

RFK, June 4, 1968
Ambassador Hotel Ballroom
Los Angeles, California

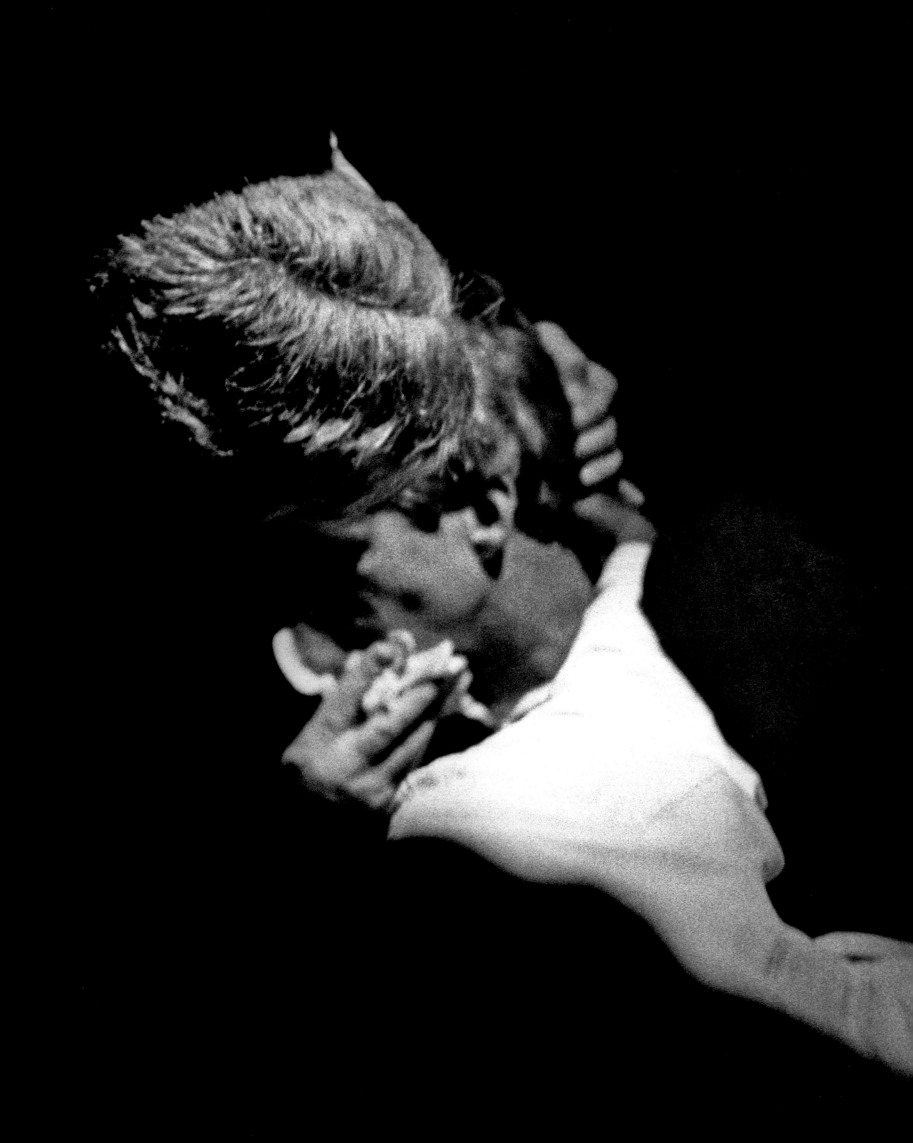

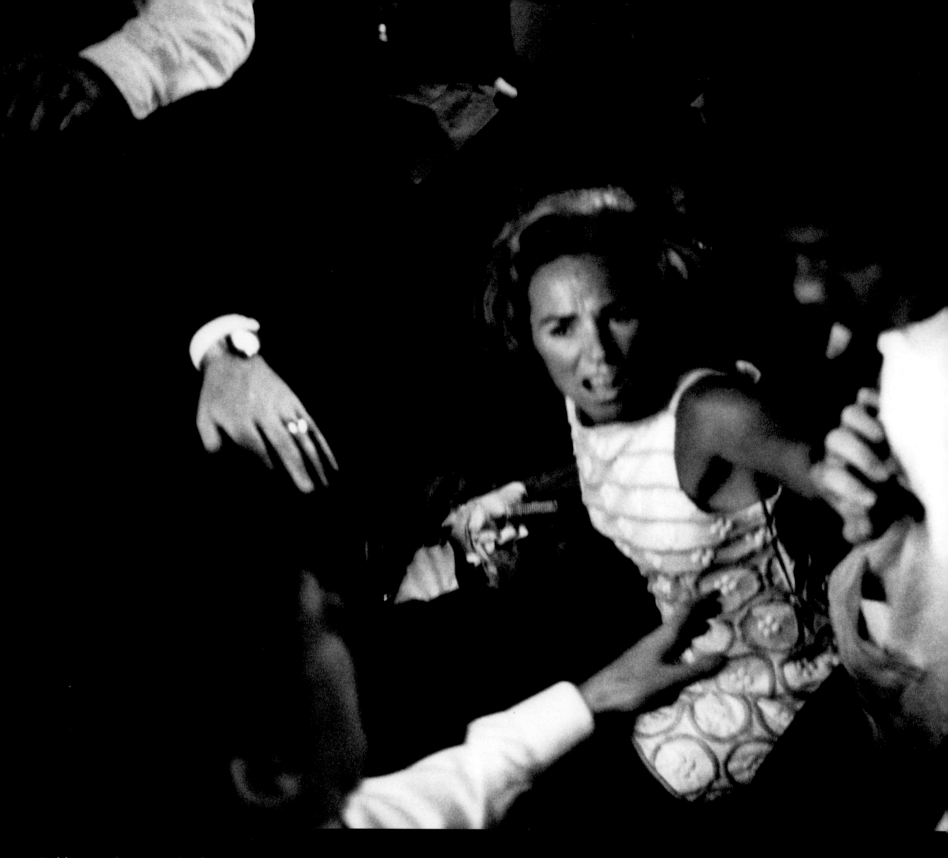

Bobby was lying on the floor with blood coming out of the back of his head. Ethel was well behind me, but she was brought over to him somehow. By then I had climbed up and was standing on a flat table in the center of the room—it was the warmer where food was placed before being taken in to the dining room. Jesse Unruh threw me off the hot plate and I found myself two feet from Bobby. That's when I saw Ethel bend down and heard her say, "I'm with you, Bobby, I'm with you." His eyes glazed over and a rosary was

placed in his hand. He did not say anything. Ethel turned around and screamed, "Give him air, give him air!"

The whole room started to move. It was hell.

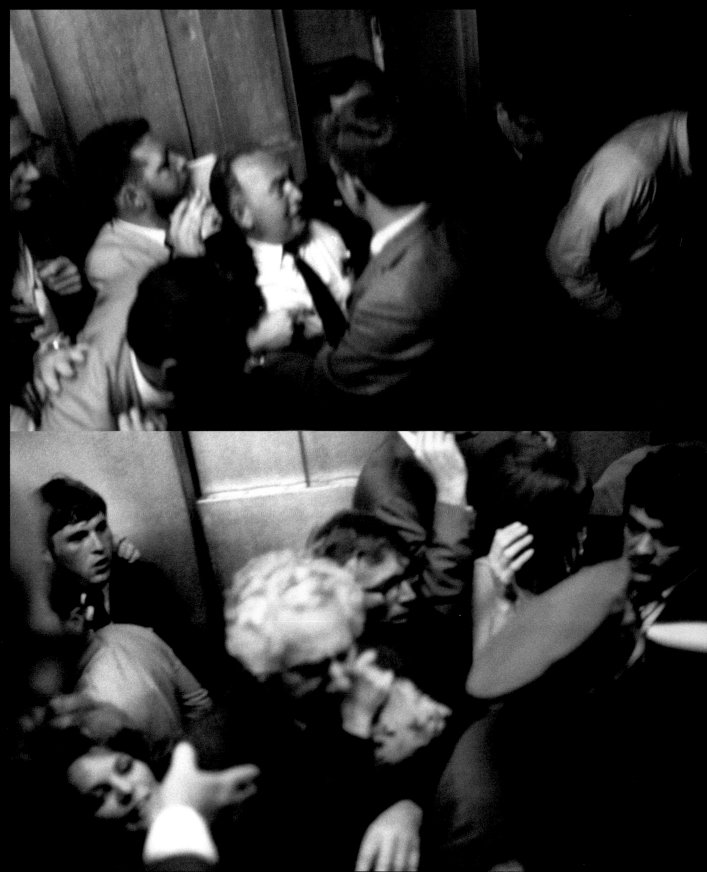

Above: Ethel Kennedy.

Top right: Pushing through.
Bottom right: Jimmy Breslin (far right), Bud Schulberg (center).

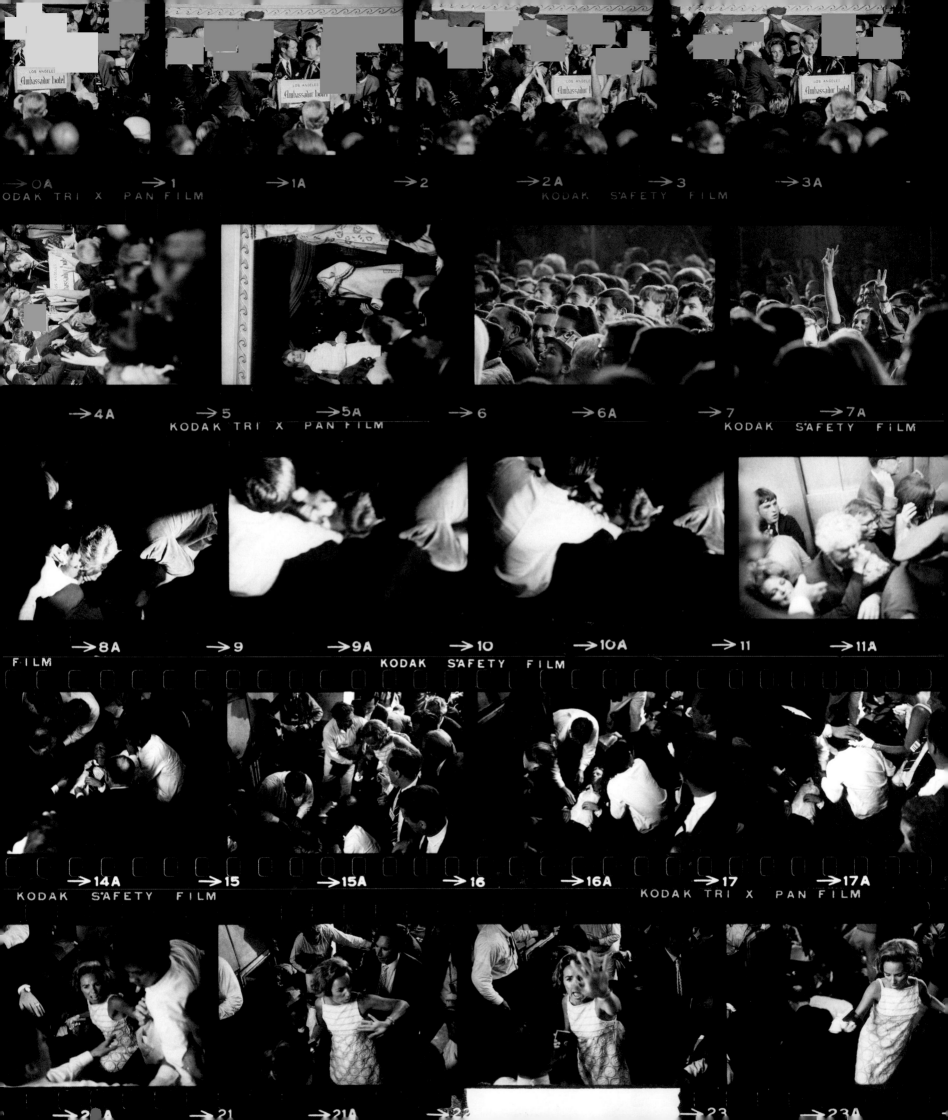

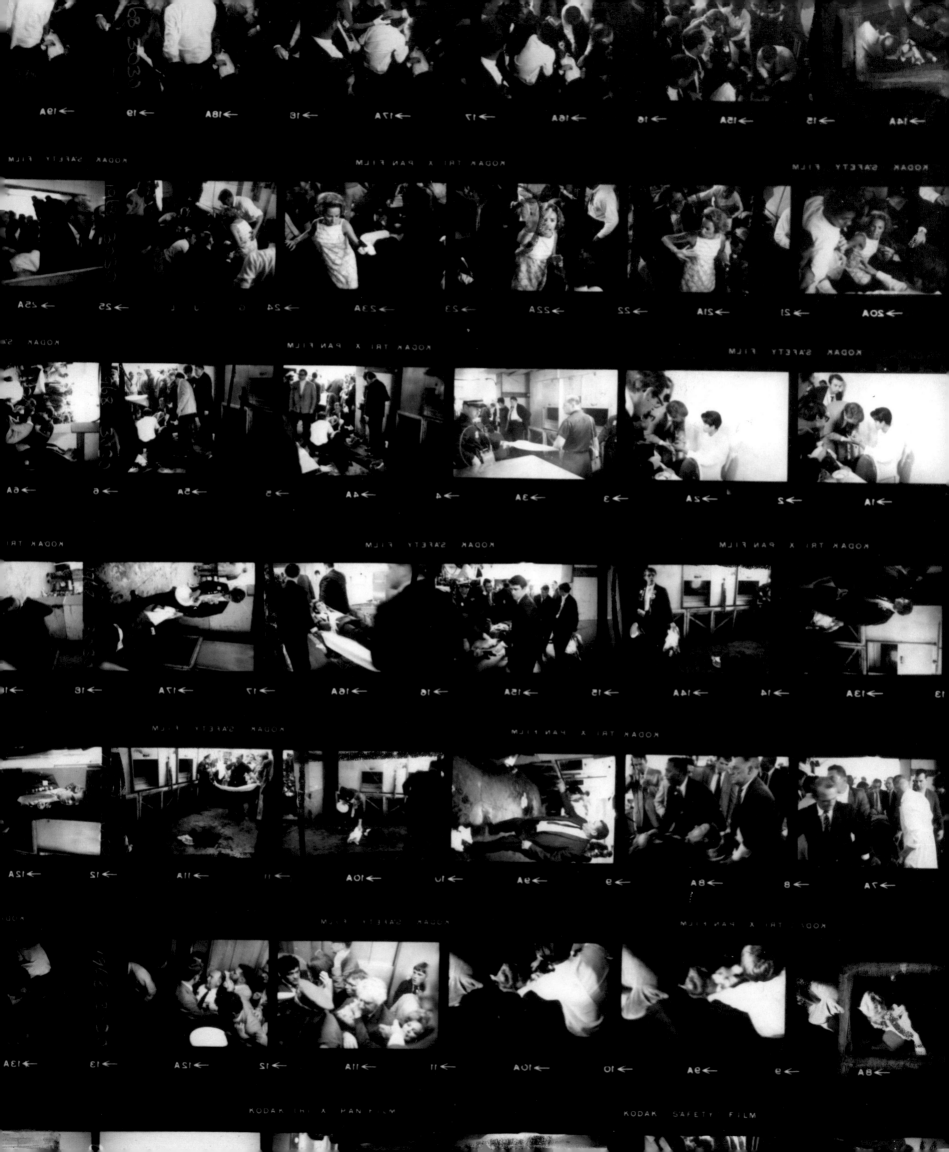

People were screaming, crying, beating their heads against the wall, shouting, "Fuck this country—not again, not again." Others were yelling, "Oh my God," and some were throwing up.

The campaign speechwriters, Bud Schulberg and Jimmy Breslin, were trying to take charge and stop the hysteria in the room, but everyone was shouting. No one even thought to wrap Bobby's head to try and stop the bleeding. Off to the side, I saw Rosey Grier and George Plimpton grabbing at Sirhan Sirhan, but no one could stop the tiny man from emptying his revolver. It was only when the agonizing melee subsided that I realized that others around me had been shot. When I looked around there were people vomiting everywhere.

P.94–95: Contact sheets, assassination.
Opposite: A reporter breaks down.

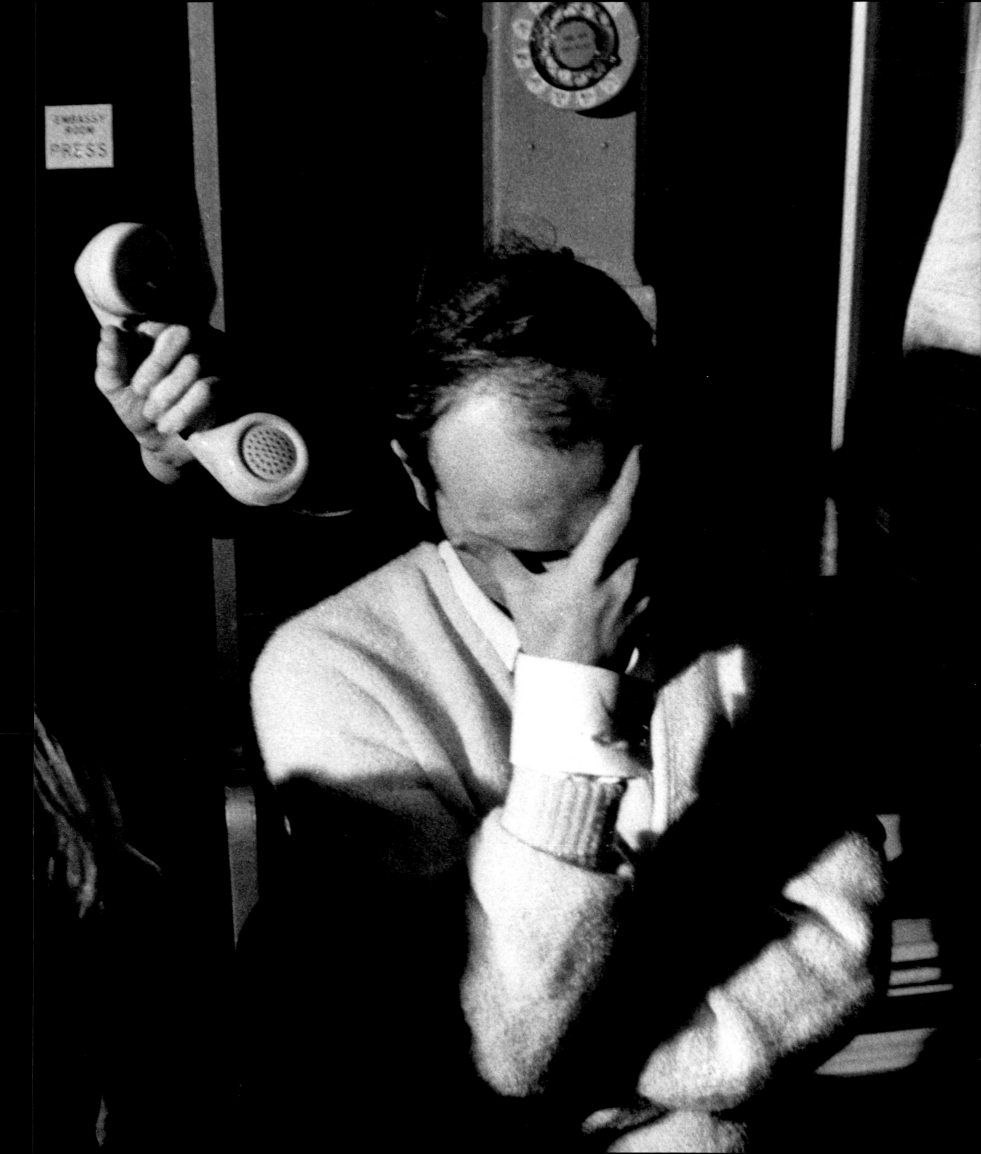

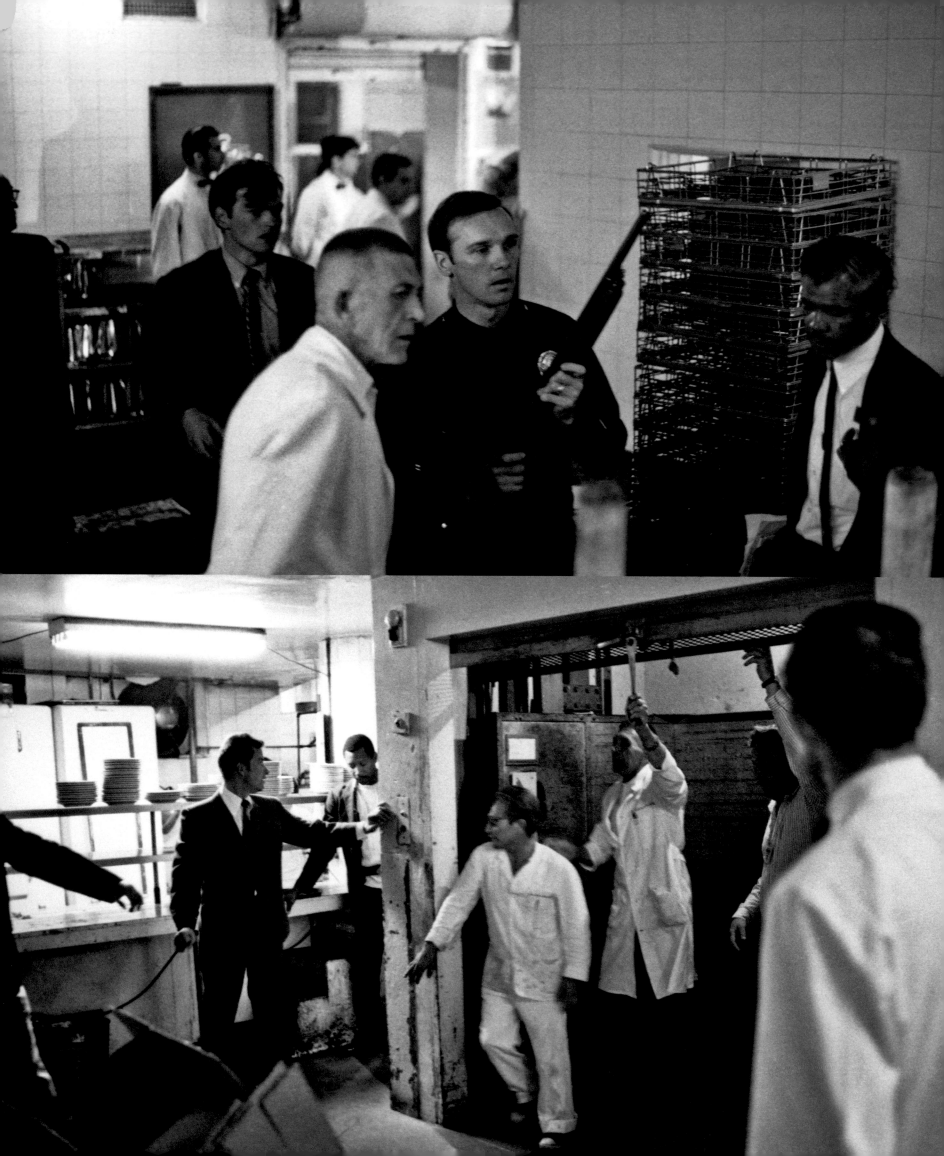

I was stuffing the exposed rolls of film into my sock so no one would take them away if the police came up to grab my camera. I was thinking about Dallas the whole time. I kept thinking that everything in the room was important. And I kept talking to myself, saying, "Please God, let me do it right. Don't fail. This is what I've come into the business for. Stay at the center. Bobby is the center. This is for history. Please God, don't let me mess up today. Mess up tomorrow, but not today. Bobby will understand my doing this, doing my job."

Opposite, top: A policeman with gun drawn is surrounded by kitchen staff and other policemen.
Opposite, bottom: Kitchen and ambulance workers.

Right: A campaign worker being interviewed by a policeman.

It was complete pandemonium, the chaos that was going on, the screaming and crying—it was as if the entire room was moving in slow motion. There was no order. It only calmed down when the police arrived. I think the Kennedy aides could have handled it better, but they were inexperienced in the midst of such unexpected tragedy.

A campaign worker stands where Bobby fell.

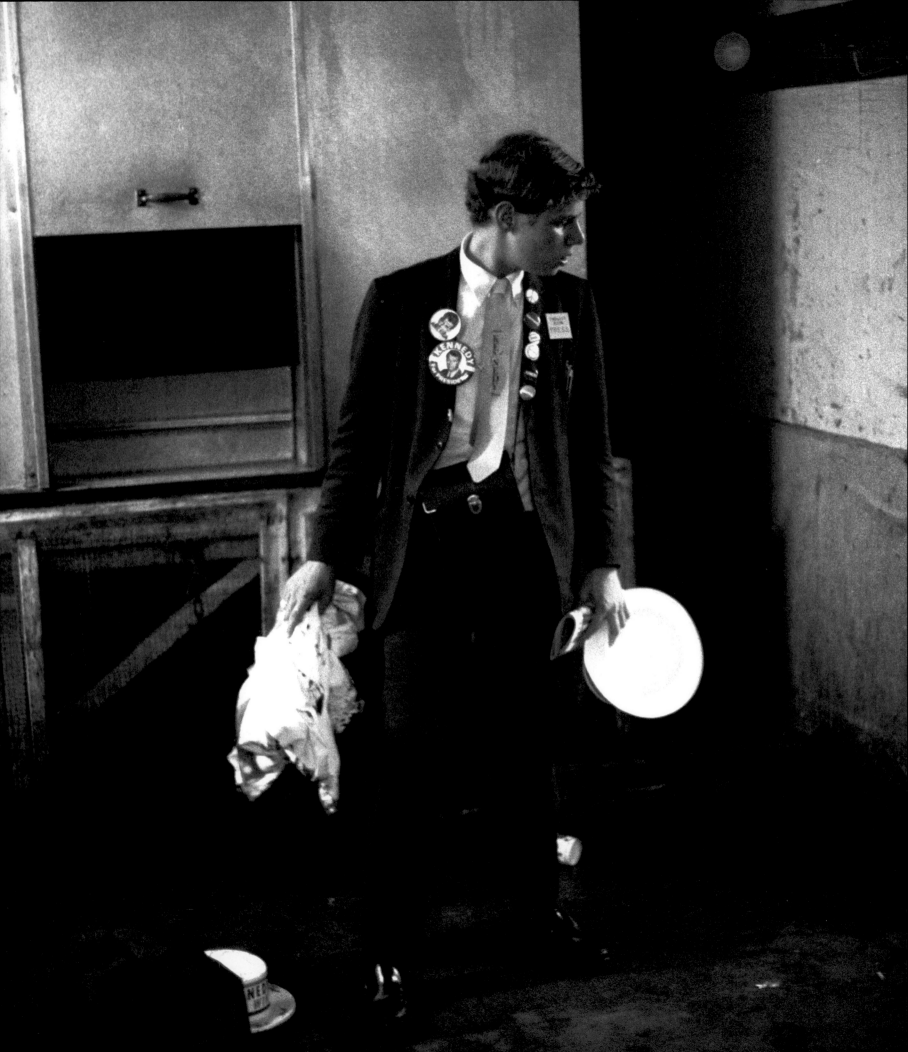

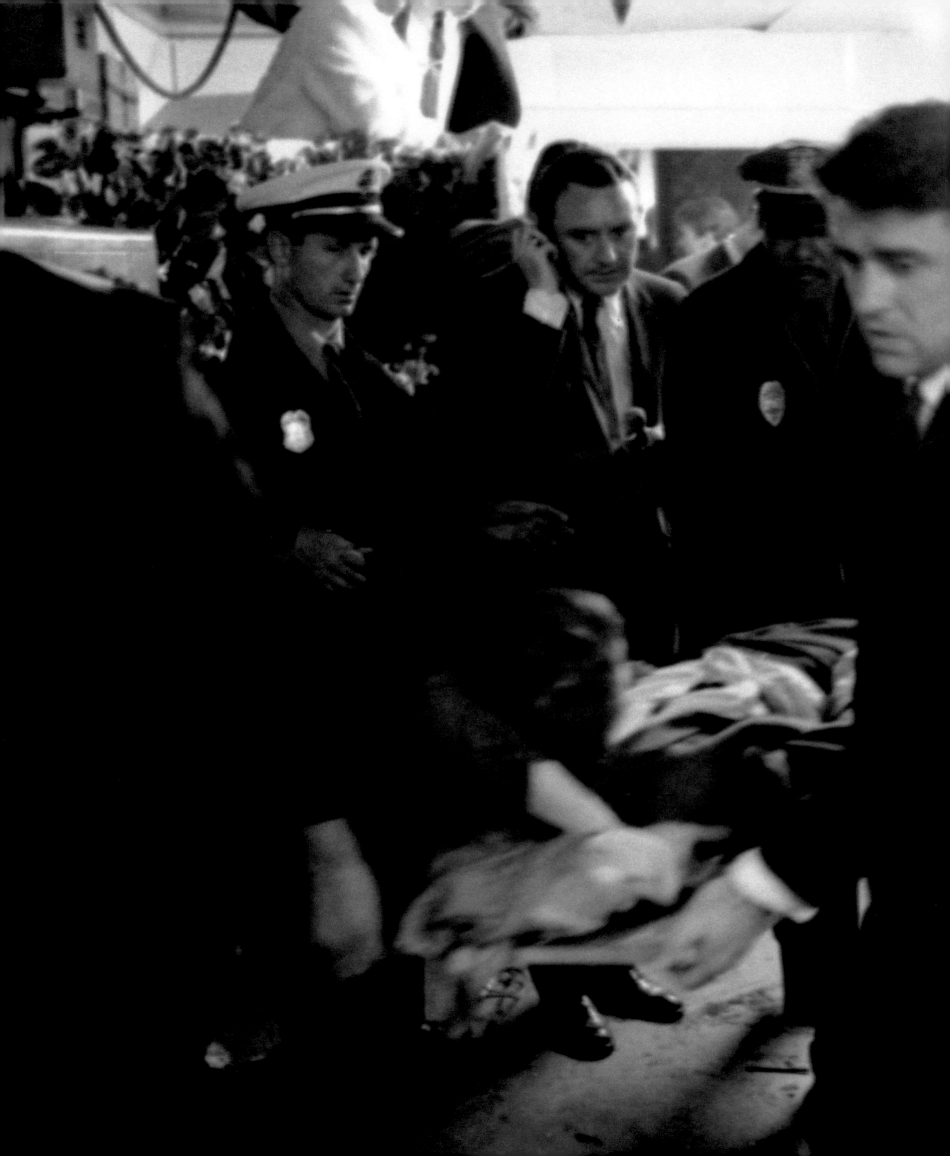

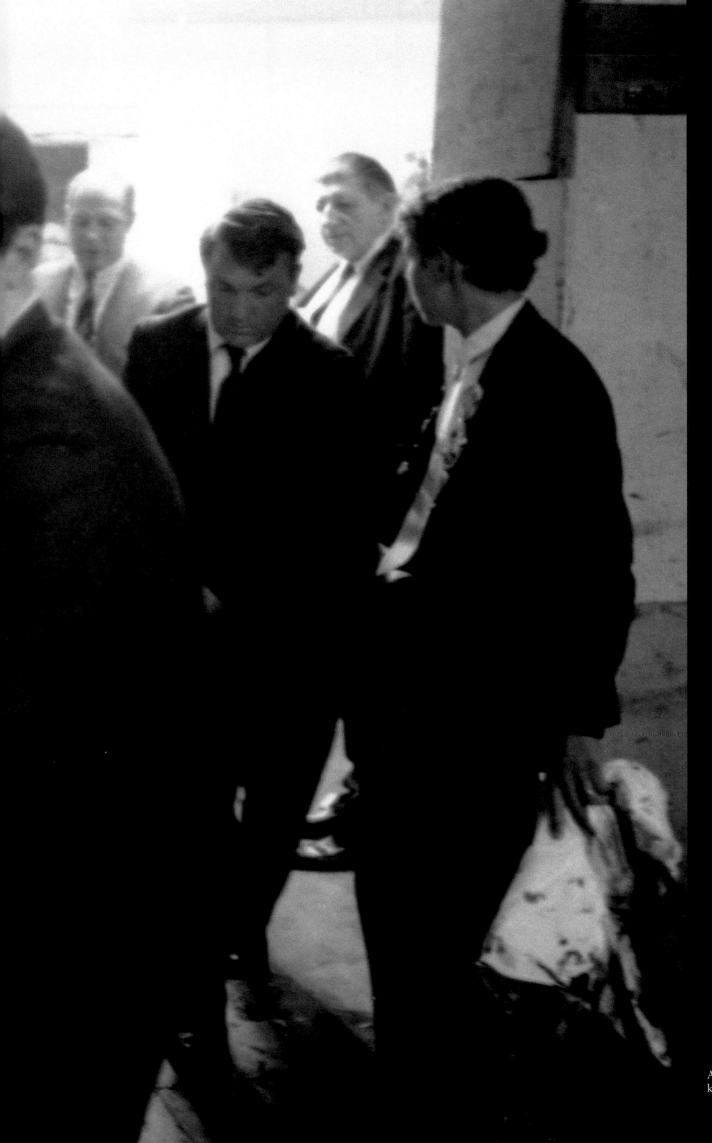

A man who was shot is taken from the kitchen on a stretcher.

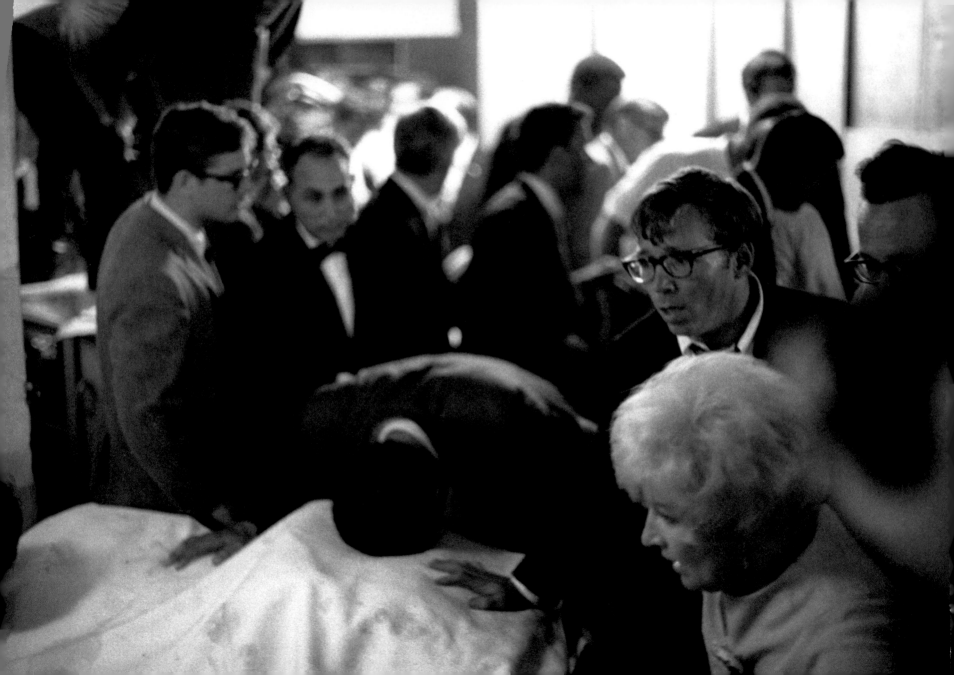

It seemed like a very long time before an ambulance arrived, and later everyone blamed each other for the delay. Kennedy was lifted by the legs and shoulders and placed on the stretcher.

I was bruised all over from being shoved around. It was like having been in a fight. I was black and blue and had a bump on my head where my camera had banged into it. When the police started throwing everybody out of the kitchen, I ducked and went back around to the other side of the room. When it was all over, I was the last photographer to leave the kitchen. The police put up a rope of sorts, made of sheets or something like that.

On the floor was a pool of blood. A young woman ducked under the rope and placed her straw boater where Kennedy had fallen. That was all that was left. I will always remember that moment.

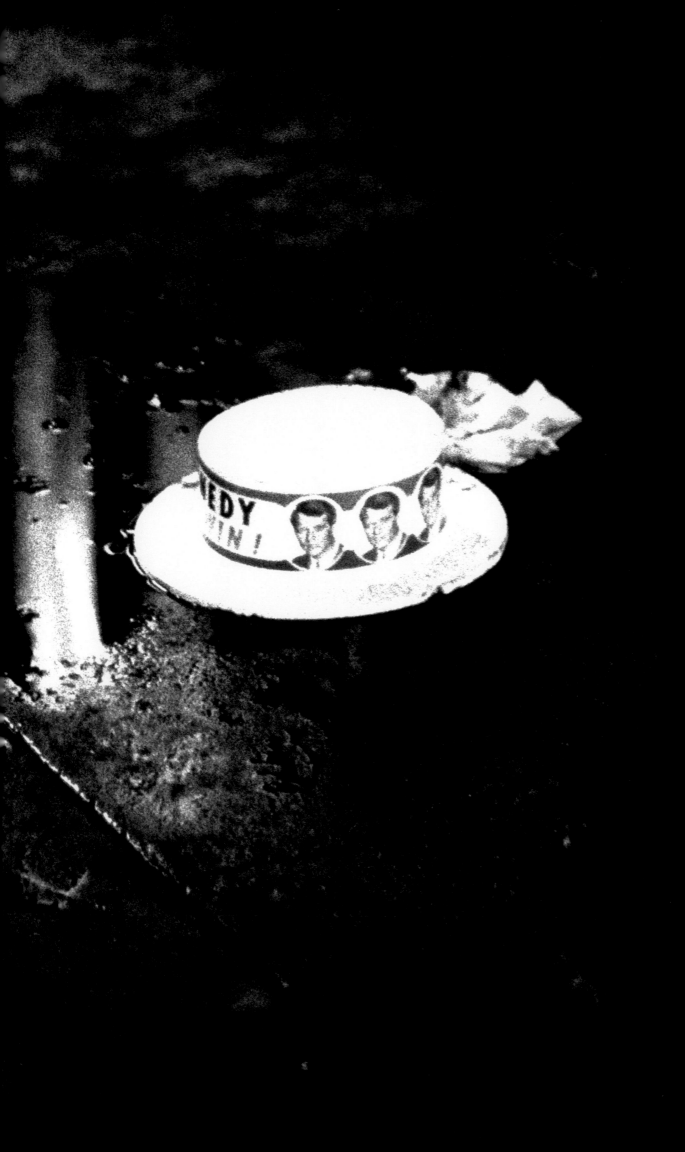

George Gale, the *Daily Express* reporter, a grand, dapper sort, did not get into the kitchen. Even though his attitude was always "I'm not here to help photographers," I gave him his story anyway, since he had nothing. I kept the important details for myself and dictated them to the *Express* in the first person.

I ran around taking pictures of everything just to stay inside. Afterward, I wandered around for a while, wanting to be alone. I felt shaken, but not shattered. There is a feeling you get, a very strong feeling, when you come through violence: a sense of having survived. That's what I felt. Even today, I sometimes wake up and relive the tragedy. The senseless horror of it all, the sadness, will stay with me forever.

After a while, I went to the Associated Press darkroom and gave them my film to wire the photos to the paper in London. I said to be careful as there hadn't been much light. They developed the film by inspection. That's the only way we got anything. I'm sure that if they hadn't developed it for me, I would have botched it. You don't really work with exposure meters under duress; there is no time.

Someone from the Associated Press called my wife, Gigi, and woke her up about 5:00 a.m. New York time to tell her that five people had been shot, but not me. I called later. *Express* editor David English called from London and wanted me to dictate another story for the paper. He said, "I hope you've been at the hospital all night." I told him I'd been through a horrific event and standing outside a hospital would be useless. I never went to the hospital. I had had enough emotion, enough drama. I couldn't do any better. I knew Bobby was dead when he left the kitchen.

I called the F.B.I. and told them I had these pictures, including one of a girl in a polka dot blouse. They had been looking for someone in a polka dot dress to question, but they never came to look at my contact sheets. It was really unbelievable.

The next day I flew back to New York to prepare for the funeral and train ride that would end with RFK's burial in Arlington Cemetery, where his brother the president had been laid to rest.

FRIDAY & SATURDAY / JUNE 7–8 / ST. PATRICK'S CATHEDRAL / NEW YORK / ARLINGTON CEMETERY / WASHINGTON, D.C.

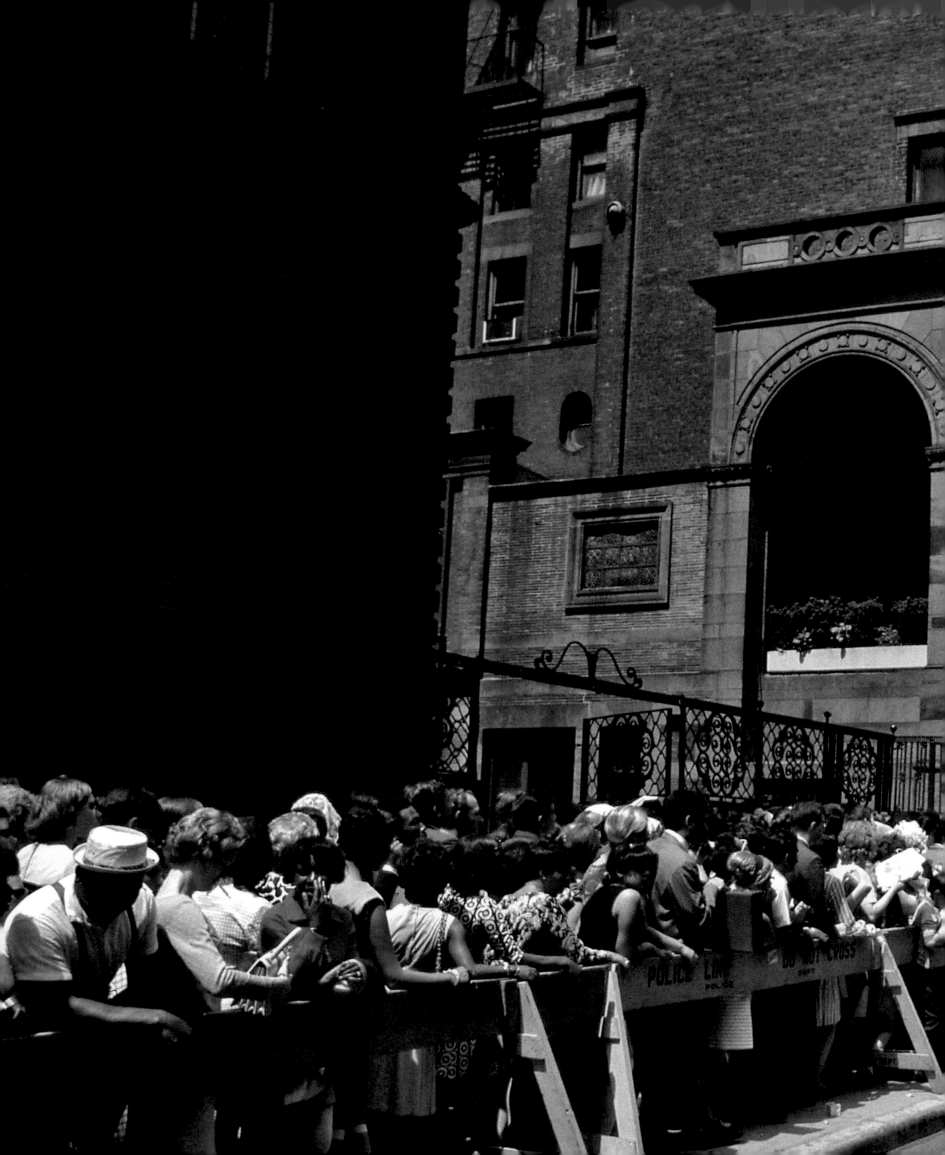

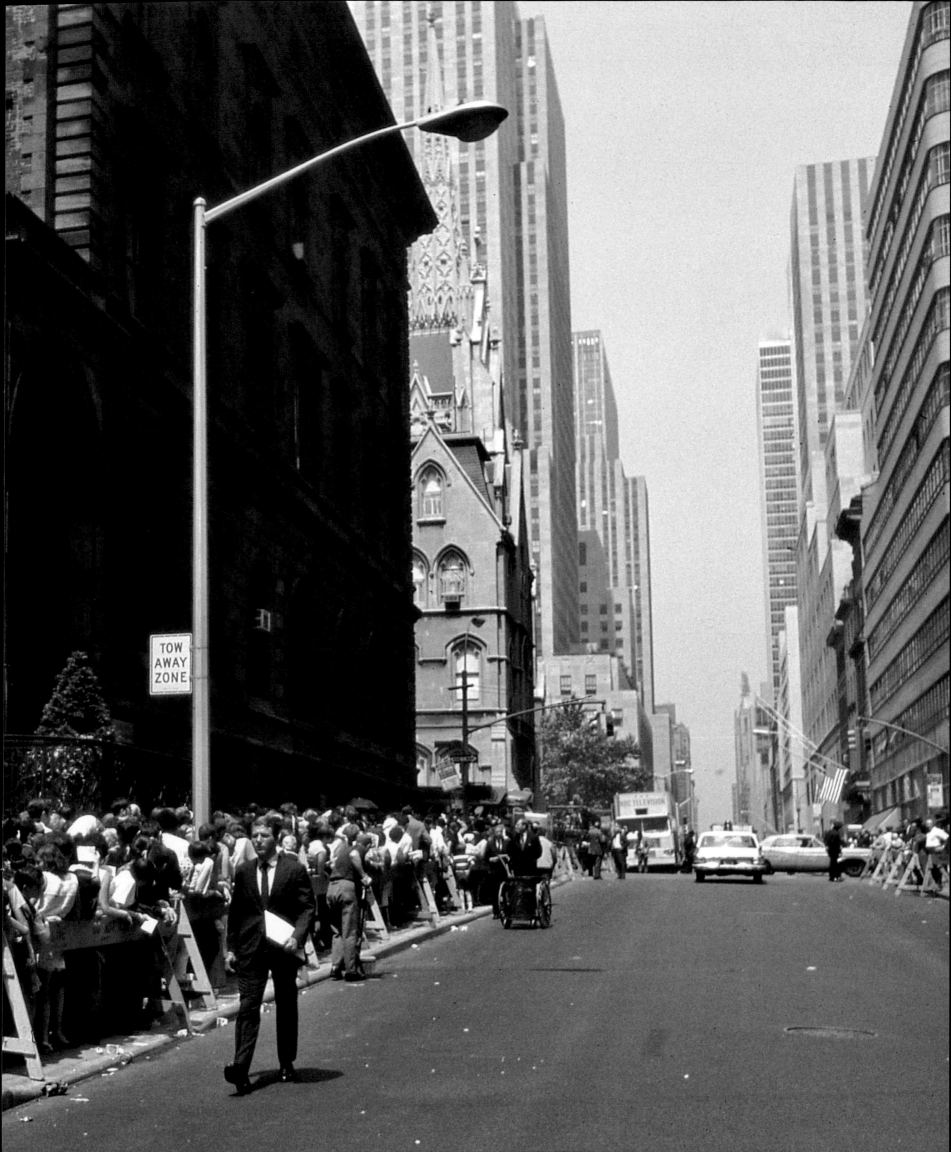

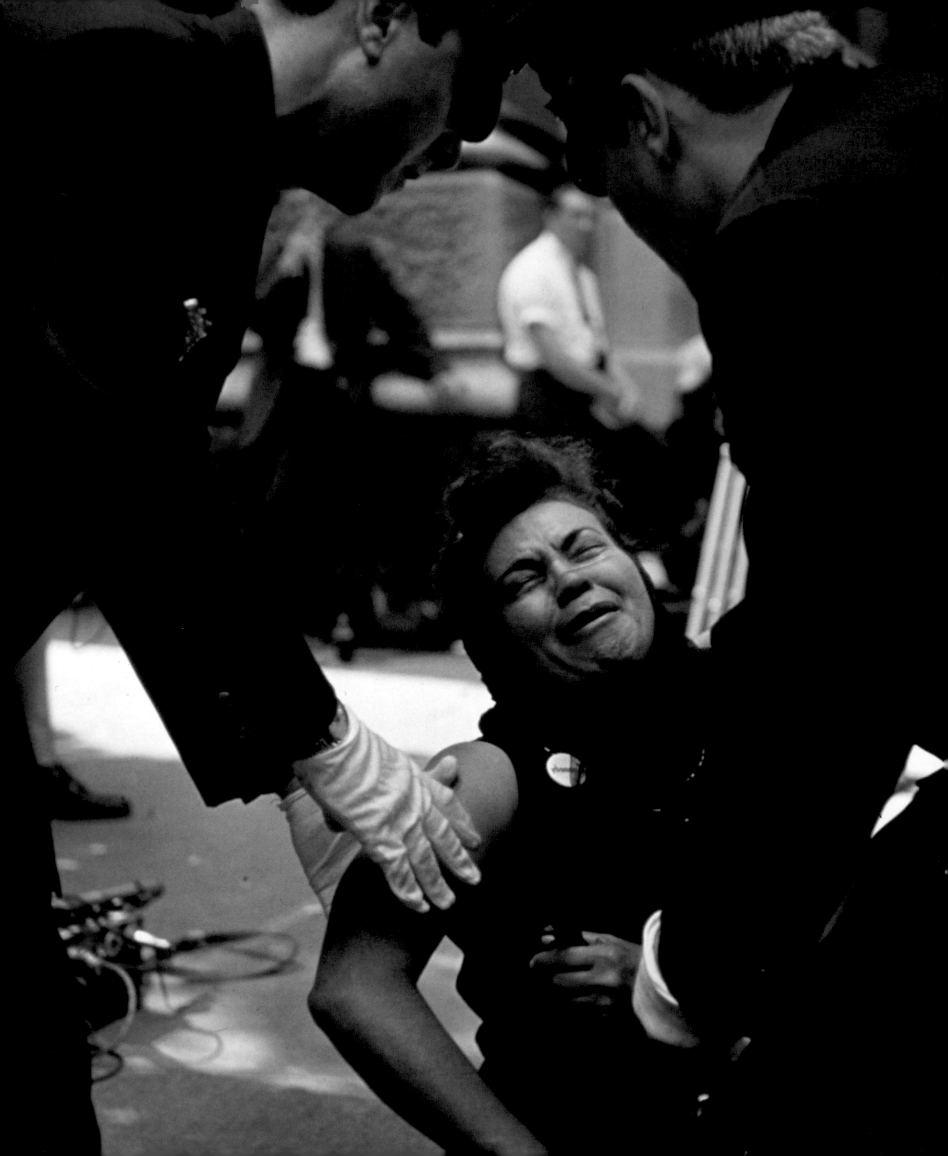

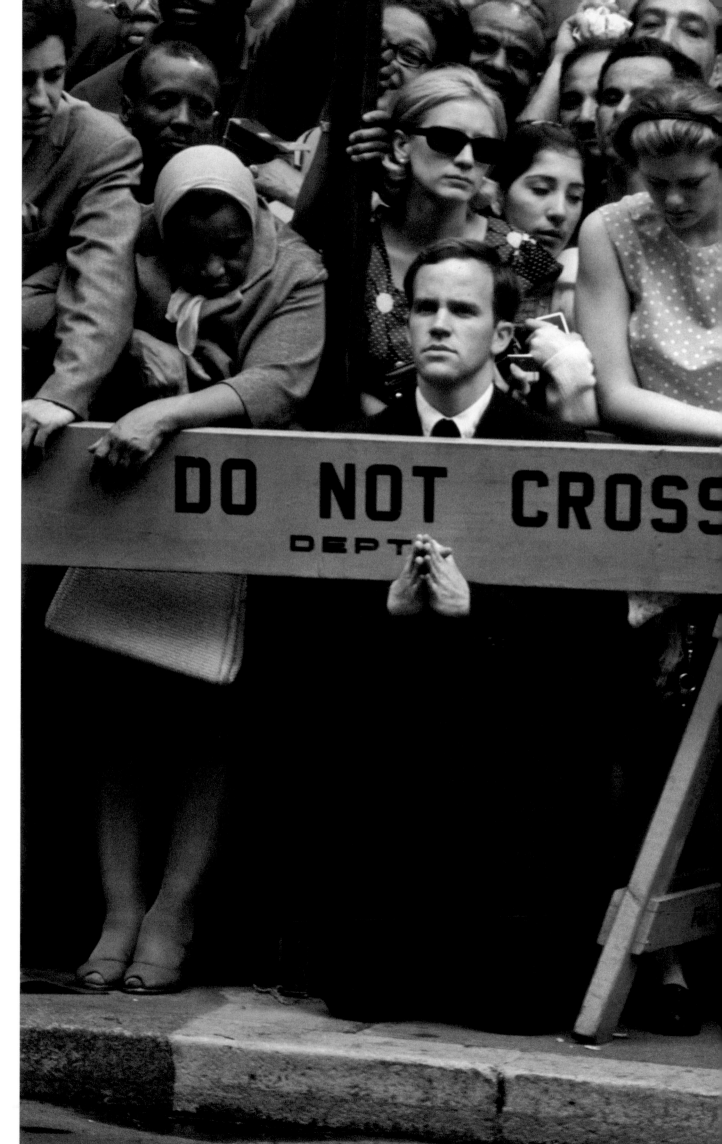

P.112–113: Mourners line up around the block waiting to enter St. Patrick's Cathedral to view the body of the slain senator.

Opposite: Cathedral mourner.
Right: Man prays outside the church.

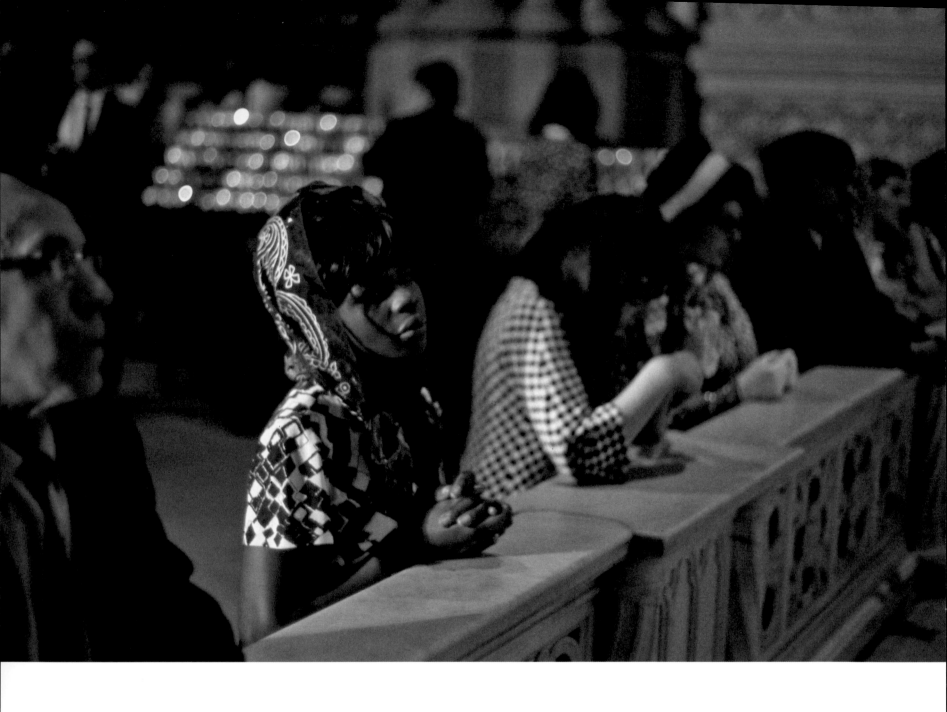

Mourners inside St. Patrick's Cathedral.

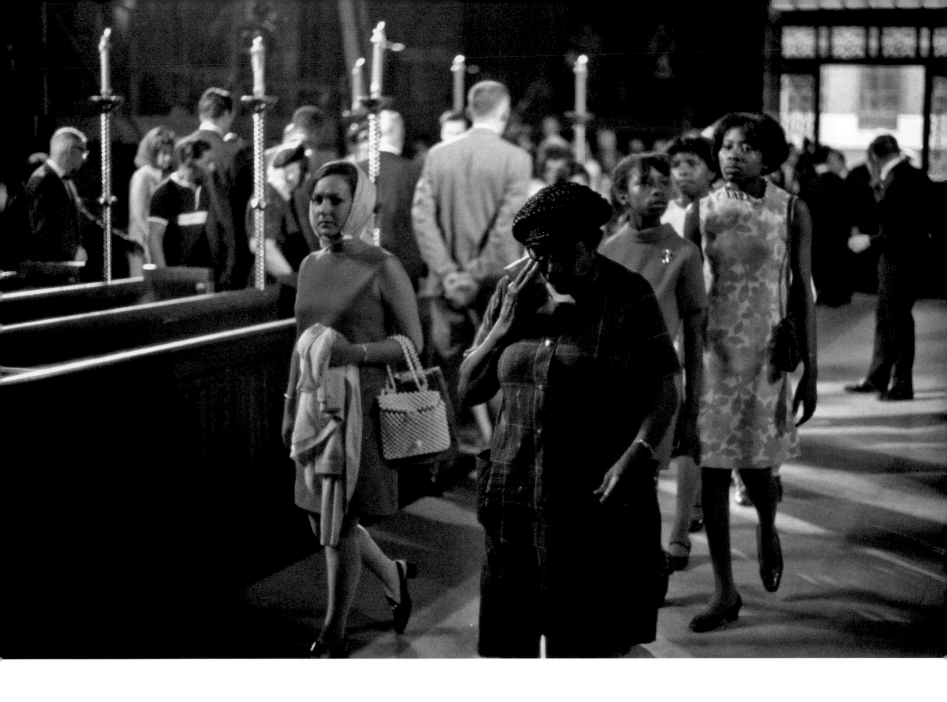

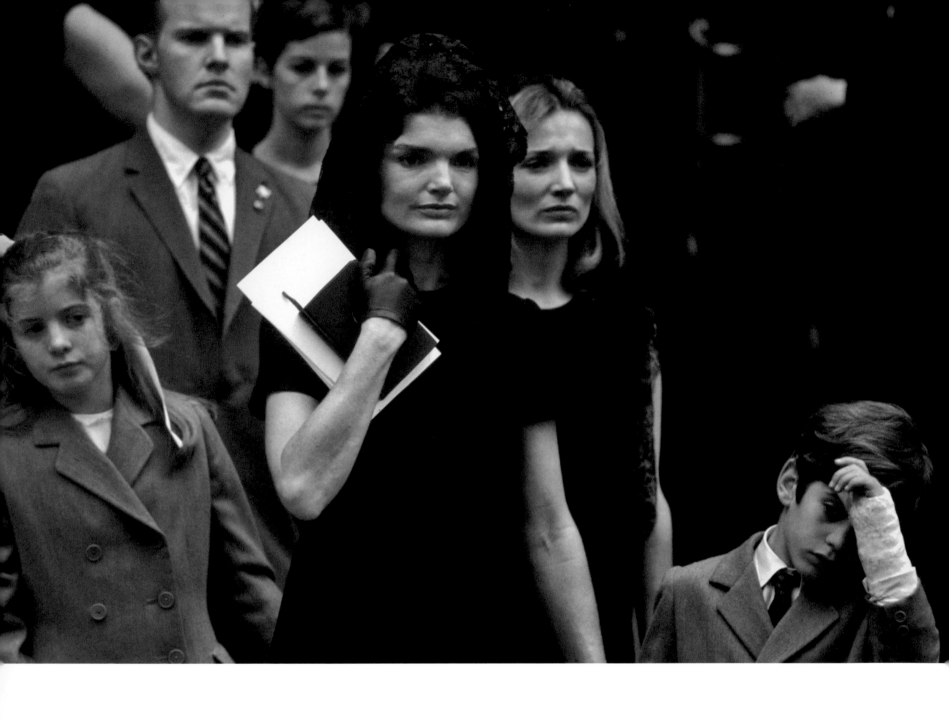

Jacqueline Kennedy, with her children
Caroline and John, Jr., and her sister Lee
Radziwill, leave the church. Claudine
Longet is in the background.

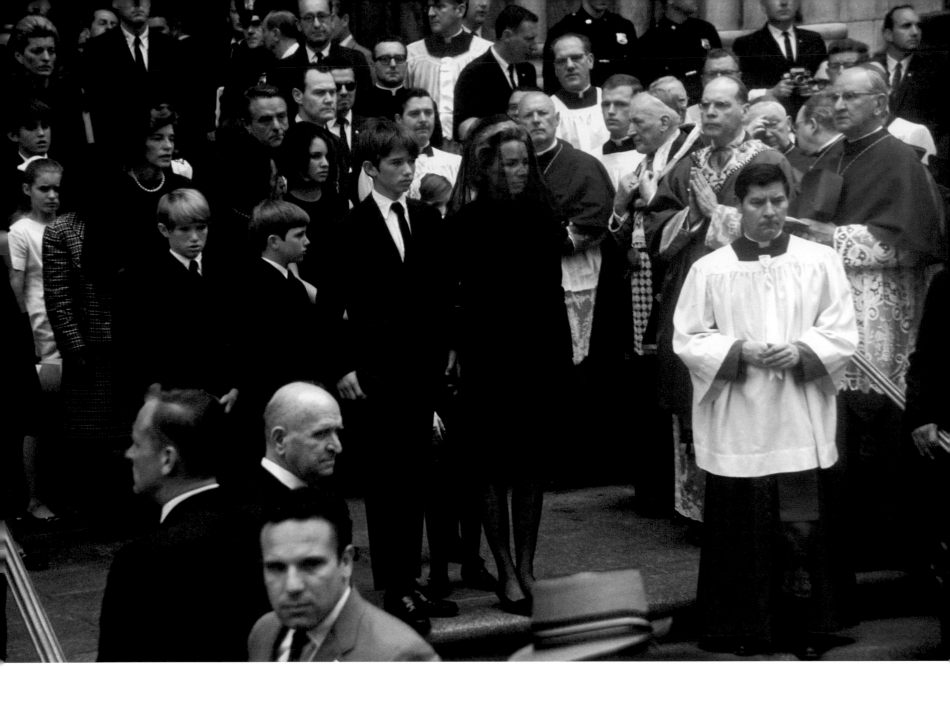

Ethel and her children leave St. Patrick's
Cathedral.

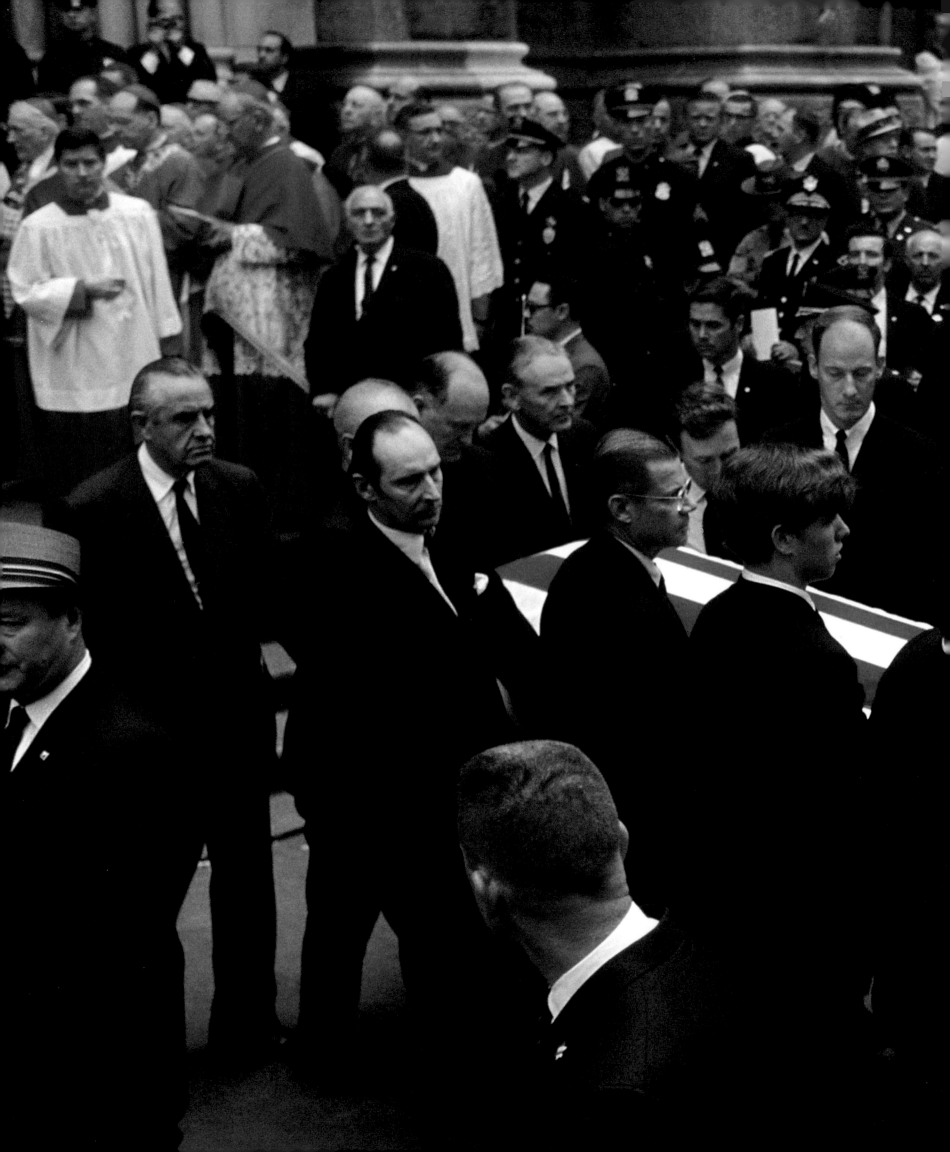

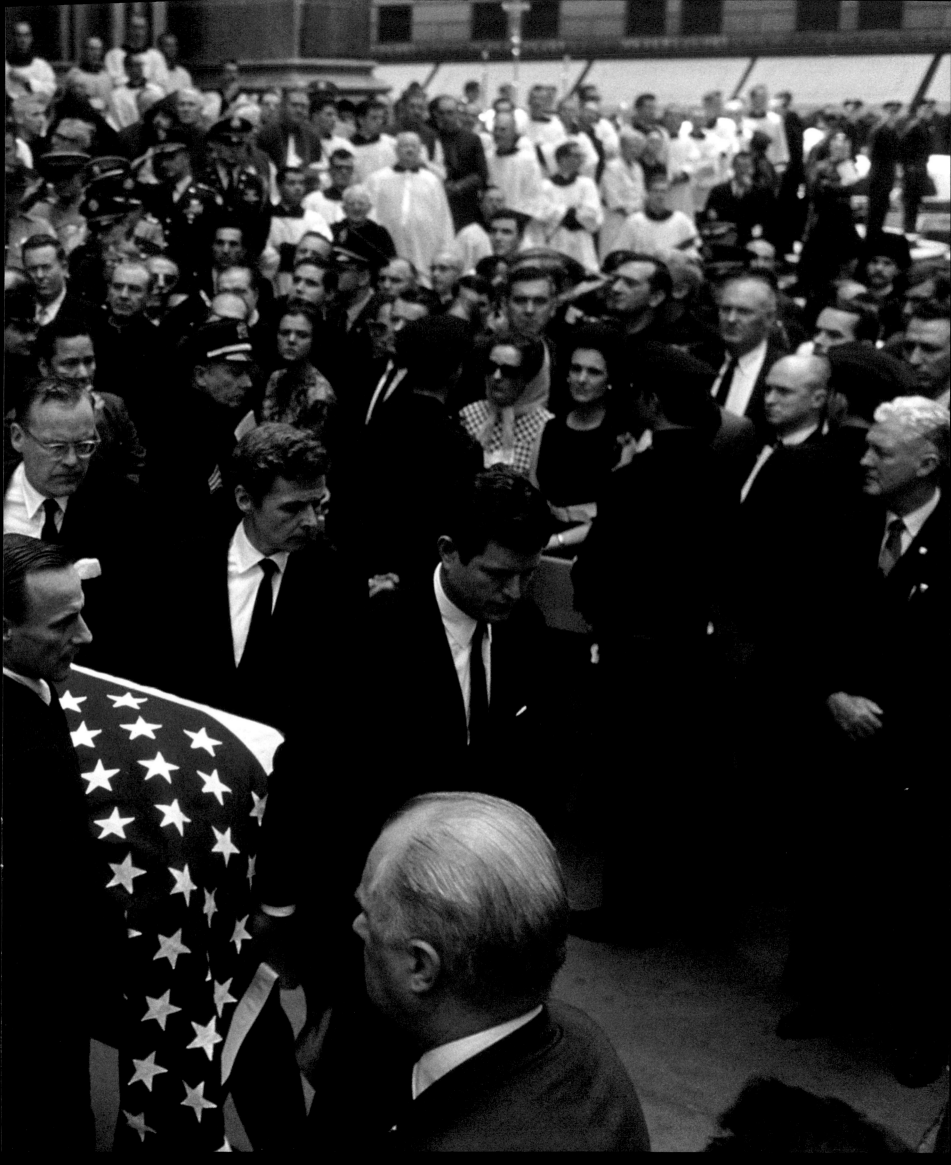

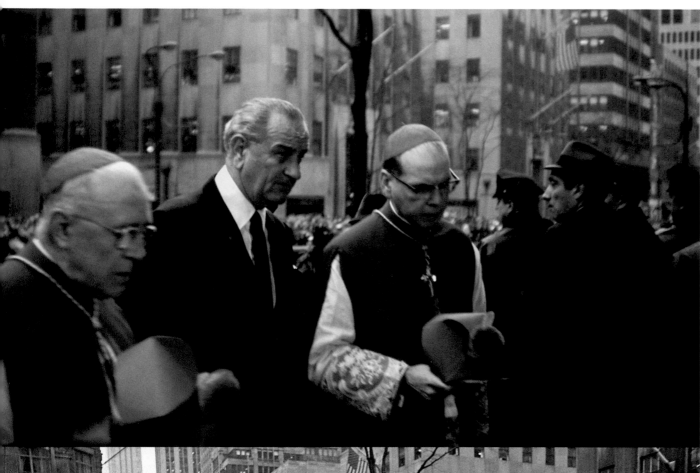

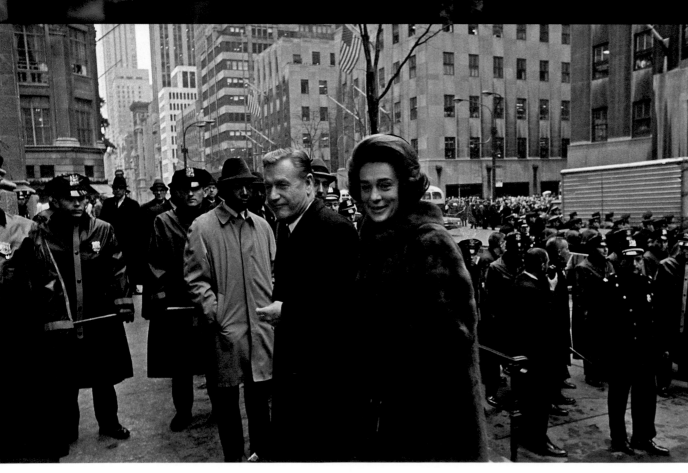

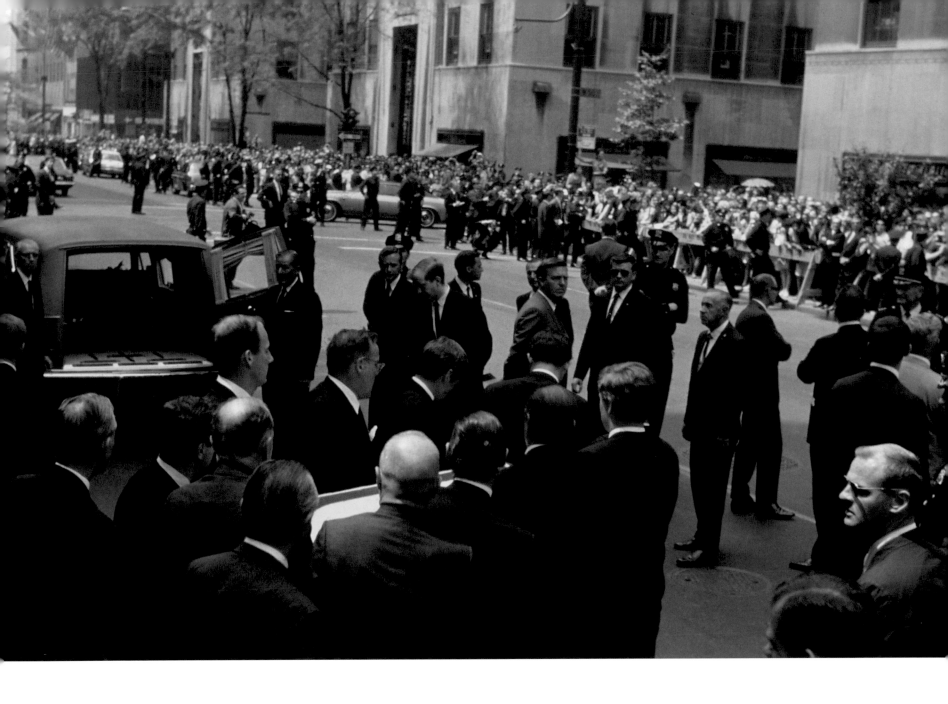

P.120–121: Pallbearers included John
Glenn, W. Averell Harriman, C. Douglas
Dillon, Kirk LeMoyne Billings (a friend
of JFK's), Stephen Smith (Jean Ann
Kennedy's husband), David Hackett, Jim
Whittaker, John Seigenthaler Sr., Robert
McNamara, and Lord Harlech.

Opposite, top: President Lyndon Johnson
enters the church.
Opposite, bottom: New York Governor
and Mrs. Nelson Rockefeller arrive for
the funeral.

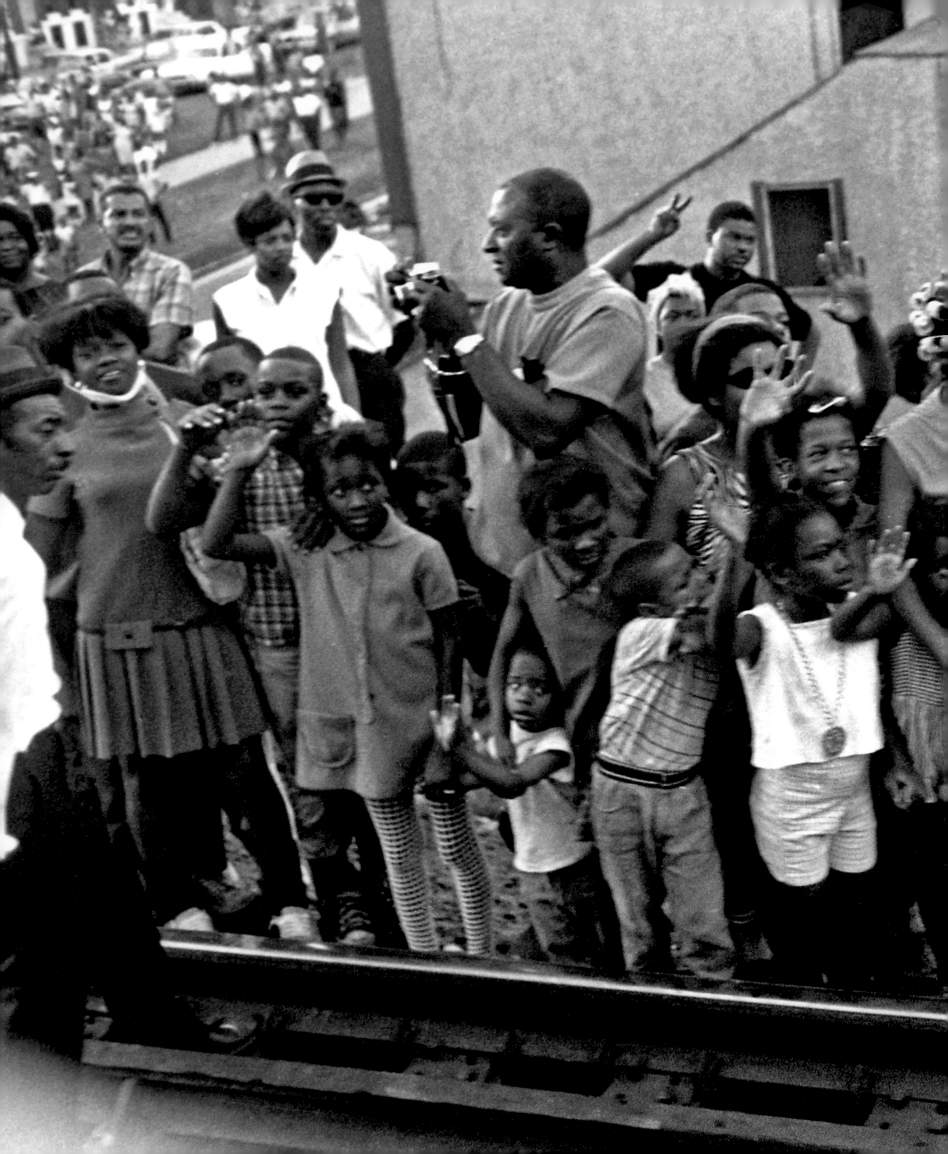

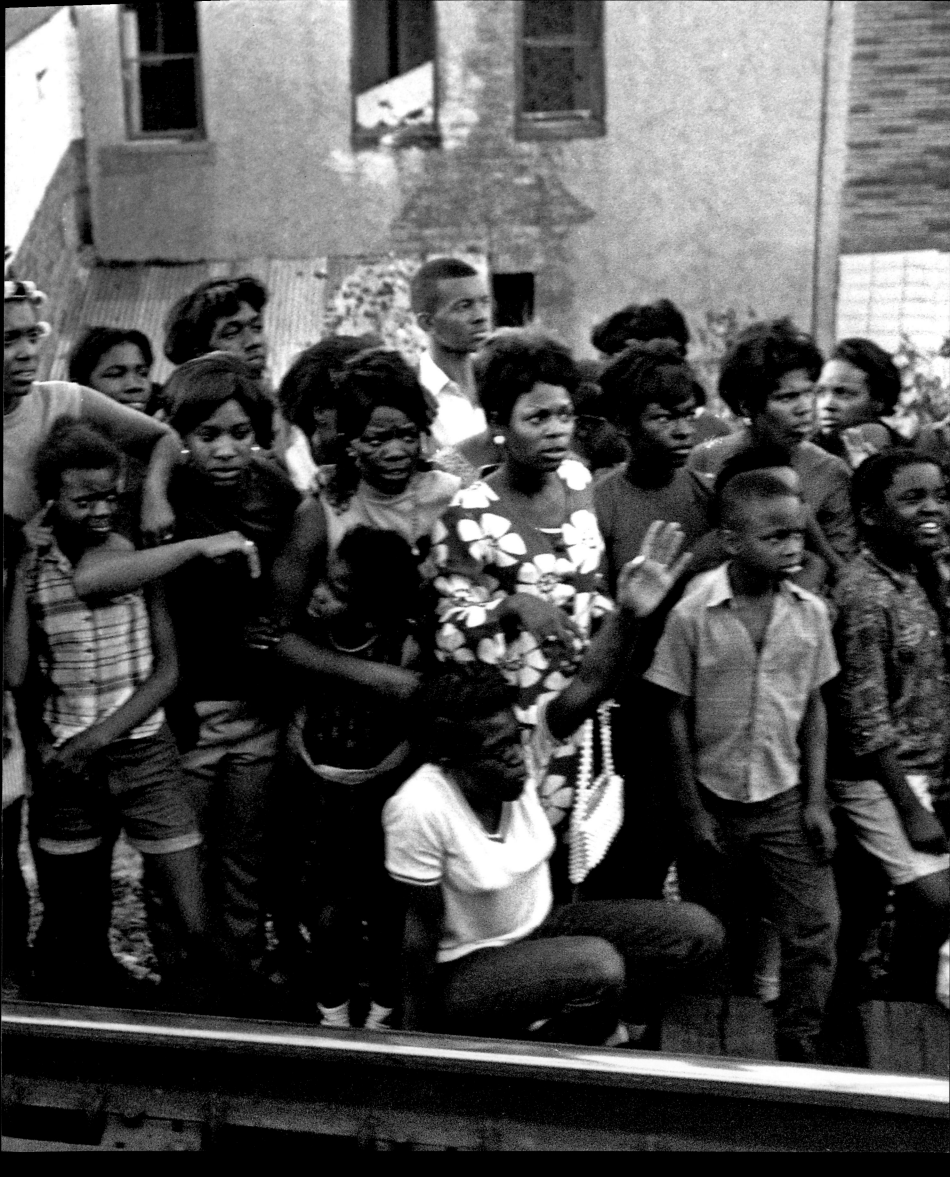

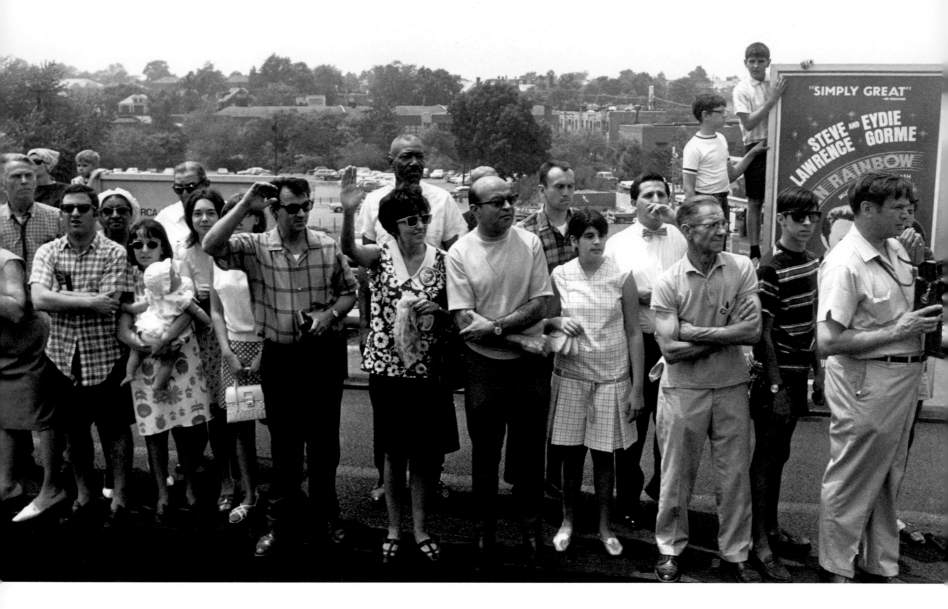

SATURDAY / JUNE 8

The St. Patrick's Cathedral service in New York City was followed by a long train ride in sweltering heat to Arlington Cemetery outside Washington, D.C. The train was full but there were very few press on board. Thousands of mourners lined the tracks to show their respect as the train carrying the body of the slain senator slowly passed. It was oppressively hot on the train, as the air conditioning was not working. Joseph Kennedy II walked from car to car, shaking hands with the distinguished and thanking them for being there.

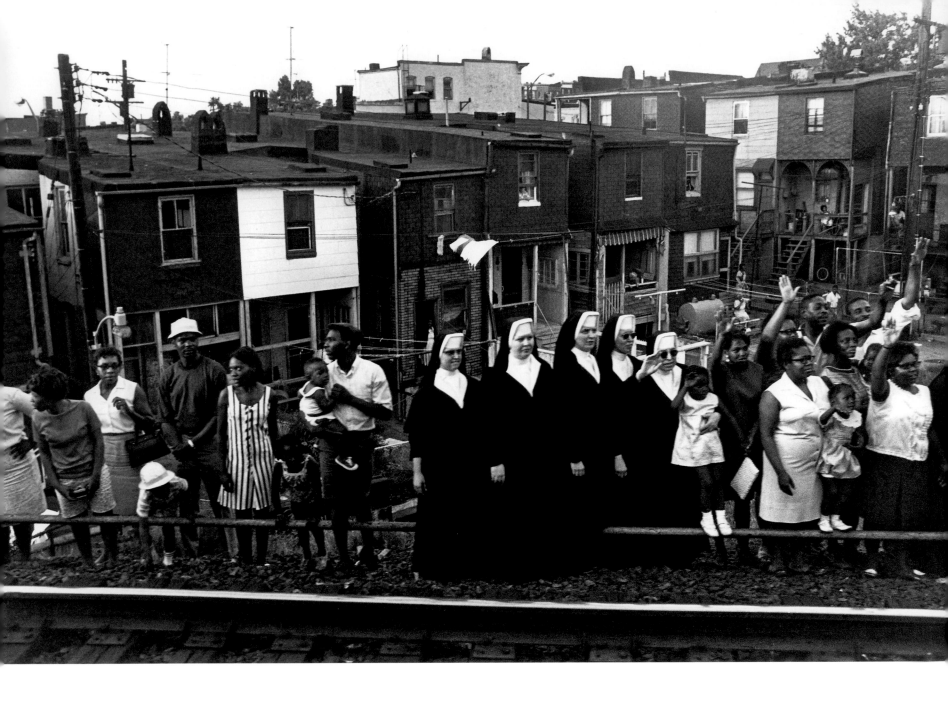

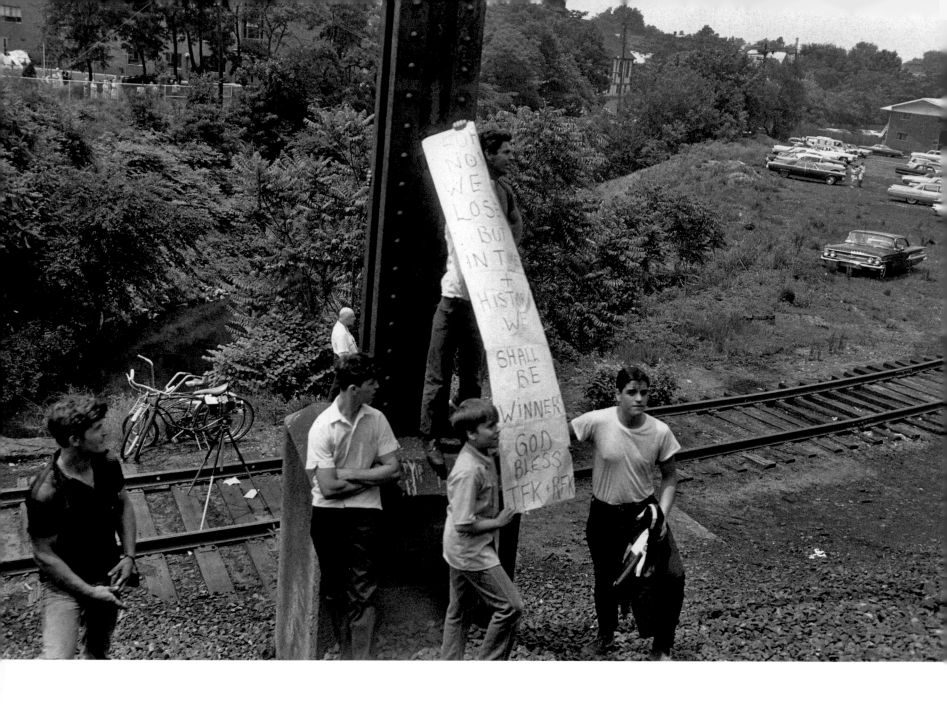

P.124–129: Mourners on the train
tracks.

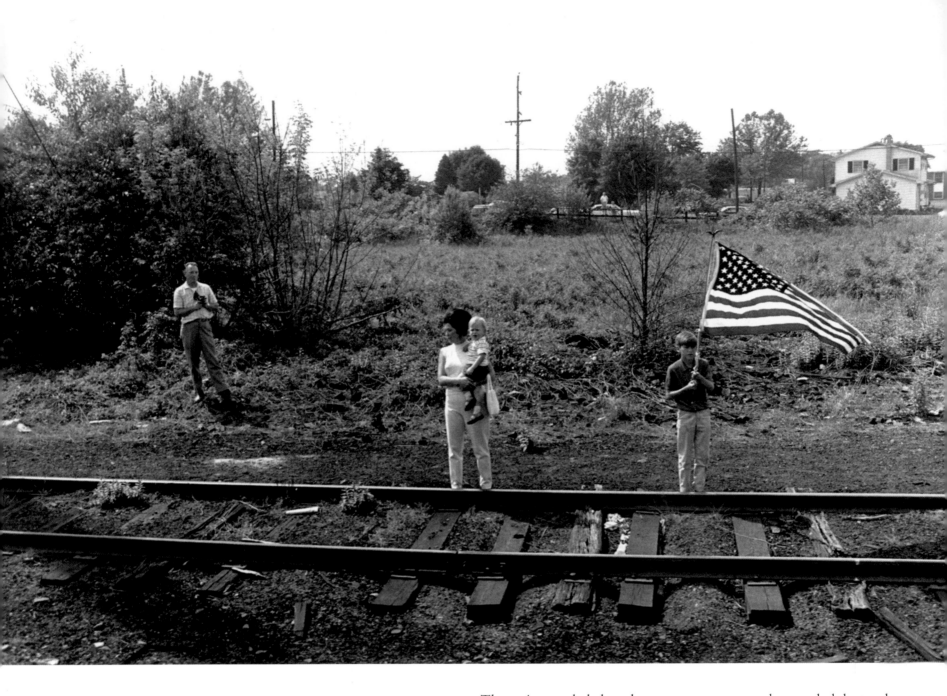

The train crawled along because so many people crowded the tracks, coming to pay their respects to their slain hero. They were crying, waving flags, and standing somberly all along the train route. It had been less than five years since JFK's assassination in Dallas, and Martin Luther King, Jr., had been shot just three months earlier. Those tragedies were still very much in people's minds. And then someone shouted, "Oh my God!" A woman standing too close to the tracks had just been killed.

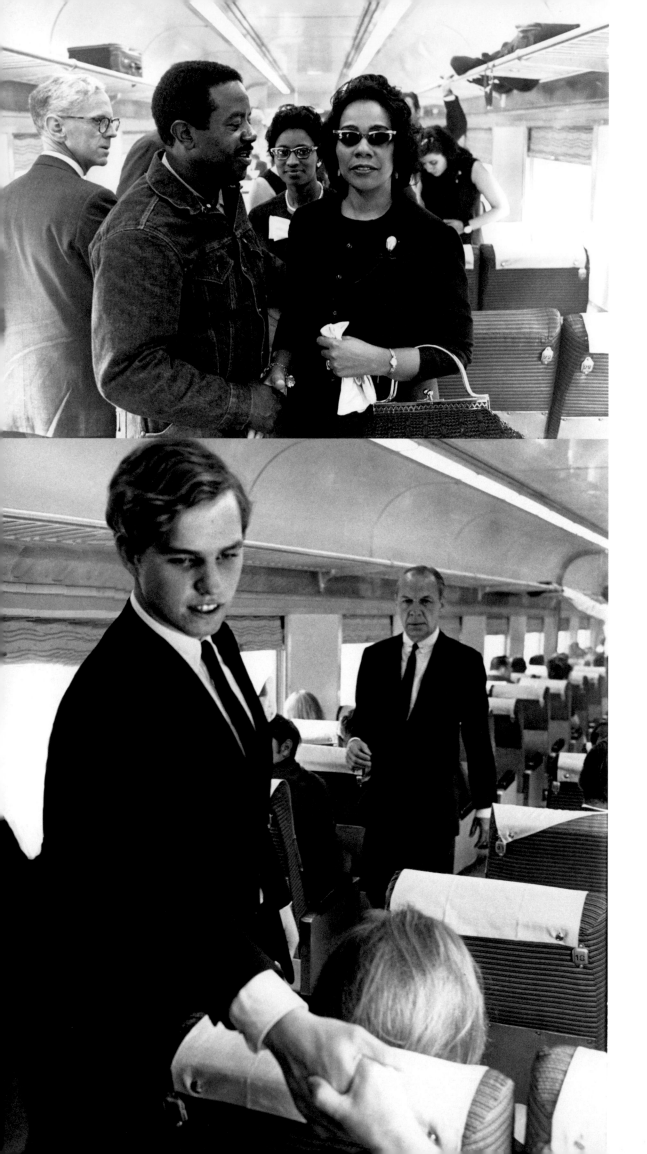

Top: Coretta Scott King and
Ralph Abernathy.
Bottom: Joseph Kennedy II.

Opposite: Sidney Poitier.

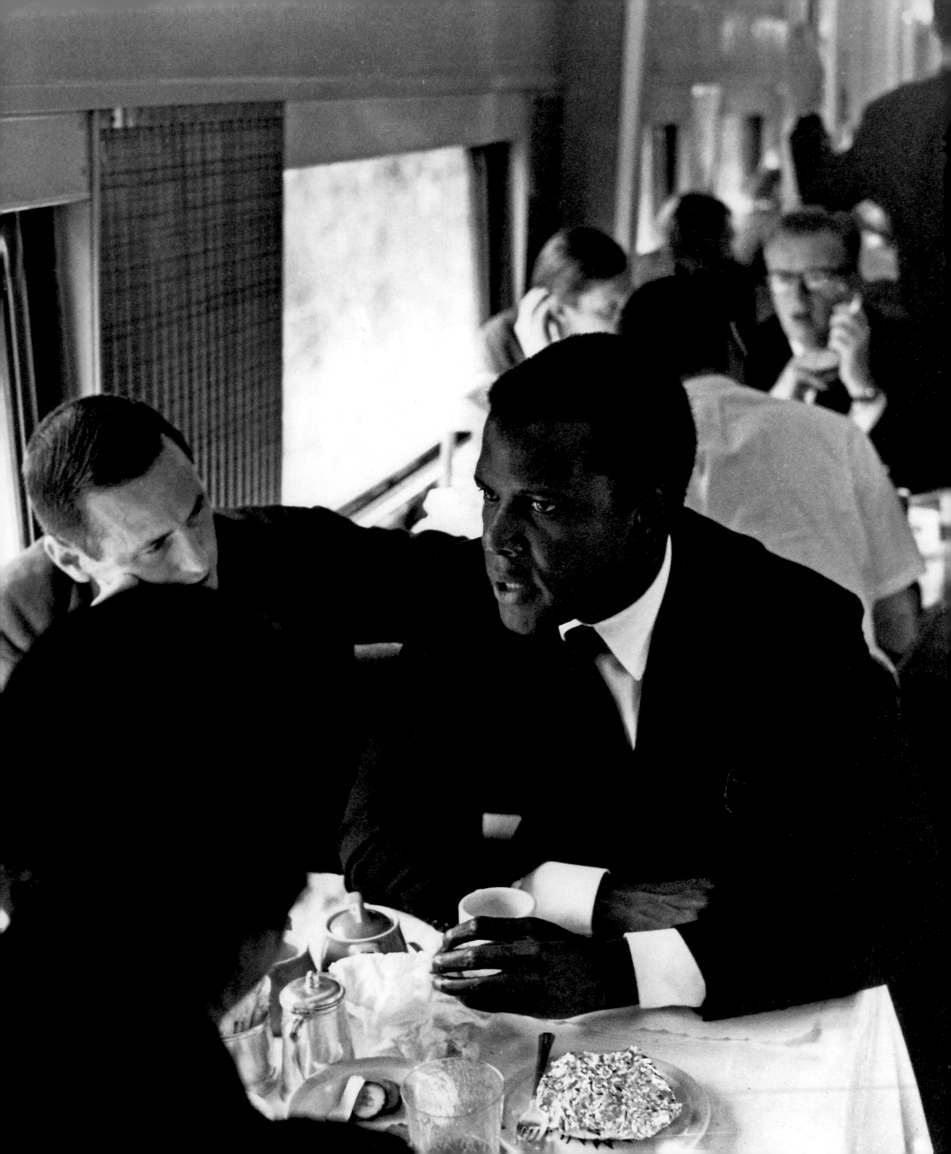

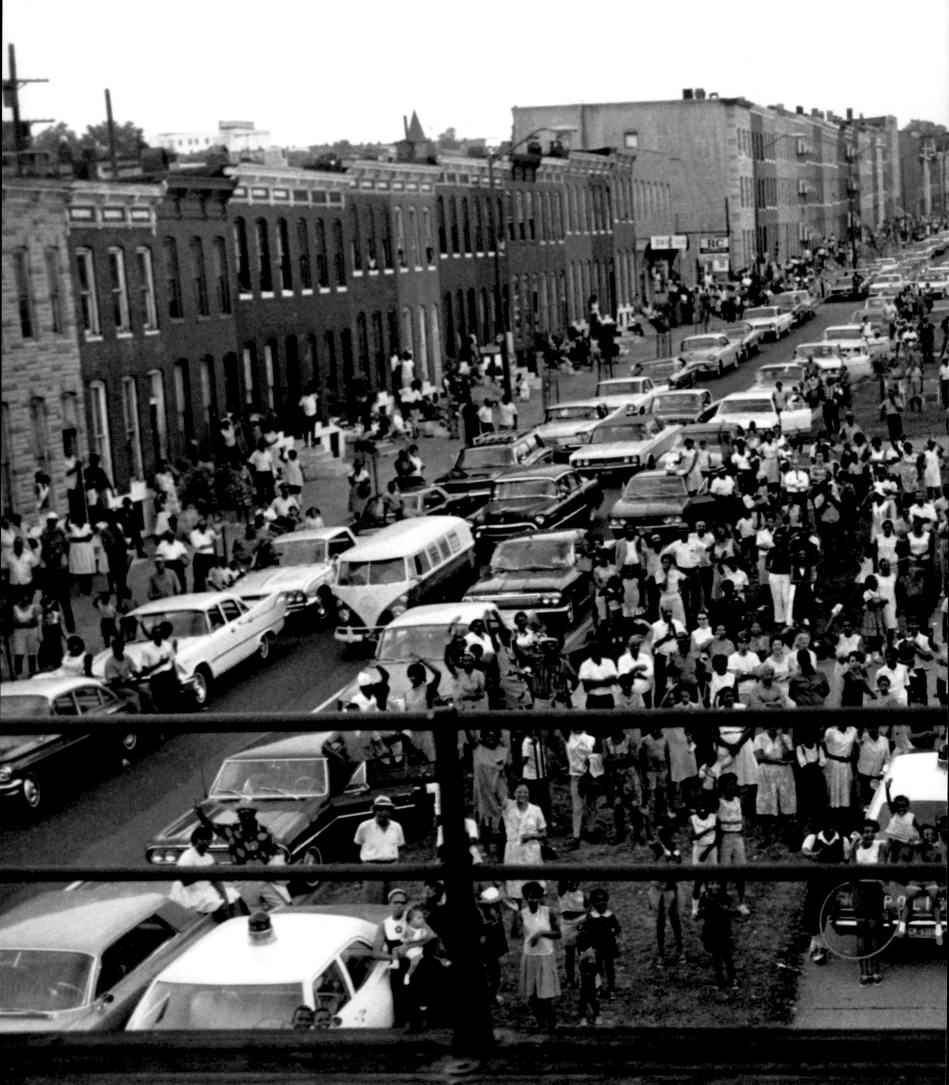

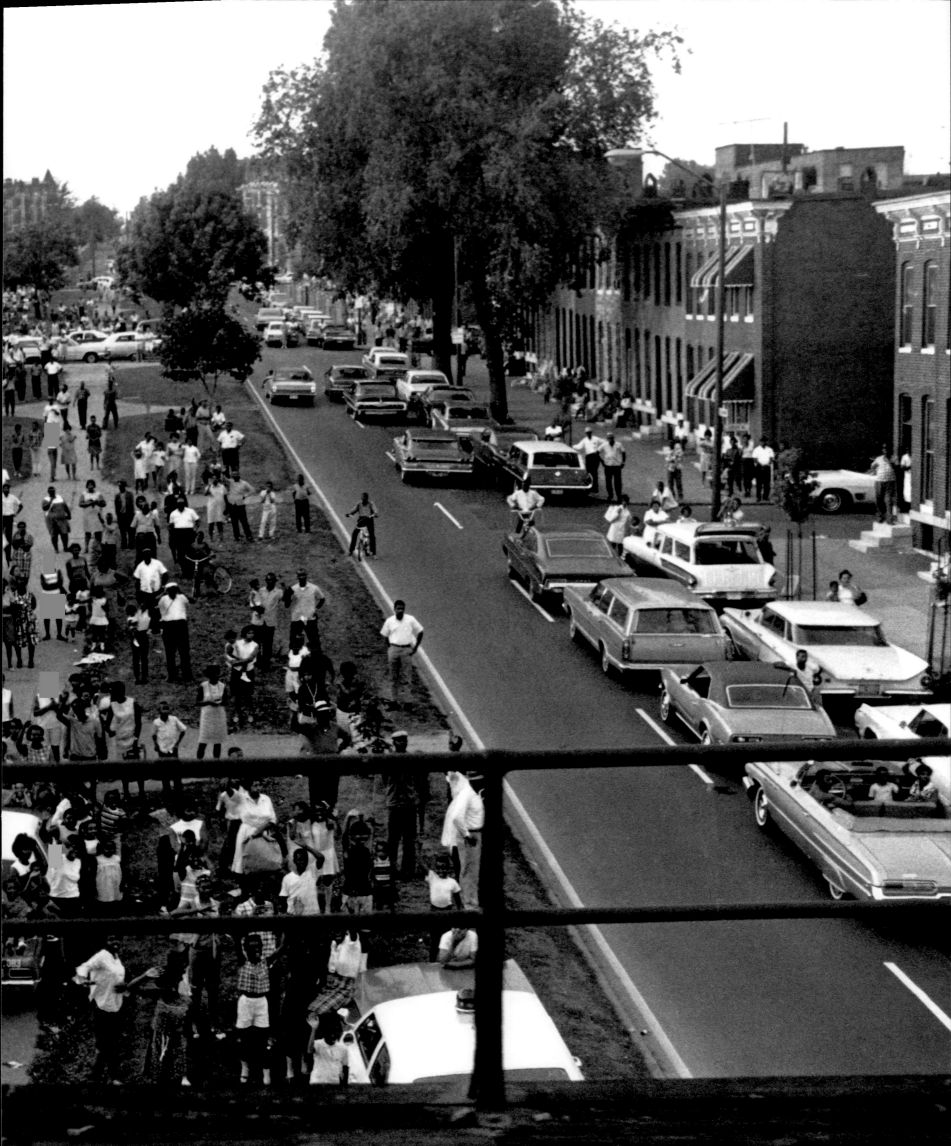

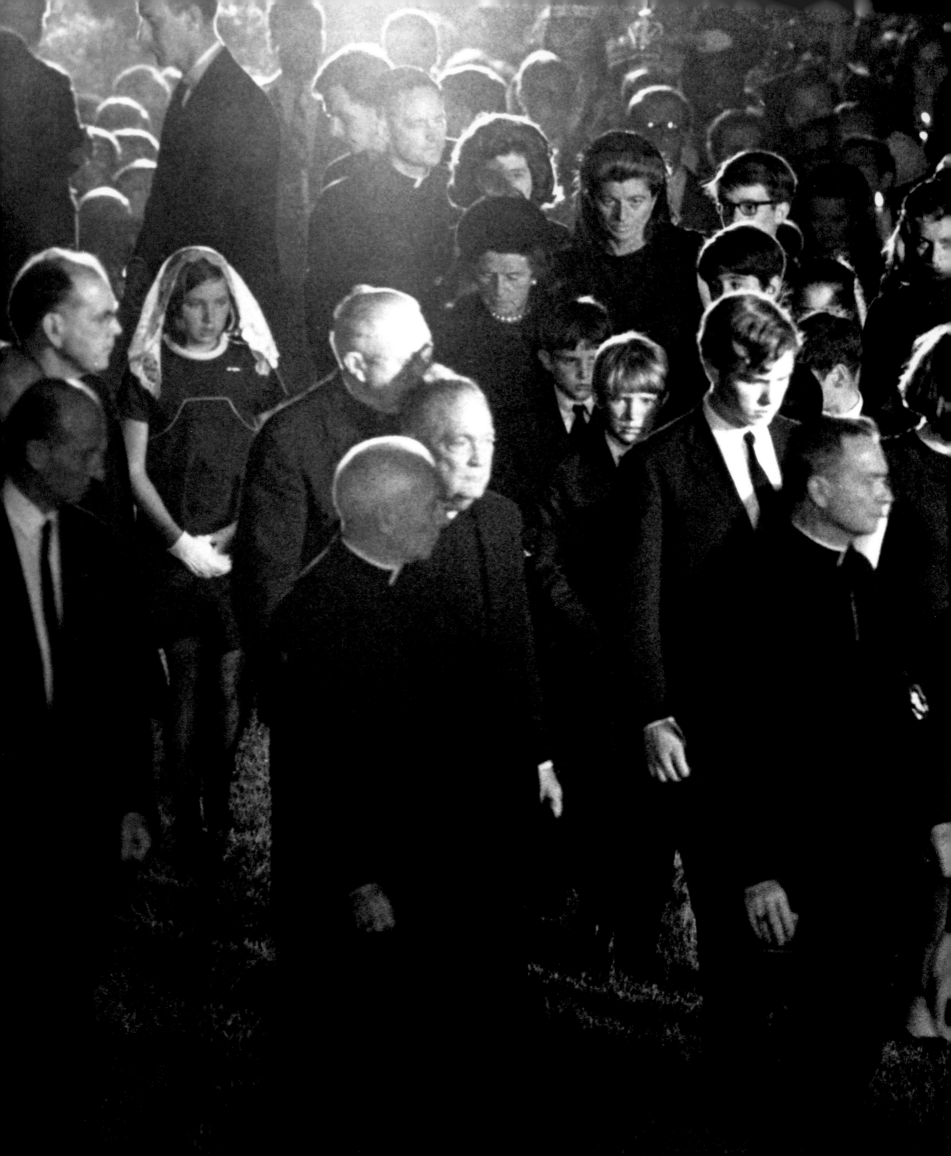

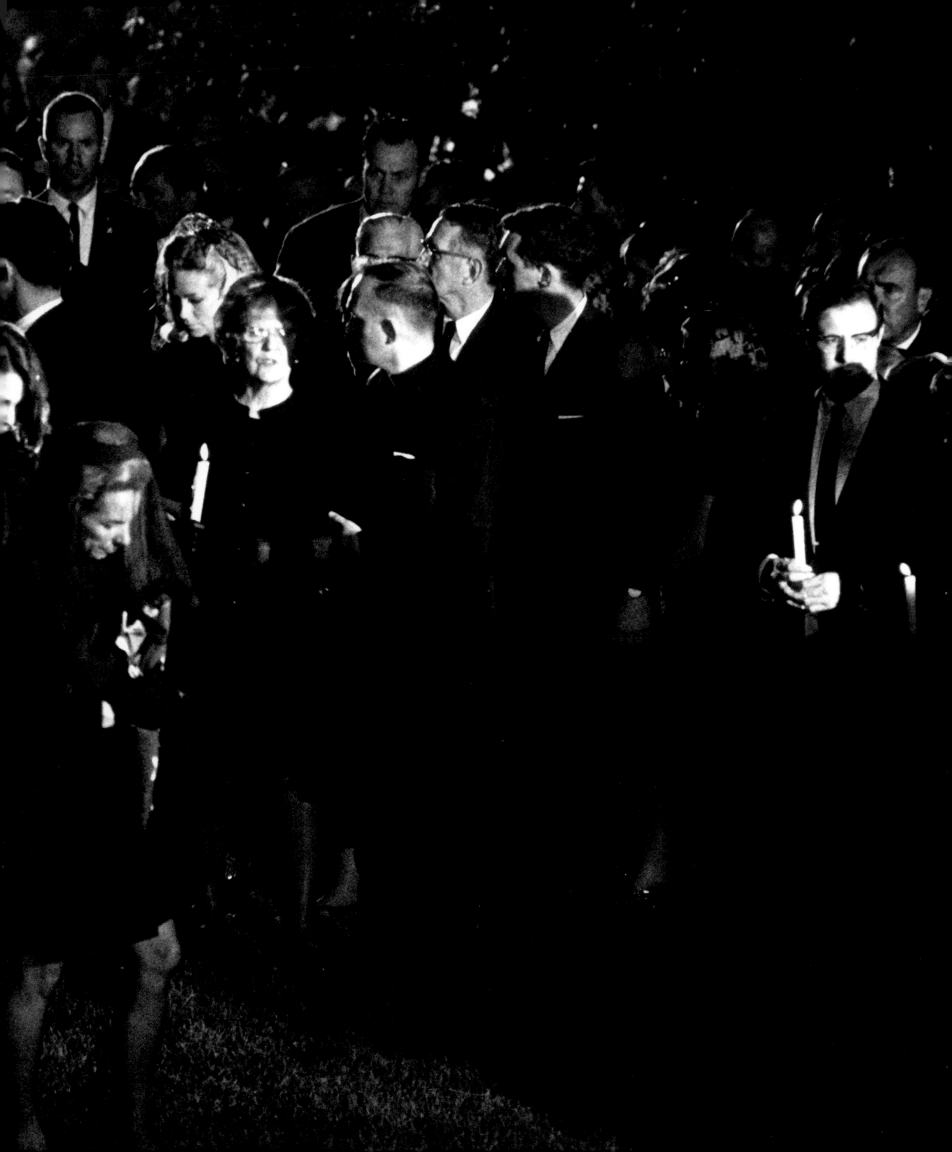

P.132–133: Mourners by the train tracks.
P.134–135: Ethel at Arlington Cemetery.

Right: Jacqueline Kennedy, with
Caroline and John, Jr., kneeling at the
grave of John F. Kennedy.

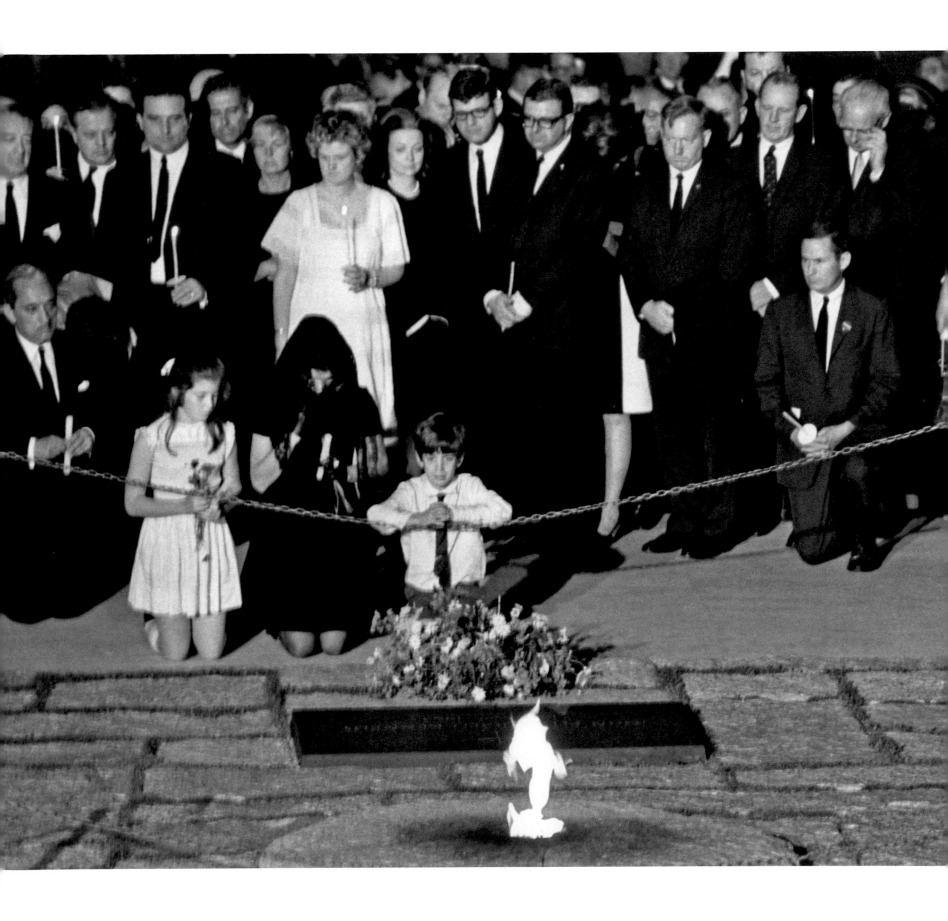

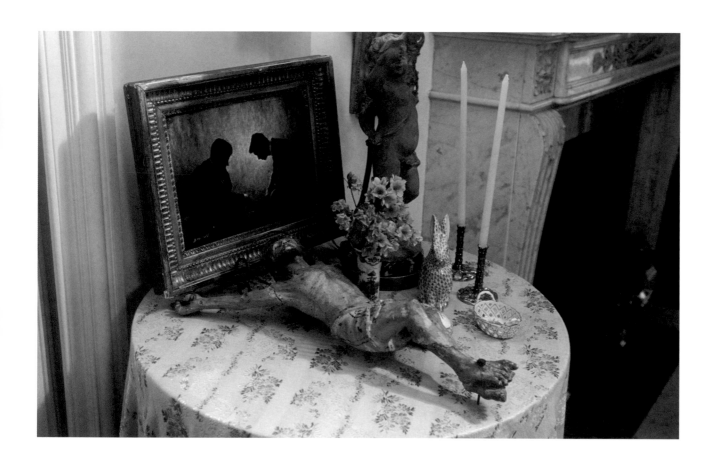

A table at the family home, Hickory Hill,
in Virginia.

The rest of the year went by with more protests, more killings and deaths in Vietnam, and a presidential election on Tuesday, November 5, in which Richard Nixon defeated Hubert Humphrey. I spent the night at Nixon's New York headquarters photographing the victory speech and celebration.

TUESDAY / DECEMBER 24

Ironically, the tumultuous year ended on an incredible note of hope—astronauts Frank Borman, Jim Lovell, and William Anders aboard Apollo 8 became the first men to orbit the far side of the Moon. From space, they could see the planet Earth as a whole. Would it ever be whole again? That was the question.

In the 40 years that have passed, the questions I hear are always the same: "What would it have been like had Bobby lived? How would he have changed the world and enriched our lives?" The truth is no one knows what would have happened.

With Bobby, it was always said that he would have made a great difference. Maybe we would have gotten out of Vietnam sooner, maybe not. There were so many problems and issues—it was a complicated mess. Instead of Bobby, we got Richard Nixon who, despite what some think, made a number of extremely important negotiations while president, including opening up China.

Personally, I miss Bobby Kennedy. He was generous in that I would always leave happy—with a photograph in hand to send back to my paper. What more could a photojournalist ask for?

I think of Bobby often—not just about that terrible night, but about his determination, his conviction that the world could be a better place. I remember the small personal things he did—like telling his driver one night during the campaign to stop and let me hitch a ride with him, or when I had a coffee and quiet conversation with Bobby in a motel in some small town on the campaign trail. You don't forget those things. Bobby also told me he thought America would be ready for a woman or a black president in 30 years. He was ahead of his time.

In the ensuing years, I have photographed Bobby's family: Ethel and their 11 children, and the myriad of spouses and grandchildren. It saddens me to think that Bobby did not live to see his children and grandchildren growing up and to see their many accomplishments. To me, that is the greatest tragedy of all.

ROBERT FRANCIS KENNEDY
NOVEMBER 20 / 1925 – JUNE 6 / 1968

"America was a great force in the world, with immense prestige, long before we became a great military power. That power has come to us and we cannot renounce it, but neither can we afford to forget that the real constructive force in the world comes not from bombs, but from imaginative ideas, warm sympathies, and a generous spirit. These are qualities that cannot be manufactured by specialists in public relations. They are the natural qualities of a people pursuing decency and human dignity in its own undertakings without arrogance or hostility or delusions of superiority toward others; a people whose ideals for others are firmly rooted in the realities of the society we have built for ourselves."

RFK, April 24, 1968
Indiana University
Bloomington, Indiana

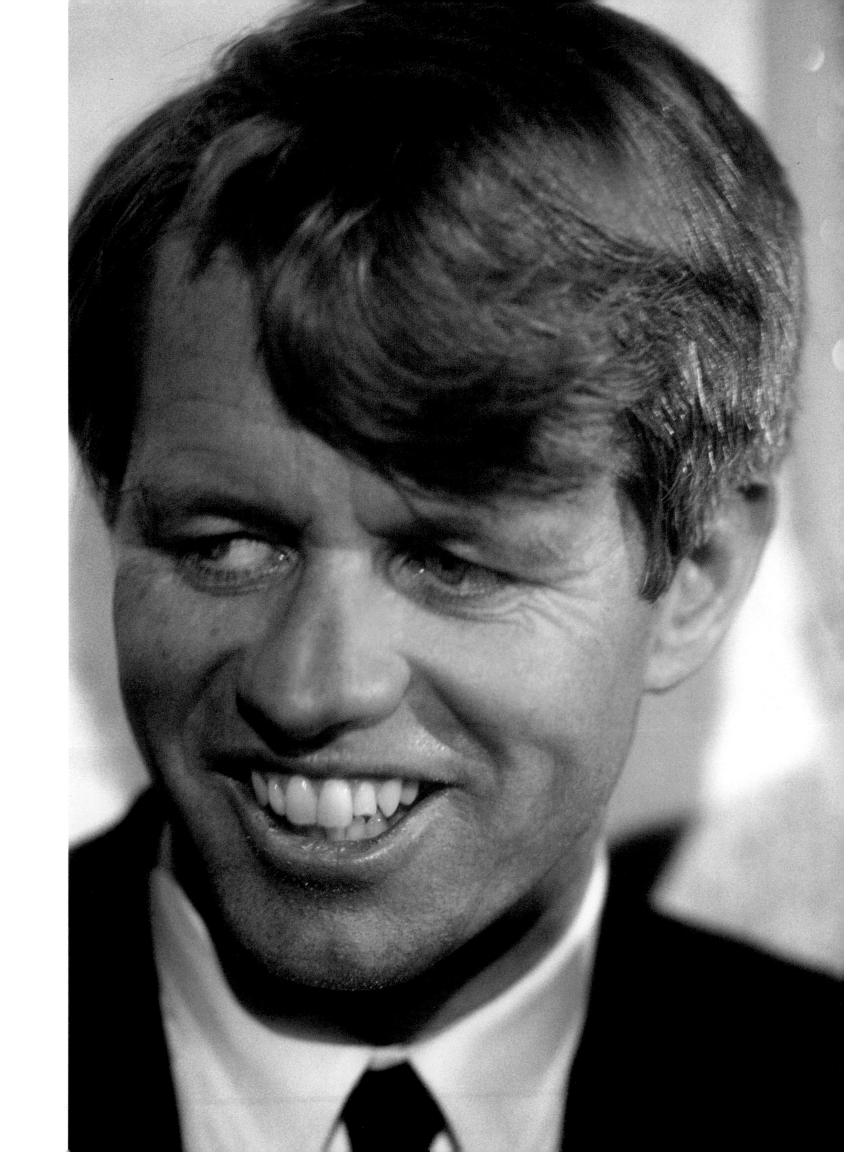

ACKNOWLEDGEMENTS

My sincere thanks to Daniel Power, C.E.O. and Publisher, and Craig Cohen, V.P. and Associate Publisher of powerHouse Books, for believing in the project and having the vision to green-light this book on such short notice. It is a book that my wife Gigi and I have wanted to do for a long time.

I would also like to thank Mine Suda for the handsome design of the book and for her cooperation and her patience; Sara Rosen for her enthusiasm and energy in promoting the book; and Daoud Tyler-Ameen for his editorial guidance and attention to detail.

To Manuela Soares, our longtime friend and editor on my first two books, my special thanks for putting Gigi and me together with Daniel and Craig at powerHouse, and for her sense of humor, her vast knowledge, and her tireless guidance.

And especially to my wife, Gigi, who found my 1968 diary, edited all of the photographs, and who would not give up on the idea that it was time to do this book, as a record for history and a document of an important part of my career.

Harry Benson

R.F.K.

A PHOTOGRAPHER'S JOURNAL

Published in the United States by powerHouse Books,
a division of powerHouse Cultural Entertainment, Inc.
37 Main Street, Brooklyn, NY 11201-1021
telephone 212 604 9074, fax 212 366 5247
e-mail: rfk@powerHouseBooks.com
website: www.powerHouseBooks.com

First edition, 2008

Library of Congress Control Number: 2008923270

Hardcover ISBN 978-1-57687-450-9

Printing and binding by Midas Printing, Inc., China

Edited by Gigi Benson and Manuela Soares

Book design by Mine Suda

A complete catalog of powerHouse Books and Limited Editions is available upon request; please call, write, or visit our website.

10 9 8 7 6 5 4 3 2 1

Printed and bound in China